GIRLS
OF THE
WORLD

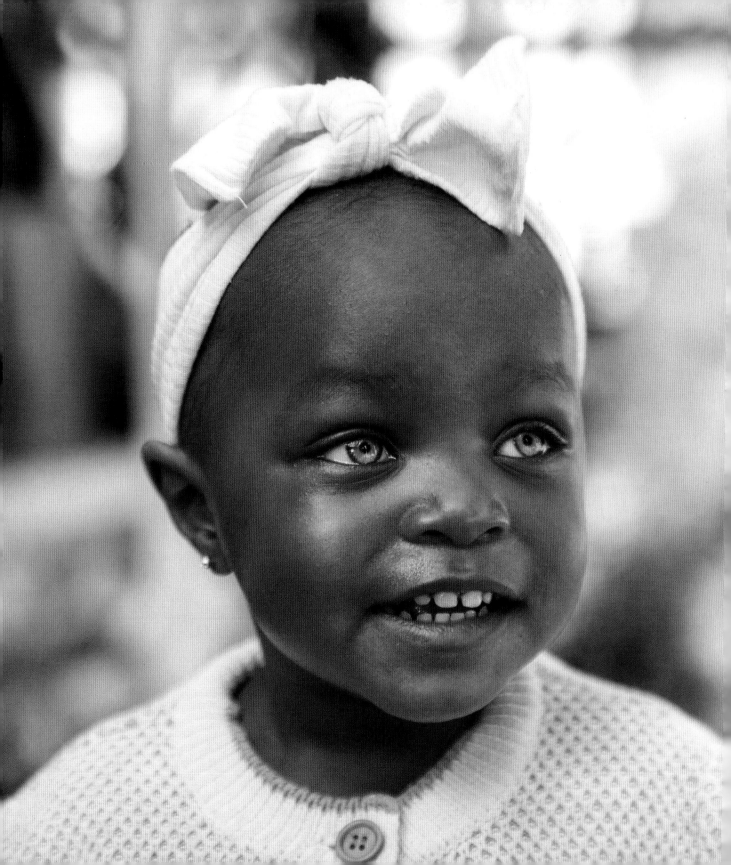

GIRLS OF THE WORLD

250 Portraits of Awesome

Mihaela Noroc

Andrews McMeel
PUBLISHING®

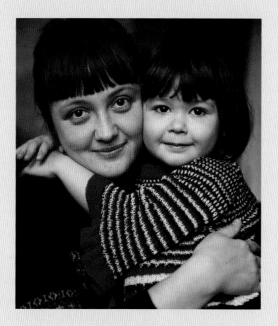

**To my daughter, Natalia,
and to all the girls of the world**

Also by Mihaela Noroc

The Atlas of Beauty: Women of the World in 500 Portraits

INTRODUCTION

Imagine this book as a journey around the world. Together, we will travel to 55 countries and meet awesome girls from very different environments. We will discover endless ways that girls can experience authentic joy, and we will learn amazing and fascinating things about the cultures in our world and the true diversity of our planet.

I will be your guide during this colorful journey, so let me present myself. My name is Mihaela. If it's hard for you to pronounce, you can call me Ella. I'm the mother of a young girl named Natalia. To inspire her, other girls, parents, and everyone else, I've created this book.

When I look back on my own childhood, I recall feeling like an outsider most of the time. My family left one country and moved to another when I was six years old, and my accent sounded funny to my classmates. They teased me for the way I talked, the way I looked, and because I couldn't run fast or catch a ball. I wasn't a particularly good student, either. Most of the time, I just felt awkward and out of step with my peers.

Back then, I didn't know that every girl has her own superpowers—but I soon got on the path to working this out.

The only place where I used to feel great was in my father's art studio. My dad was a painter, and he'd give me my own brush and palette and let me paint alongside him. I'd delight in experimenting with all the different colors—and that's how I found my first super-power: creativity.

Growing up in Eastern Europe in the 1990s, there was a lot of uncertainty. When I was painting, however, I was free from the constraints of the outside world, and I could express things that were personal to me. I could also escape my usual worries, like my problems in school and the financial struggles of my family.

I was not a skilled painter, but that was beside the point. My first superpower was starting to grow.

When I was sixteen, my parents gifted me my first camera. That marked the beginning of my photography career. I'd found my medium.

I went to college to study photography, but unfortunately I received little encouragement from my professors. I felt like I wasn't good enough, and I even stopped doing any photography for a while. But then my second superpower came to me: persistence.

In 2013, I drained my small savings to back-pack around the globe for a year, taking my camera with me. My two superpowers, creativity and persistence, had the opportunity to work hand in hand for the first time in my life.

I had the vague idea that I wanted to photograph various women along the way, but soon a mission began to take shape. I ended up traveling to all the major populated parts of the world and photographing women everywhere. I called my project "The Atlas of Beauty."

With every picture I snapped, I realized that beauty is a quality without standards, without rules, without sizes, colors, ages, or circumstances. Any "ideal" concepts of beauty quickly seemed ridiculous to me, now that I had gotten to meet so many amazing women with their own strong gazes. As so many women stared poignantly through my lens, it became clear to me that beauty is found in our authenticity and comes from the inside.

Over time, I grew my social media pages and ended up with more than a million followers, and my project published as a book! I couldn't believe that I was giving radio and TV interviews around the world, sharing the story of how I came to photograph thousands of women.

Just after that, a new chapter of my life began: I became a mother. I knew my daughter would grow up in a complex world, with challenges even tougher than those we face today. There will probably still be pressure on girls and women to look and act a certain way, so I wanted to inspire her and to inspire all the girls in the world to be their authentic selves, to find their superpowers, and to become our awesome women of tomorrow.

While working on this book, my daughter, Natalia, accompanied me on more than half of my travels. She's now four and has already visited thirty-five countries with me!

In Norway, she crawled for the first time. In Morocco, she said her first "mama." In Iceland, she took her first steps. In the United States, she danced for the first time. In Colombia, she got her first eye infection. In Indonesia, she took her first bath in the ocean. Together, we discovered our planet, but more than that, we discovered the amazing girls on it.

In all these years, I have realized that all the young women of the world—no matter their culture or circumstance—have the potential to move mountains. They just need a little support and encouragement to find their superpowers.

Looking back, I sometimes can't believe I've been fortunate enough to travel the globe and chronicle a multitude of special places and the people who inhabit them.

That awkward girl who was bullied in school has now found success with her passion for photography. If I did it, any girl could do it.

And now, let's start the journey. Are you ready?

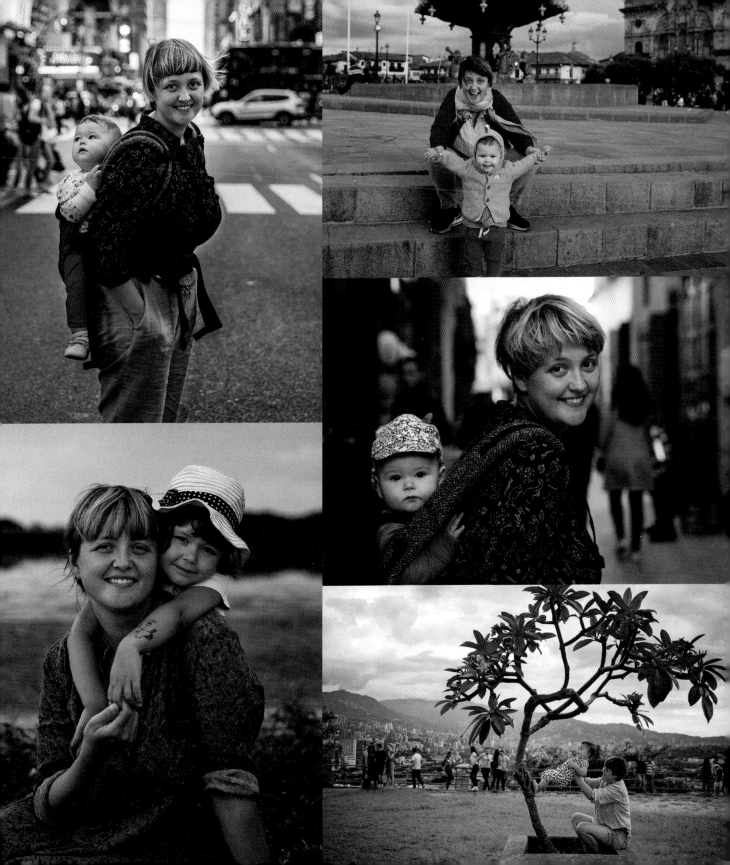

DUBAI, UNITED ARAB EMIRATES

Michelle loves to mix different kinds of music, like Afrobeat, house, hip-hop, and R & B. At only nine years old, she's already an experienced DJ who's won prizes in adult competitions. She's originally from Azerbaijan, but she grew up and developed her musical talent in Dubai.

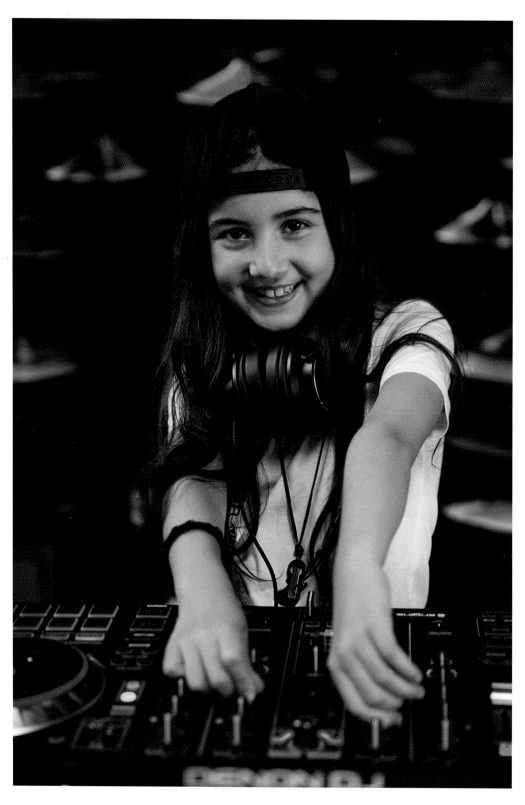

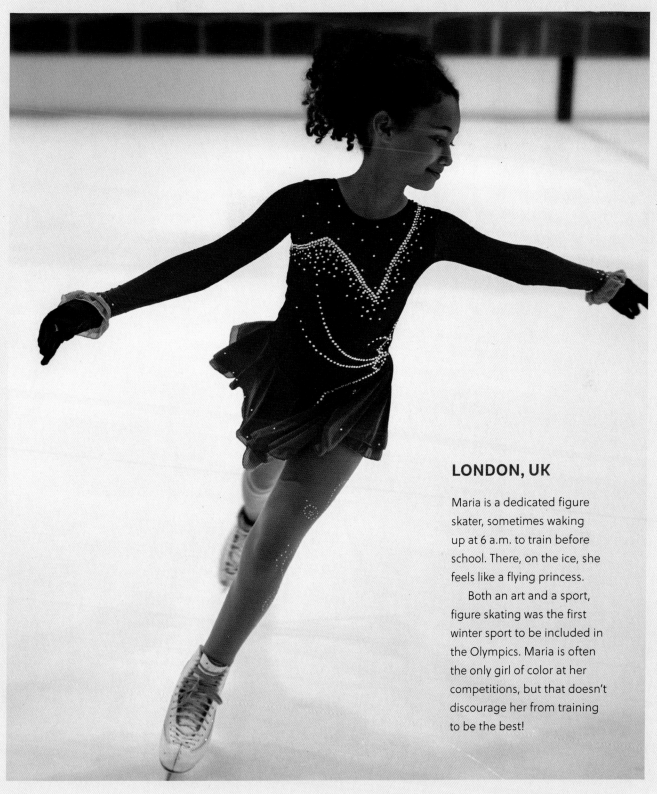

LONDON, UK

Maria is a dedicated figure skater, sometimes waking up at 6 a.m. to train before school. There, on the ice, she feels like a flying princess.

Both an art and a sport, figure skating was the first winter sport to be included in the Olympics. Maria is often the only girl of color at her competitions, but that doesn't discourage her from training to be the best!

ETHIOPIA

Abeyna is a member of the nomadic Afar tribe, inhabiting one of the hottest places on Earth, the Danakil region of Ethiopia. Most Afar people are camel herders: their lives and livelihoods depend exclusively on their camels. They drink their milk, eat their meat, and sell them at the market.

Usually, it's the men who take care of the herds, but Abeyna has a special connection to her camels. Moving from place to place can be difficult, but Abeyna is clearly at her happiest when she's around her animals.

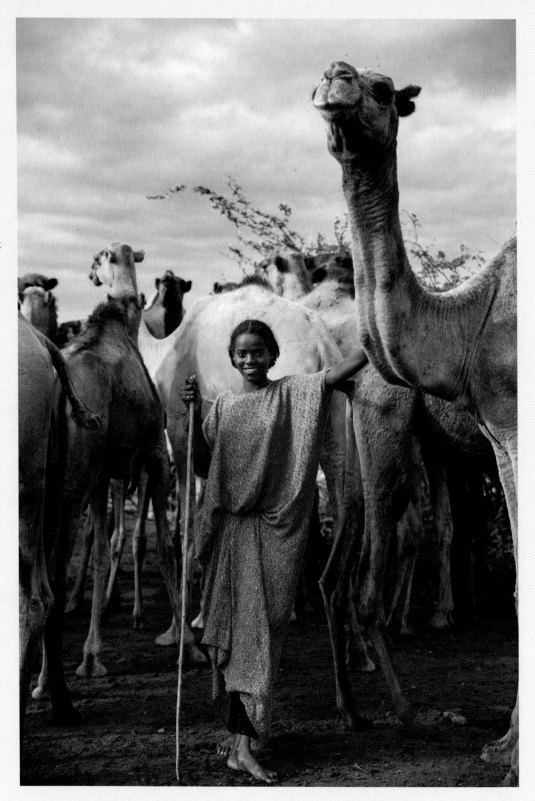

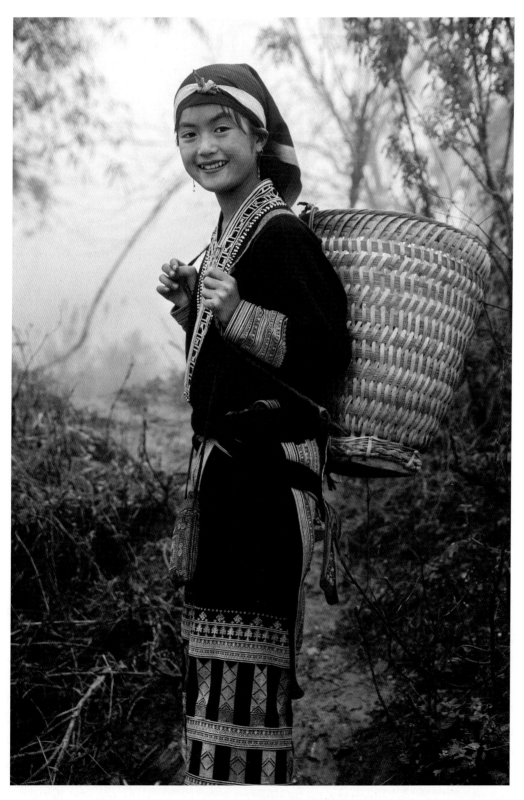

NORTHERN VIETNAM

Lu May is helping her parents with their small souvenir business. Lu May herself creates handmade jewelry and sells it to tourists. Most of her days are tiring, with both work and school, but she's delighted to meet tourists from different countries. She studies English in school and has plenty of opportunities to practice.

DAMASCUS, SYRIA

These Syrian girls are taking part in their weekly ballet class, practicing their poses with poise. Starting ballet at a young age helps dancers develop discipline and good technique.

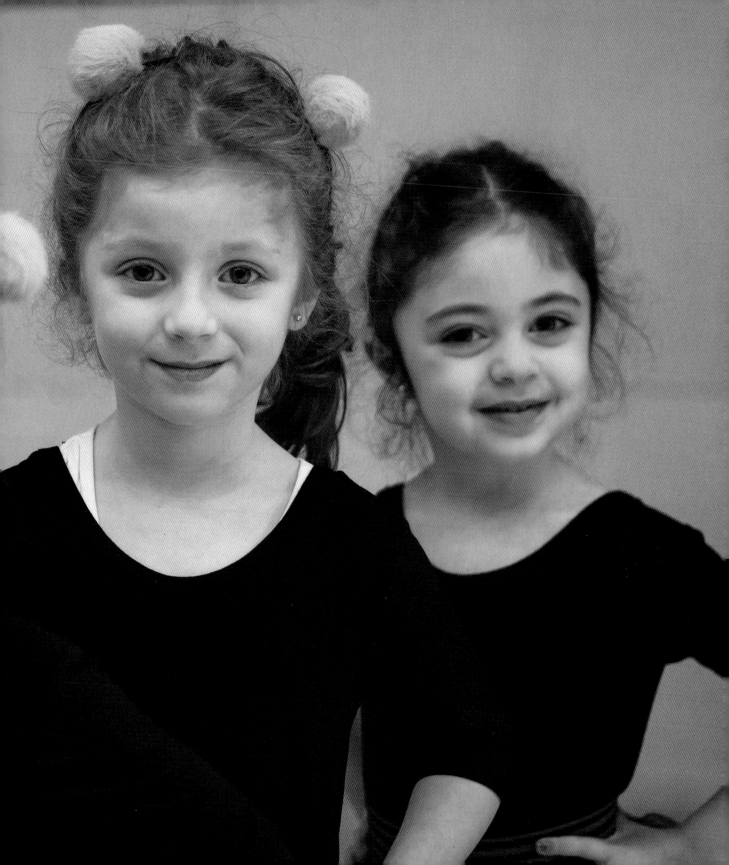

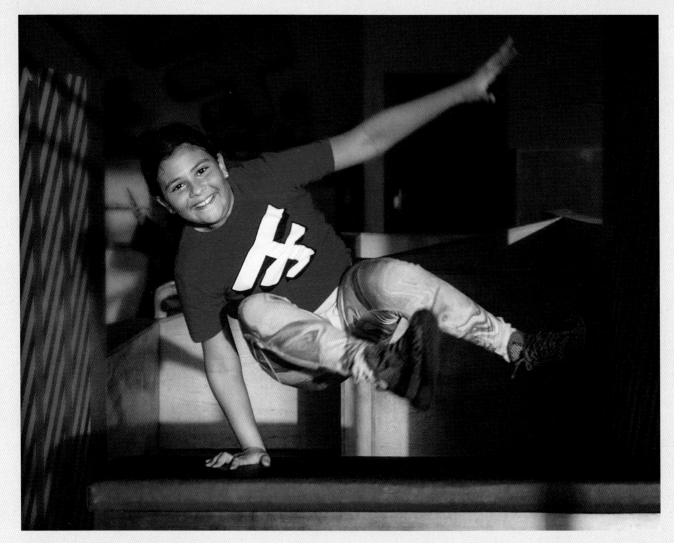

JEDDAH, SAUDI ARABIA

Aisha is a parkour athlete, meaning she runs and jumps over complex obstacles to get from point to point as quickly as possible. It's amazing to watch as she leaps and tumbles through the obstacle course, smiling as she vaults over a bar.

Until recently, women in Saudi Arabia were not allowed to drive a car or travel unaccompanied by men. But many brave Saudi women stood up for their rights, and things are changing. Aisha's teacher said Aisha used to be very shy, but when she discovered parkour, she found a courage she didn't know she had. Aisha is devoted to practicing parkour every day without fail and is determined to become a competitive champion.

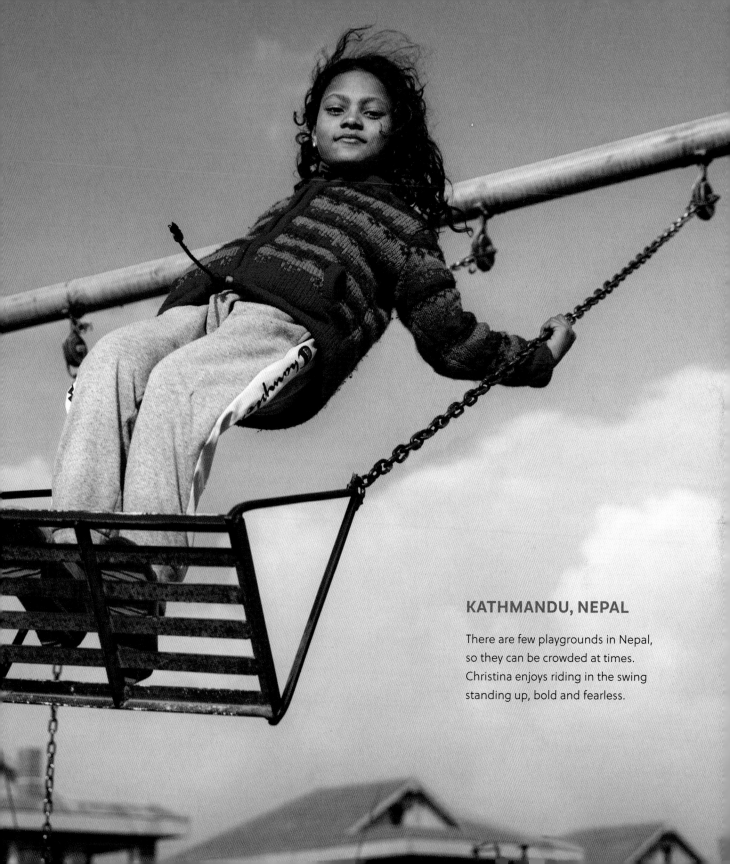

KATHMANDU, NEPAL

There are few playgrounds in Nepal, so they can be crowded at times. Christina enjoys riding in the swing standing up, bold and fearless.

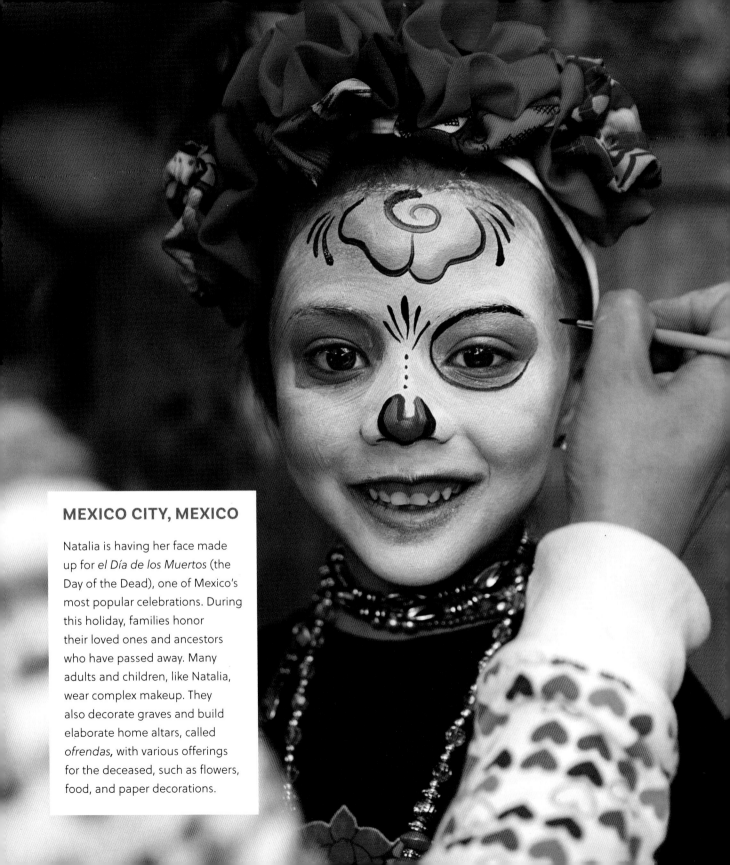

MEXICO CITY, MEXICO

Natalia is having her face made up for *el Día de los Muertos* (the Day of the Dead), one of Mexico's most popular celebrations. During this holiday, families honor their loved ones and ancestors who have passed away. Many adults and children, like Natalia, wear complex makeup. They also decorate graves and build elaborate home altars, called *ofrendas*, with various offerings for the deceased, such as flowers, food, and paper decorations.

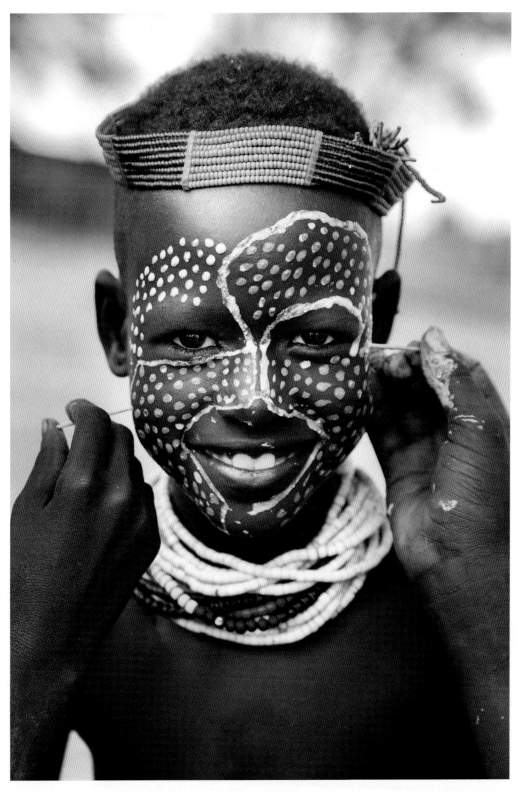

OMO VALLEY, ETHIOPIA

The Karo people are famous for painting their faces with natural materials. Here, Palekach is having her face painted by her friends. Karo children become artists at a young age, creating unique designs like their parents and grandparents do.

AUSTIN, TEXAS, USA

Montannah is fascinated by mountains. There are only small mountain ranges where she lives, so she loves to travel in search of higher peaks. When she was just seven years old, she traveled to Tanzania in Africa and became the youngest girl in the world to climb Mount Kilimanjaro, the continent's highest summit.

She wanted to honor her father, who passed away when she was very young. She told me, "There, on the peak of the mountain, I felt closer to Heaven, closer to Dad. I blew kisses to him, so he knew I was there."

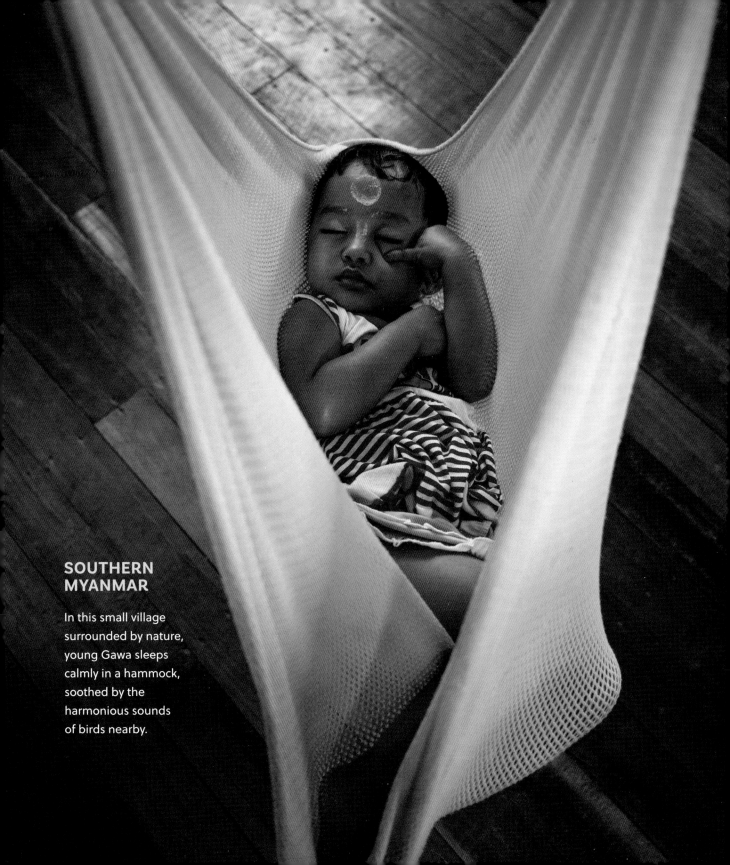

SOUTHERN MYANMAR

In this small village surrounded by nature, young Gawa sleeps calmly in a hammock, soothed by the harmonious sounds of birds nearby.

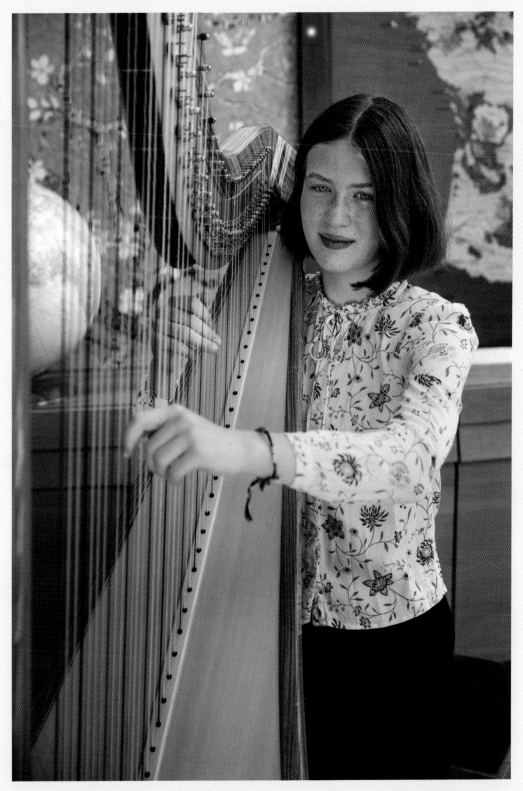

PARIS, FRANCE

At thirteen, Alessa is already an experienced and celebrated harpist. This instrument is fascinating—physically huge with forty-seven strings, it sounds incredibly gentle. Alessa enjoys the calming sounds of her harp, feeling her worries fade as she plays.

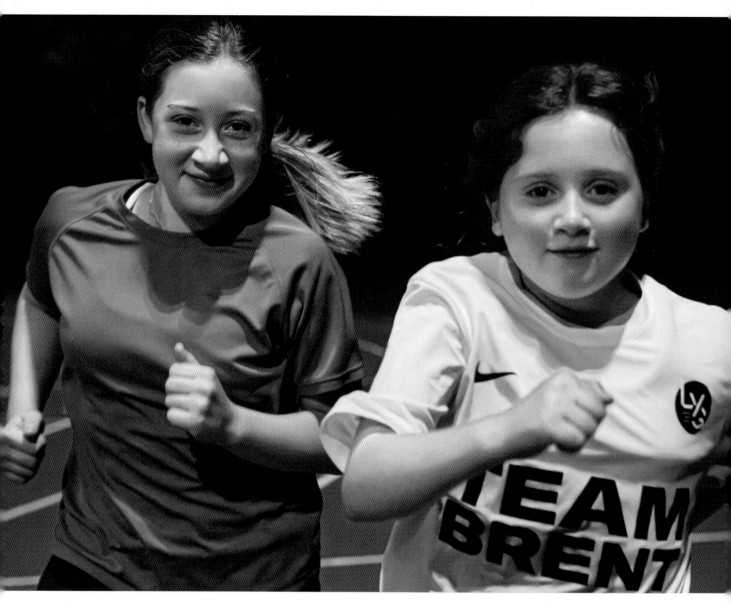

LONDON, UK

Sisters Layla and Hanna were born to run. Every morning, before school, they run about a mile and a half, and every Saturday, they run about three miles.

They get along well, but sometimes they argue. They solve those arguments by running, as it calms them down and makes them feel more positive. Running helps them stay close.

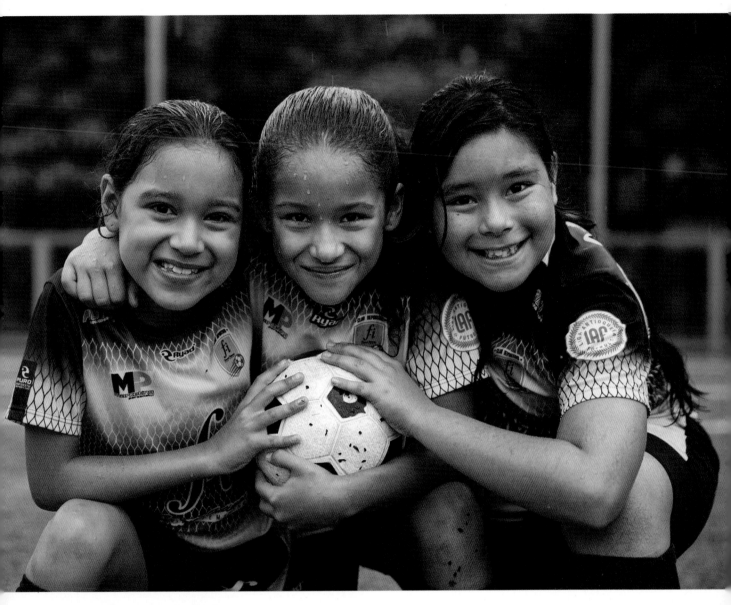

MEDELLÍN, COLOMBIA

Medellín is Colombia's second-biggest city. This is a place of eternal spring, with warm temperatures year-round, though sometimes it rains pretty hard.

Not even the heaviest rain can stop Maria, Luciana, and Ana from playing soccer, or *fútbol*, for their club. They live far from the city, up in the surrounding mountains, and coming to the pitch is a long journey, which they take on foot. But their passion makes the journey worth it. Soccer taught them to be strong and ambitious and to work together both on the pitch and in life.

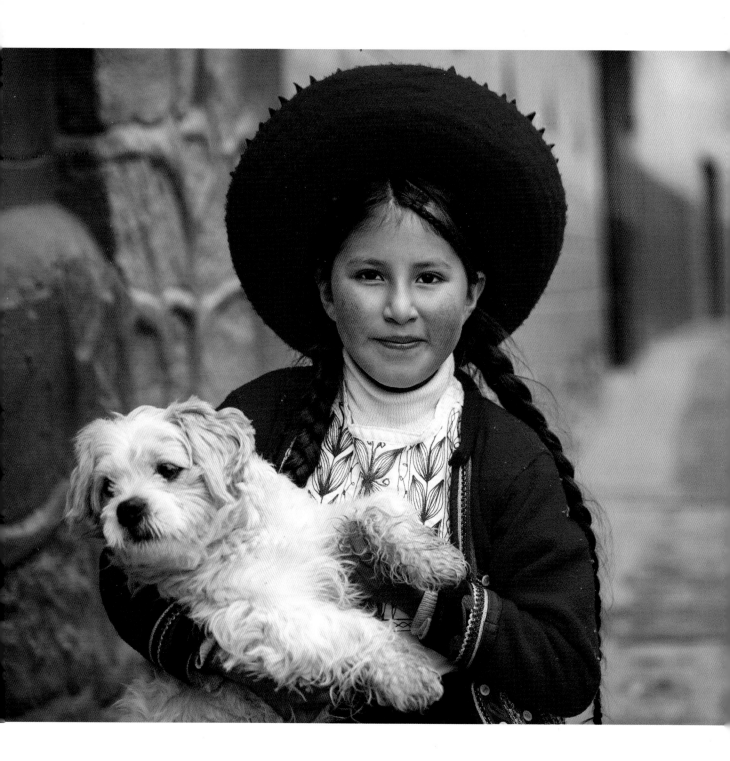

SACRED VALLEY, PERU

Cori Anca lives in a village where most people wear traditional handmade clothes, as she does here. One day, she will learn to weave wool into these fabrics to make her own detailed and colorful traditional clothes. She wants to make traditional clothes for her puppy, too!

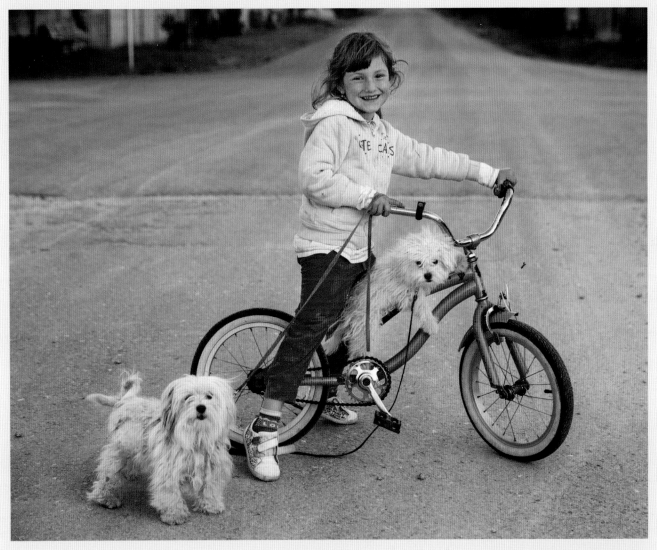

SOUTHERN ROMANIA

Walk the puppies or go for a bike ride? Why not both at the same time?

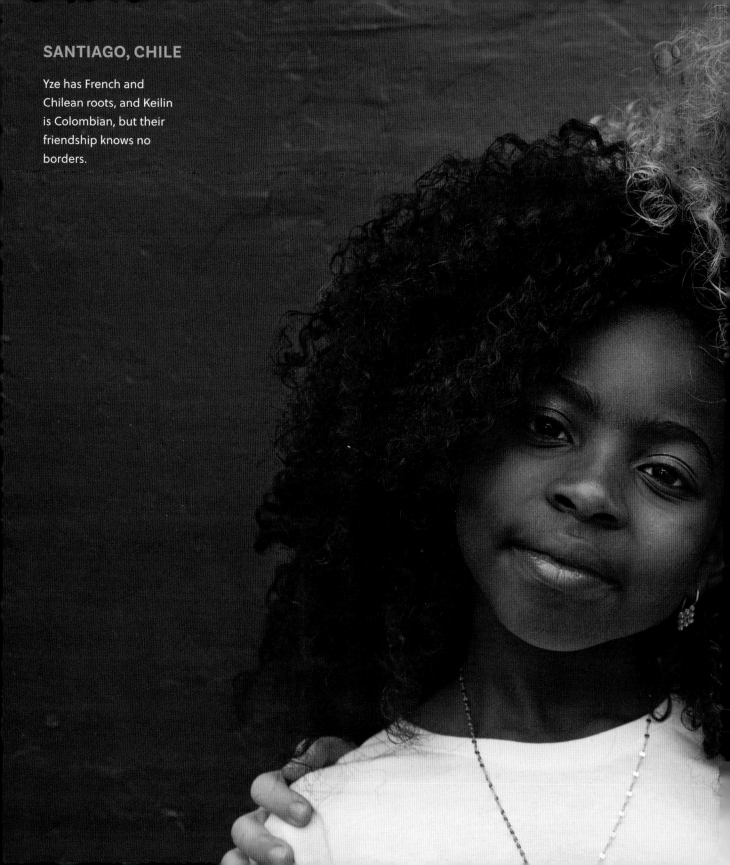

SANTIAGO, CHILE

Yze has French and
Chilean roots, and Keilin
is Colombian, but their
friendship knows no
borders.

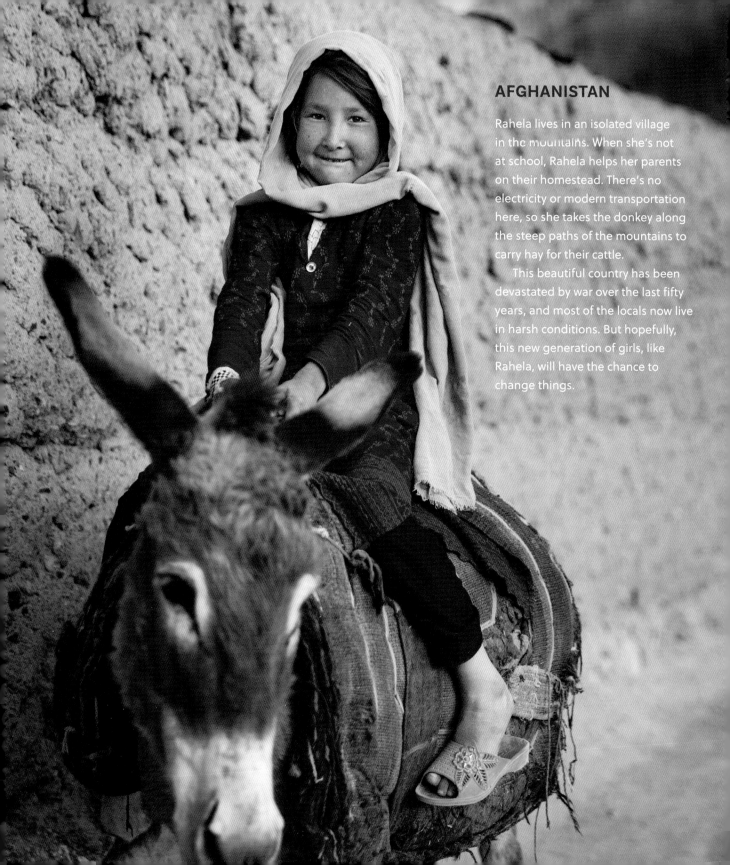

AFGHANISTAN

Rahela lives in an isolated village in the mountains. When she's not at school, Rahela helps her parents on their homestead. There's no electricity or modern transportation here, so she takes the donkey along the steep paths of the mountains to carry hay for their cattle.

This beautiful country has been devastated by war over the last fifty years, and most of the locals now live in harsh conditions. But hopefully, this new generation of girls, like Rahela, will have the chance to change things.

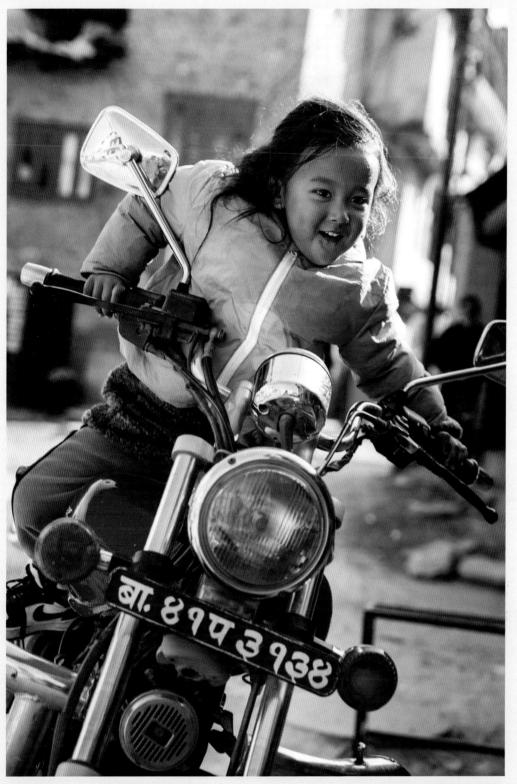

KATHMANDU, NEPAL

This is Prins, playing on her dad's motorcycle and imitating the sounds of its engine. (She doesn't have the keys, though!)

Prins can't wait to grow up and have her own motorcycle. In Nepal, few people can afford a car, so motorbikes are the most common means of private transportation.

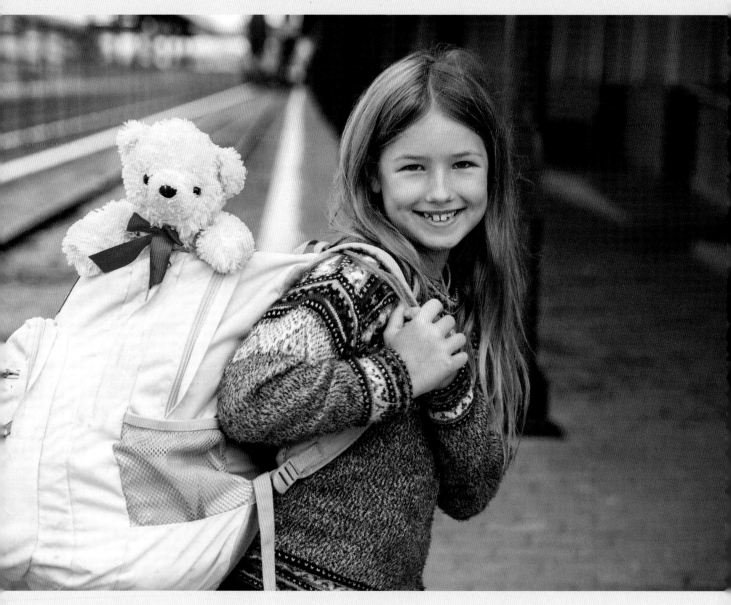

SIBIU, ROMANIA

Arabella was traveling in Europe when I met her. She's American but feels that the entire world is her home. She has already traveled to many countries with her family. Her backpack is full of clothes and her beloved teddy bear. She has even visited remote tribes in Tanzania and been on a camel in Morocco.

Arabella has been learning about the many cultures of the world and the lifestyles people have in different places on our shared planet.

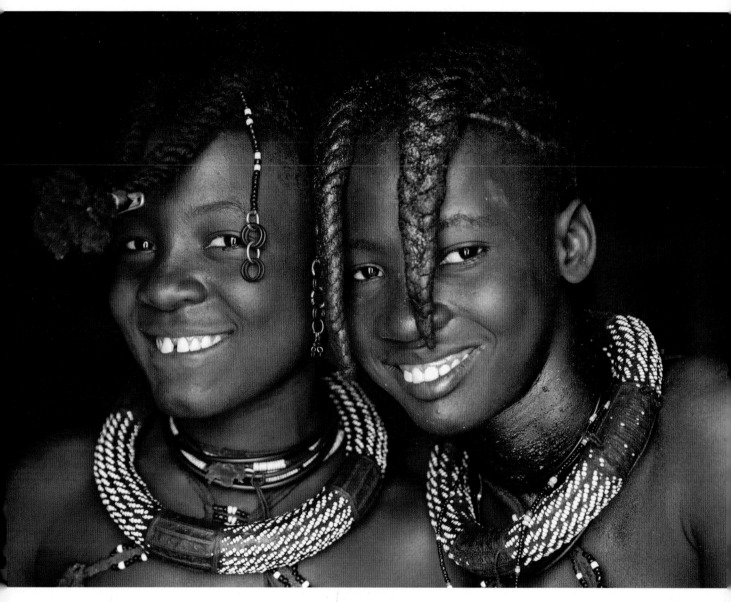

NORTHERN NAMIBIA

Kahirona and Kauripura are very good friends. They are part of the Himba people. The Himba are famous for covering their skin and hair with otjize twice a day. It's a mixture of butterfat and ocher, or red clay pigment, and they often include a scent such as myrrh.

Otjize has several uses in this harsh desert climate. First, it cleanses the skin over long periods, without needing much water, which is scarce. Second, it protects the wearer from insect bites. Third, it works as a perfume. Finally, it's also used for hair styling to create very complex designs and to protect the hair.

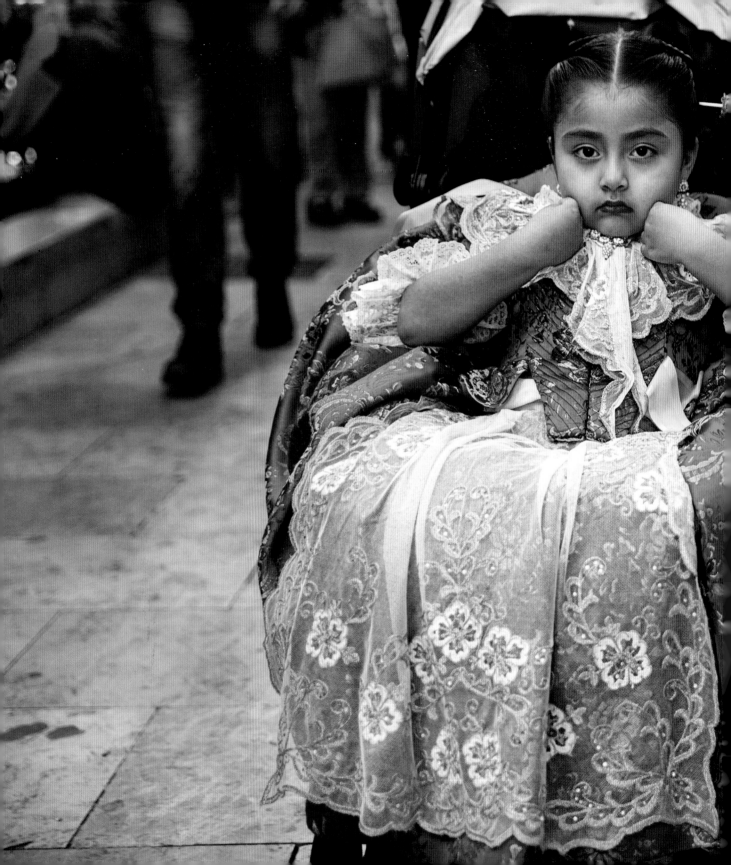

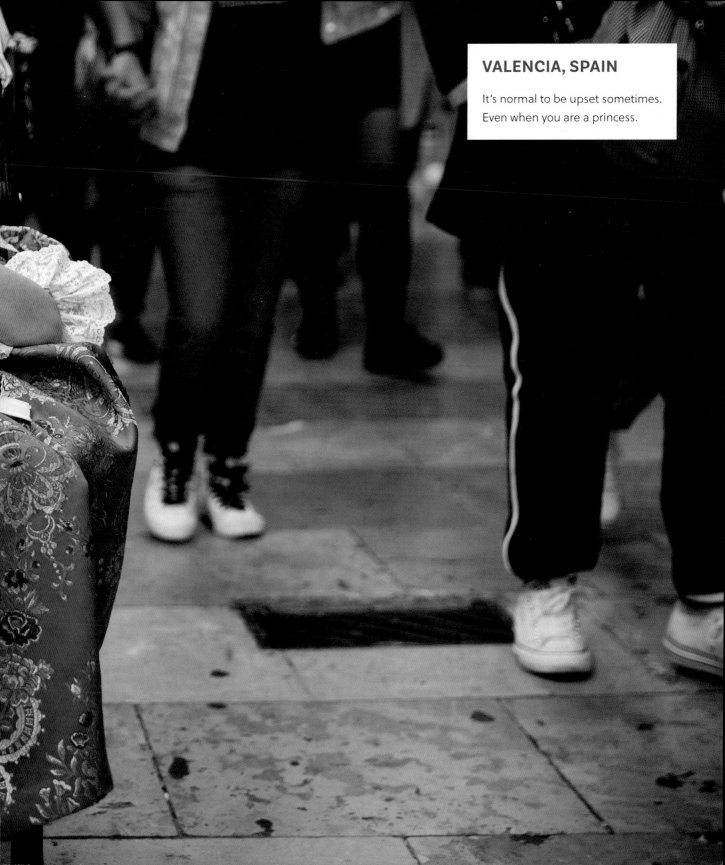

VALENCIA, SPAIN

It's normal to be upset sometimes.
Even when you are a princess.

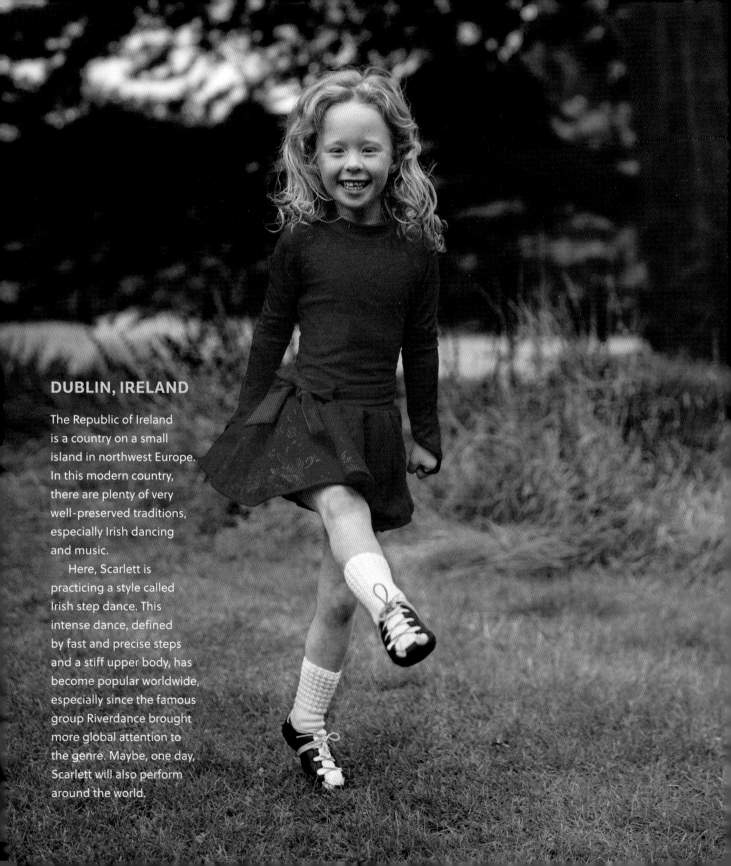

DUBLIN, IRELAND

The Republic of Ireland is a country on a small island in northwest Europe. In this modern country, there are plenty of very well-preserved traditions, especially Irish dancing and music.

Here, Scarlett is practicing a style called Irish step dance. This intense dance, defined by fast and precise steps and a stiff upper body, has become popular worldwide, especially since the famous group Riverdance brought more global attention to the genre. Maybe, one day, Scarlett will also perform around the world.

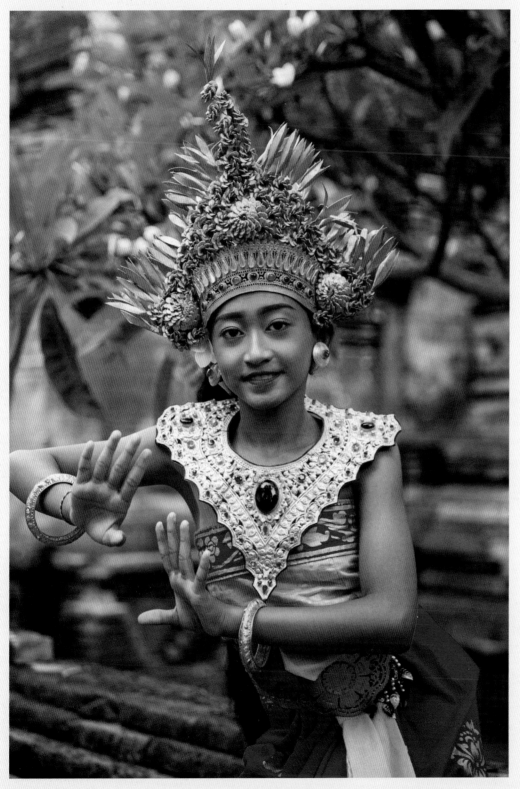

BALI, INDONESIA

Luh practices traditional Balinese dance. Bali is an island in Indonesia with its own distinct culture and language. Many people here follow Hinduism, which is more popular in India than in Indonesia.

For hundreds of years, Balinese people have performed this unique dance, through which they express complex stories and symbolism. Luh learned this dance from her mother and continues this ancient tradition.

BERLIN, GERMANY

Baseball is not as popular in Europe as it is in the United States, but Nora loves it, and she's a very talented player. Although she's the only girl on her team, she quickly earned the respect of her teammates when she showed her skills on the field.

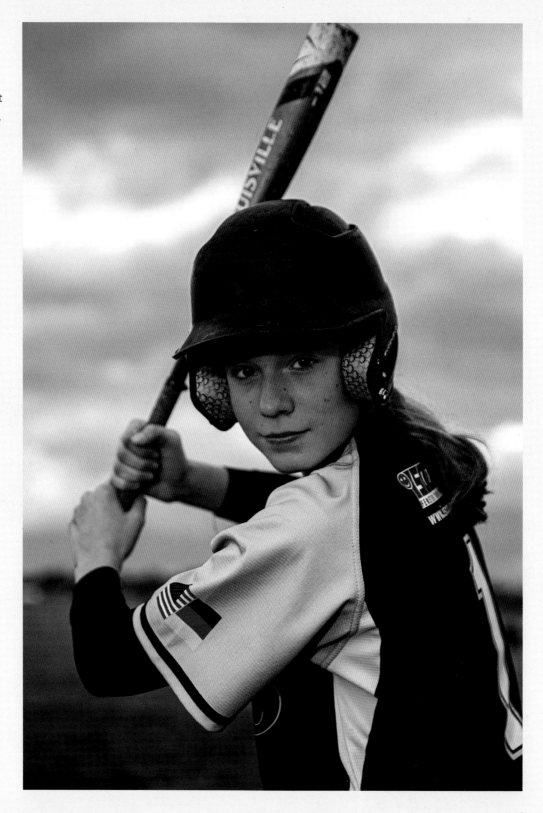

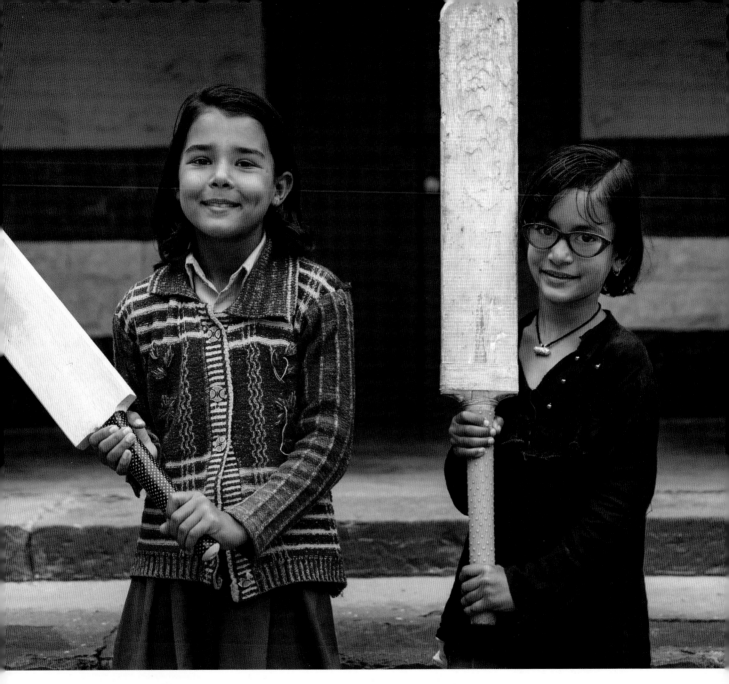

RAJASTHAN, INDIA

Every time they have a break at school, Kanchan and Bhawna go out in the courtyard and play cricket. Like in baseball, cricket involves hitting a ball and running—but that's where the similarities end.

 Cricket is the most popular sport in India, and some perceive it as exclusively a "boys' sport," but Kanchan and Bhawna don't let that stop them!

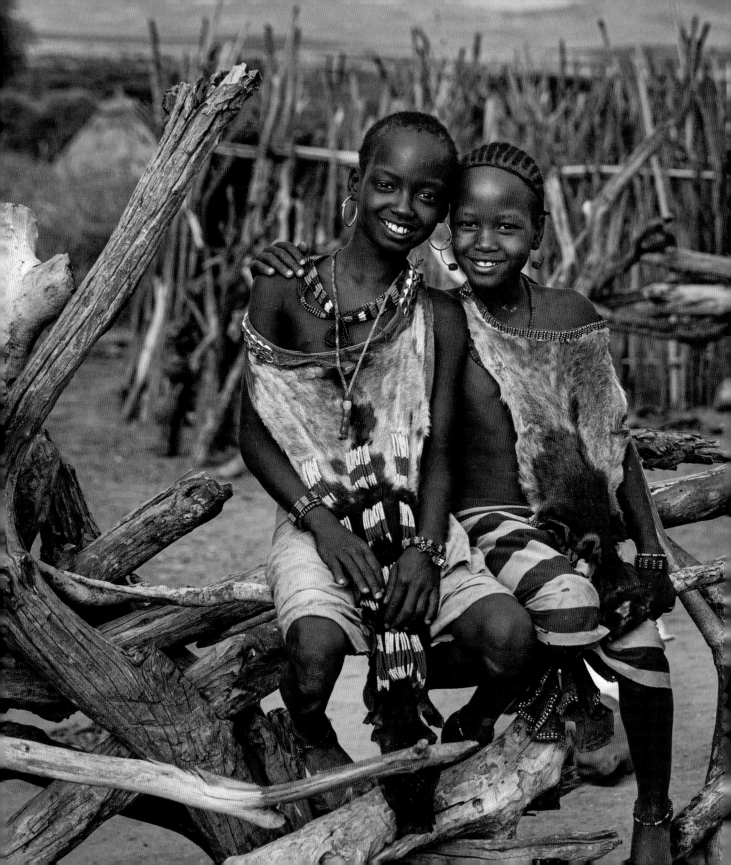

OMO VALLEY, ETHIOPIA

These two friends are part of the Hamar community in southern Ethiopia. The Hamar people care for their environment and get all their materials directly from nature. Their clothes, for example, are made of goatskin. They built this fence from tree branches, and their homes are roofed with hay. In the evening, they play under the light of the moon.

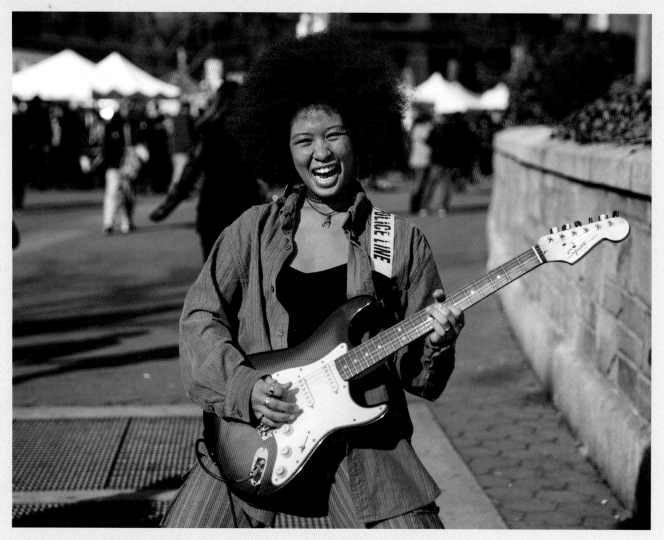

NEW YORK CITY, USA

Mareko was attracting a lot of attention with her guitar when I met her. Her performance was truly electric. She wasn't asking for tips; she just wanted to rehearse in front of people to build up her confidence at the beginning of her career as a musician.

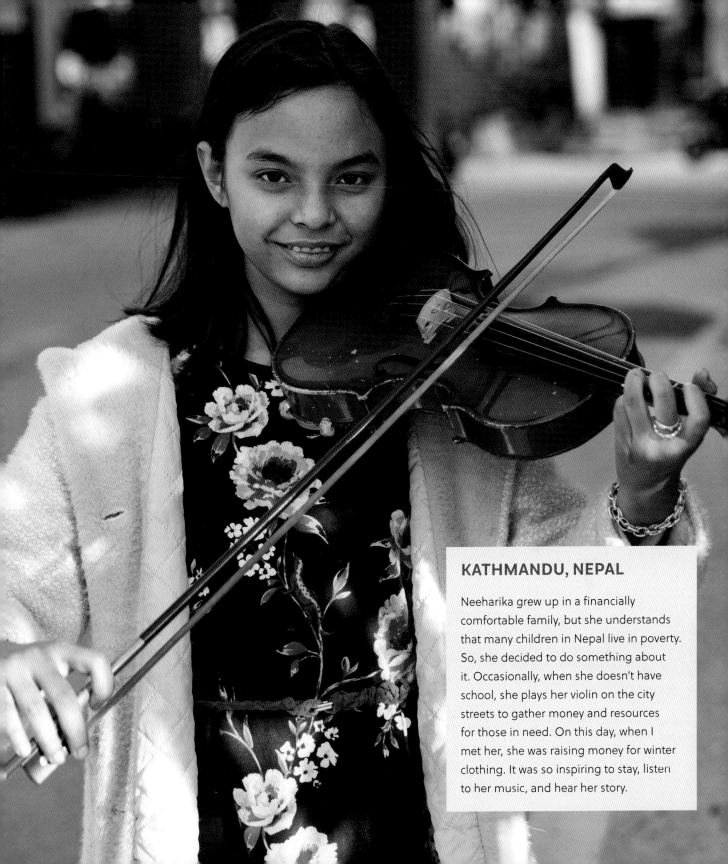

KATHMANDU, NEPAL

Neeharika grew up in a financially comfortable family, but she understands that many children in Nepal live in poverty. So, she decided to do something about it. Occasionally, when she doesn't have school, she plays her violin on the city streets to gather money and resources for those in need. On this day, when I met her, she was raising money for winter clothing. It was so inspiring to stay, listen to her music, and hear her story.

BERLIN, GERMANY

At nine years old, Frida is a remarkable swimmer who competes at a high level. She's so happy in the pool and clearly in love with the water. Frida is legally blind, but that never stopped her from striving to be the best.

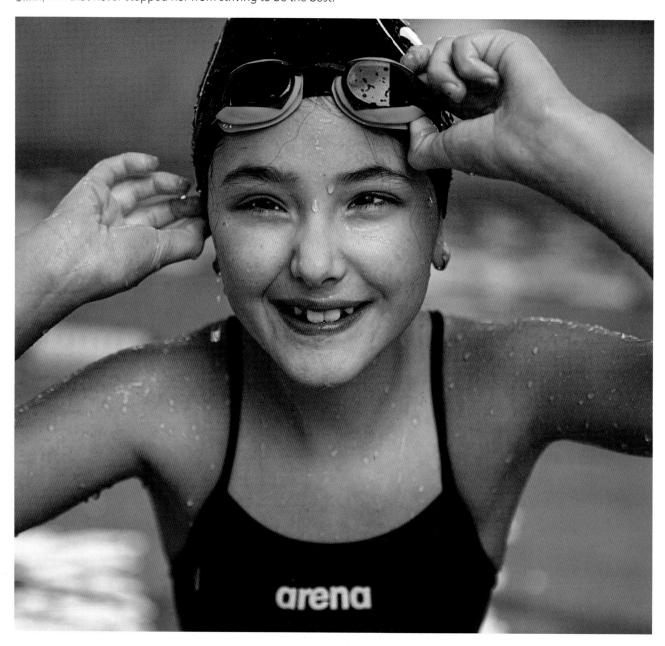

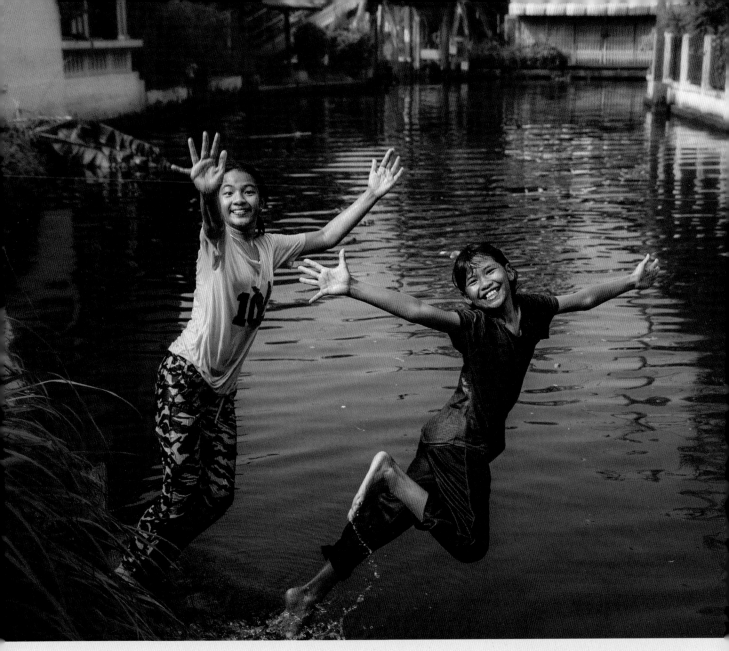

SOUTHERN THAILAND

Thailand is a country in Southeast Asia surrounded by seas and oceans. It's hot here year-round, so cooling off in the water is a popular choice. Saifon and Kanytha play in the water every day, preferring it to being on their phones. They live in a floating village, meaning their houses sit on stilts above the water, and they go to school by boat. They told me they love the water so much, they'd rather swim to school!

Lavinia was taking part in a contest when I photographed her, creating a traditional beadwork belt. Beading is a craft that takes a lot of patience, dexterity, and creativity. Lavinia has these qualities and more, and she won the grand prize!

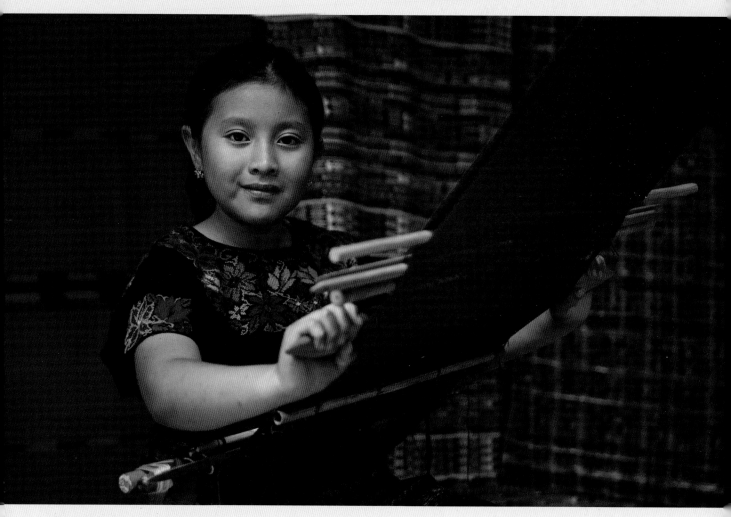

SOUTHERN GUATEMALA

Daniela lives in a village famous for its weaving. Most girls here learn to weave from an early age. Daniela, for example, learned the craft from her mother when she was only four years old. Now, she's pretty much an expert!

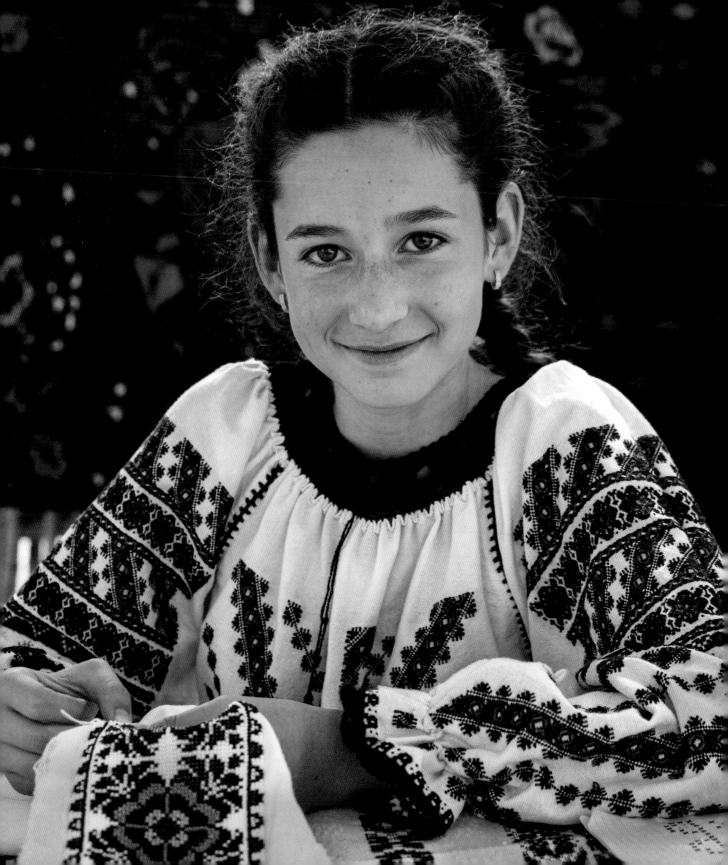

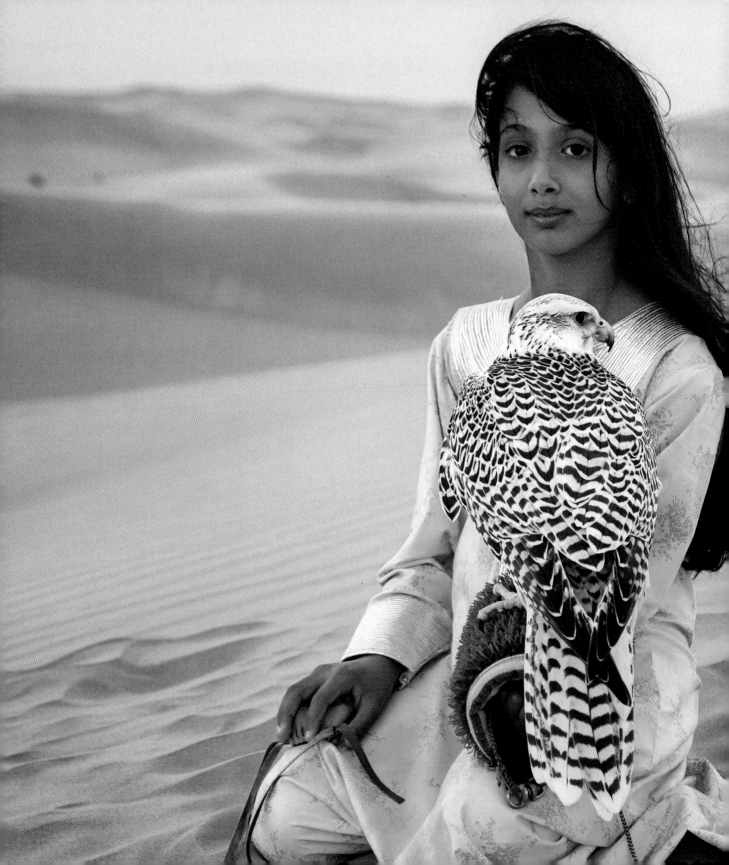

ABU DHABI, UNITED ARAB EMIRATES

At nine years old, Osha is already an experienced falconer. The ancient tradition of falconry involves hunting with a bird of prey. In the past, this was essential to getting food and surviving in the harsh desert.

Osha learned falconry from her mother, and she practices almost every day. Her opponents at competitions are usually male adults. Her falcon is extremely heavy, and it takes a huge amount of skill and strength to hold and catch it, but Osha is strong and fearless.

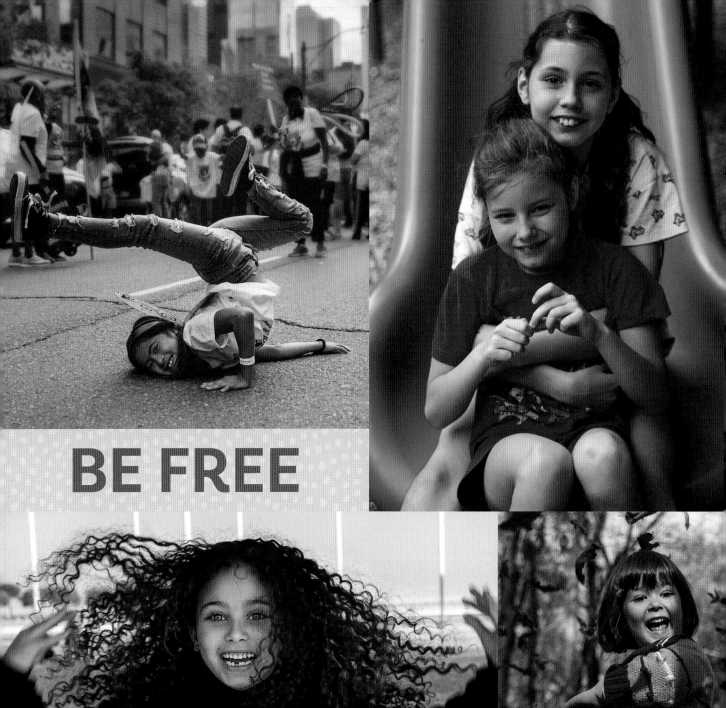

BE FREE

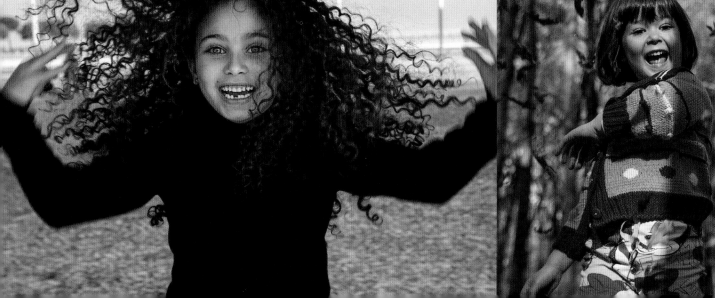

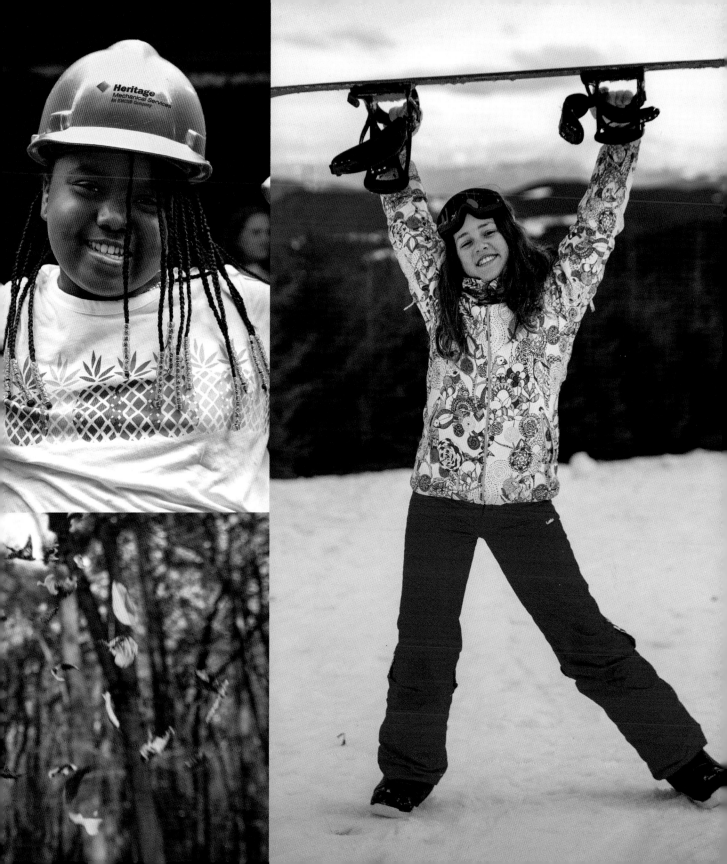

BE FREE

Our world is far from perfect. We live in a time of big challenges and conflicts. But, believe it or not, it is the best time in history to be a girl.

For thousands of years, across most of our world, women haven't had as many rights as men. The general expectation was for their work to be mostly unpaid and based in the home. Did you know that 150 years ago, almost all women of the world were forbidden from voting in elections?

Fortunately, many brave women fought for their rights and defied prejudices, and things changed little by little, year after year, country by country. In the United States, for example, women gained the right to vote in 1920. By the middle of the twentieth century, a woman wearing pants in the Western world was no longer seen as controversial.

But did you know that there are still parts of the world where women are not allowed to have a job, decide if/whom to marry, or wear certain clothes? Women are also still underrepresented in the political and corporate spheres. For example, how many presidents of the United States have been women? Not even one.

What's exciting is that you're now part of the change. You are lucky enough to live in a world that is more equal than ever before. You could be the first female president of your country or maybe the first woman on the moon. Or, better said, you can be whomever you want to be.

Let's be clear. If you love it, nothing can stop you. You can be free to do anything you like and follow your mission freely. There's no such thing as boys' activities, male dreams, or men's vocations. The world belongs to all of us together, and we're making it a better place. You will find your superpowers, and you will be free to be awesome!

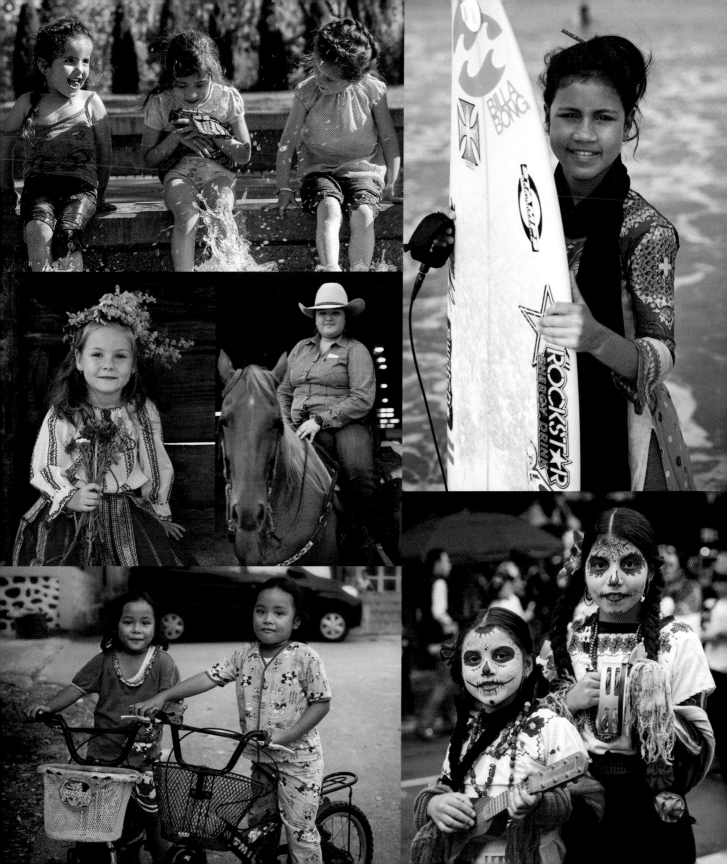

SANTIAGO, CHILE

Florencia taught herself skateboarding two years ago. It was incredibly difficult at first, because she was always falling off the board. Then, a teacher noticed her skills at the skate park and invited her to join a class. She improved over time and started winning competitions.

She still falls sometimes and still might cry when she's hurt. However, she quickly stands back up and gets back to skating. Her persistence is a major key to her success.

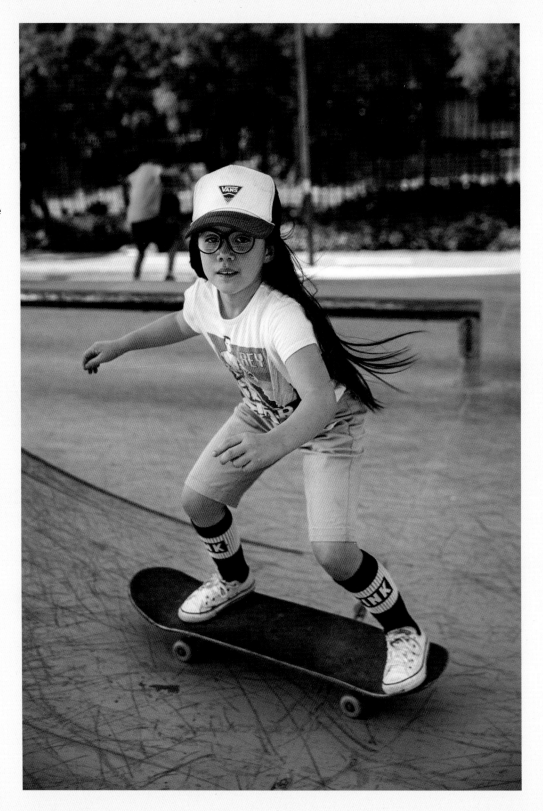

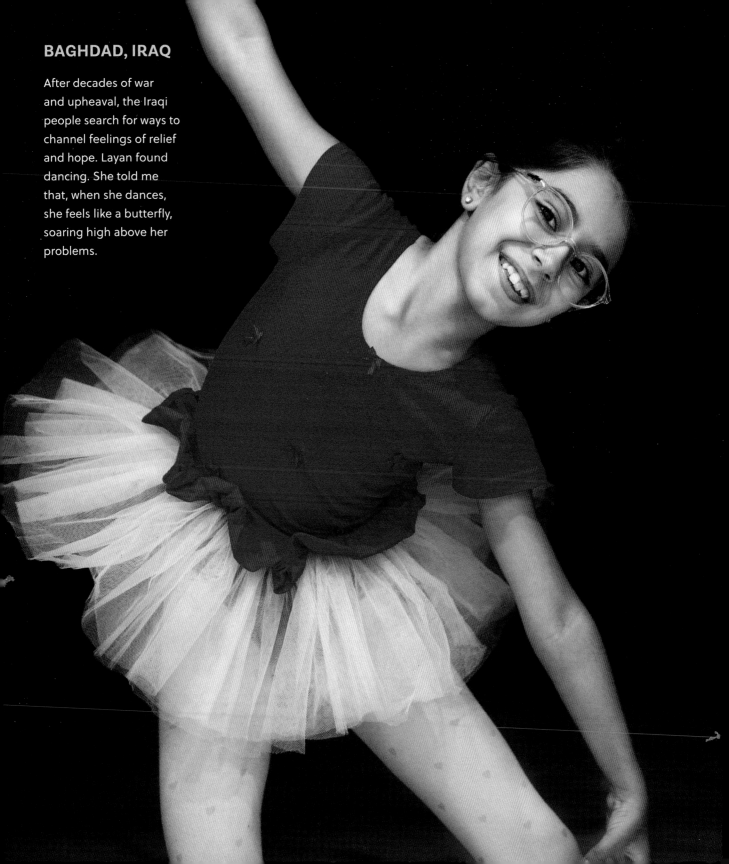

BAGHDAD, IRAQ

After decades of war and upheaval, the Iraqi people search for ways to channel feelings of relief and hope. Layan found dancing. She told me that, when she dances, she feels like a butterfly, soaring high above her problems.

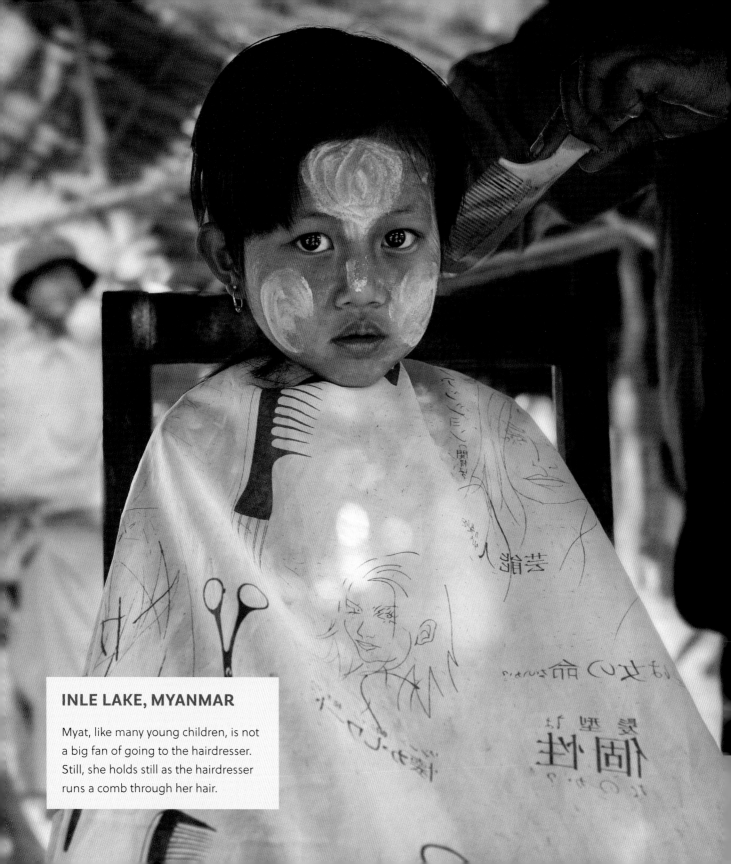

INLE LAKE, MYANMAR

Myat, like many young children, is not a big fan of going to the hairdresser. Still, she holds still as the hairdresser runs a comb through her hair.

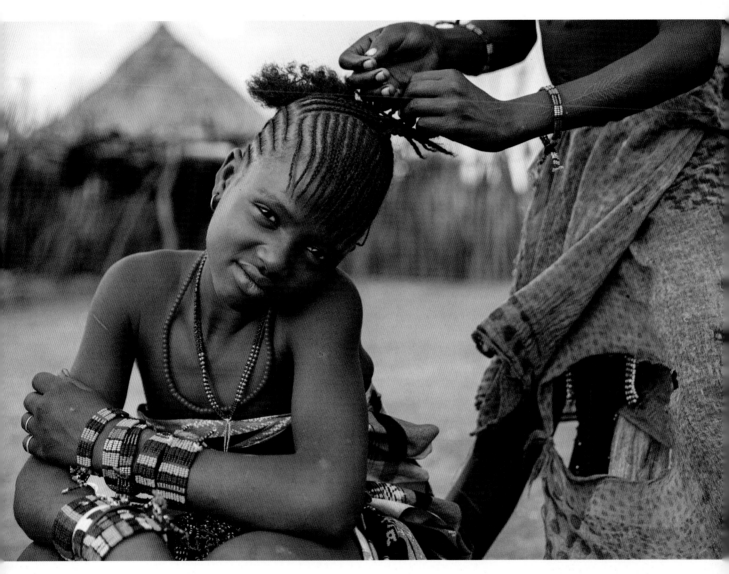

OMO VALLEY, ETHIOPIA

Presenting Kato, ready to show off her new
traditional hairstyle. It took a bit of patience,
but Kato is pleased with the results.

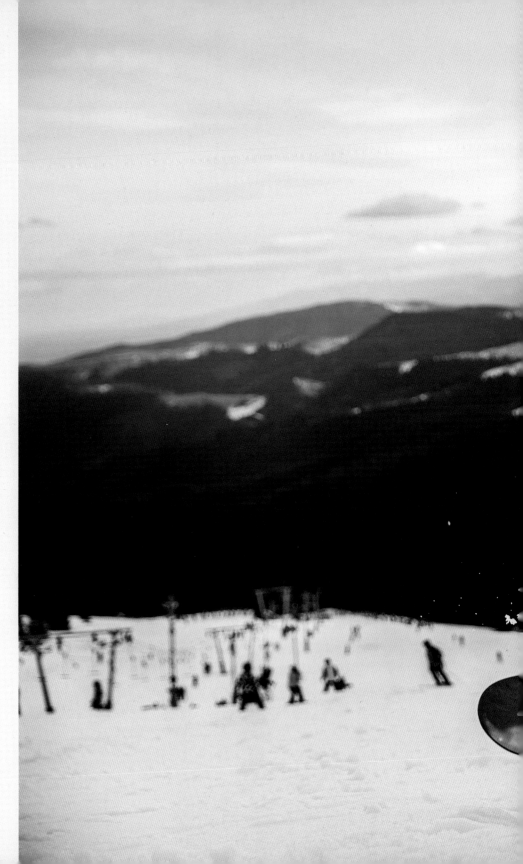

PĂLTINIȘ, ROMANIA

Eliza is sixteen years old. She grew up in an orphanage, and her childhood was very difficult. Then, at age ten, she discovered snowboarding, and it changed her life.

Initially, she was too shy to talk to the other snowboarders or try to make friends on the slopes. But, little by little, the sport gave her more confidence, and today she's very outgoing and sociable. Recently, after just six years, she was certified as a professional snowboarding instructor! Now, she is building a new dream: she wants to help other children in need and pay it forward.

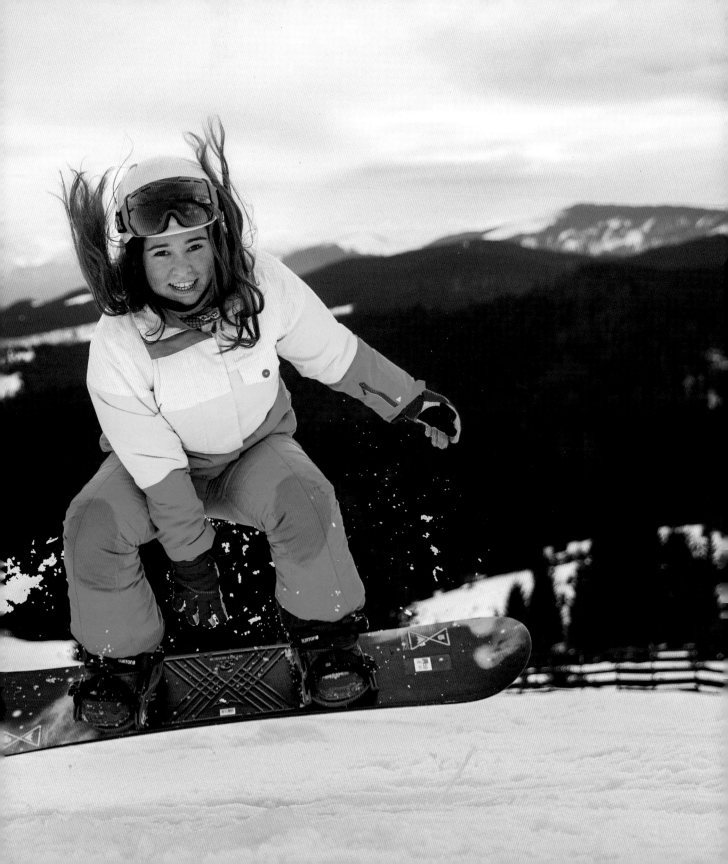

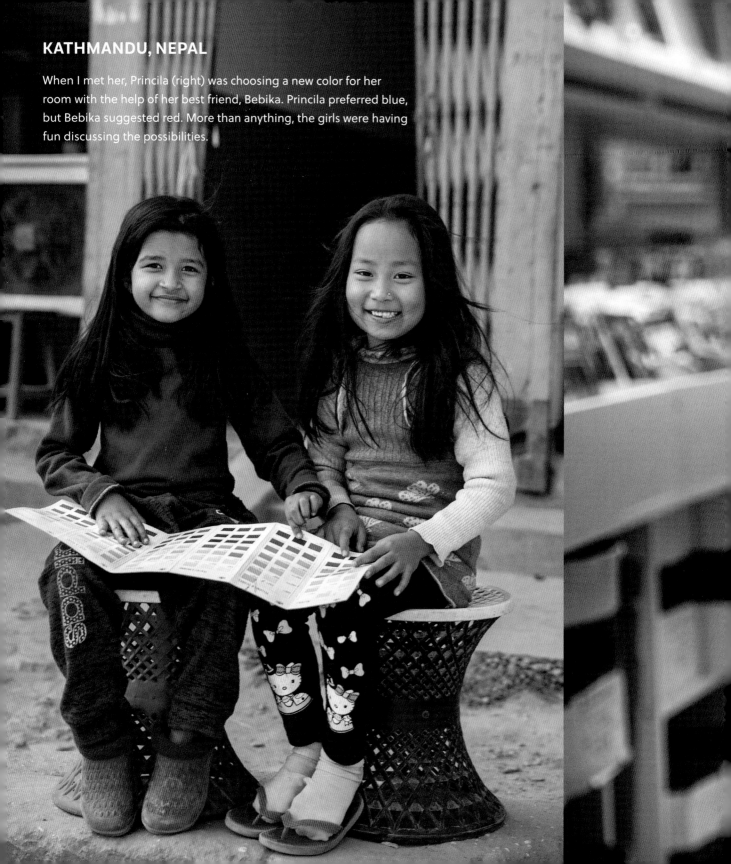

KATHMANDU, NEPAL

When I met her, Princila (right) was choosing a new color for her room with the help of her best friend, Bebika. Princila preferred blue, but Bebika suggested red. More than anything, the girls were having fun discussing the possibilities.

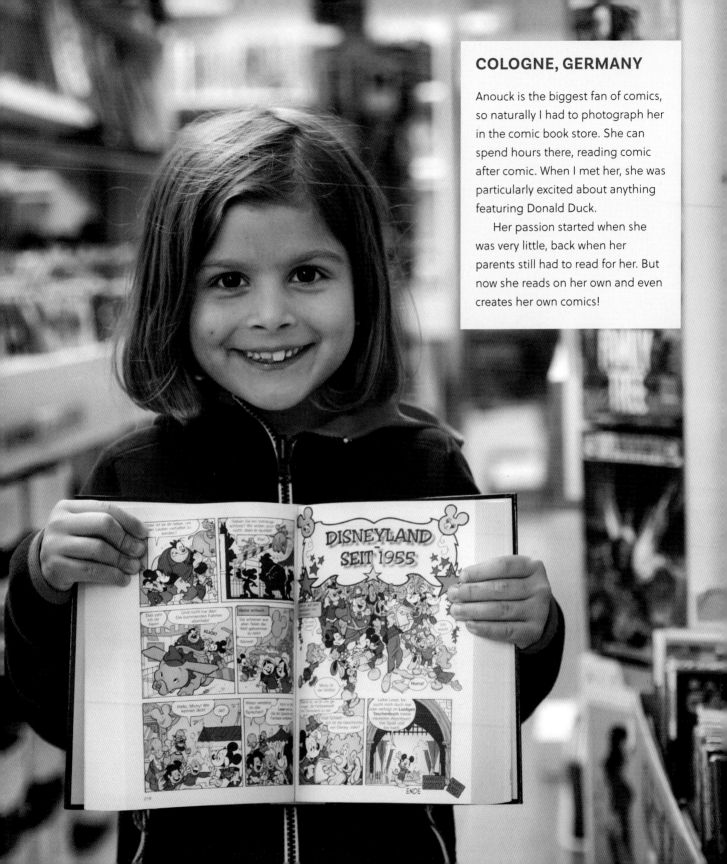

COLOGNE, GERMANY

Anouck is the biggest fan of comics, so naturally I had to photograph her in the comic book store. She can spend hours there, reading comic after comic. When I met her, she was particularly excited about anything featuring Donald Duck.

Her passion started when she was very little, back when her parents still had to read for her. But now she reads on her own and even creates her own comics!

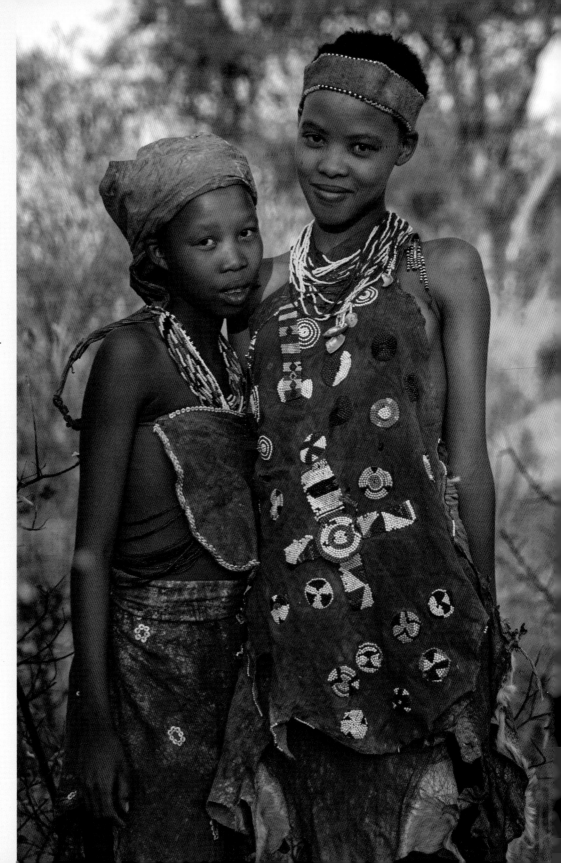

EASTERN NAMIBIA

Bagu"cwi and N#asa"" are good friends. They are part of one of the oldest surviving cultures and languages on Earth, called San, so their names are not easily transcribed using modern alphabets.

Their grandparents were hunter-gatherers: they hunted animals and gathered plants for food and medicines. Their communities were self-sufficient, meaning that they didn't need anything from the outside world. Their community has since changed, and now these girls' family members are mostly farmers.

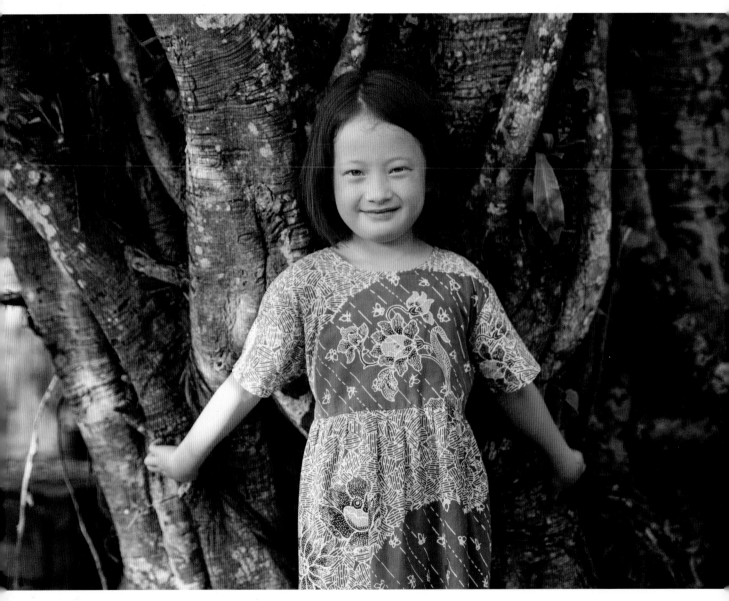

SINGAPORE

Sienna is a true nature lover, and she's especially passionate about plants. That's why she wants to be a biologist when she grows up. The diversity of nature is incredible in this humid part of the world. In this picture, Sienna leans on a banyan, a tree that lives for about three hundred years.

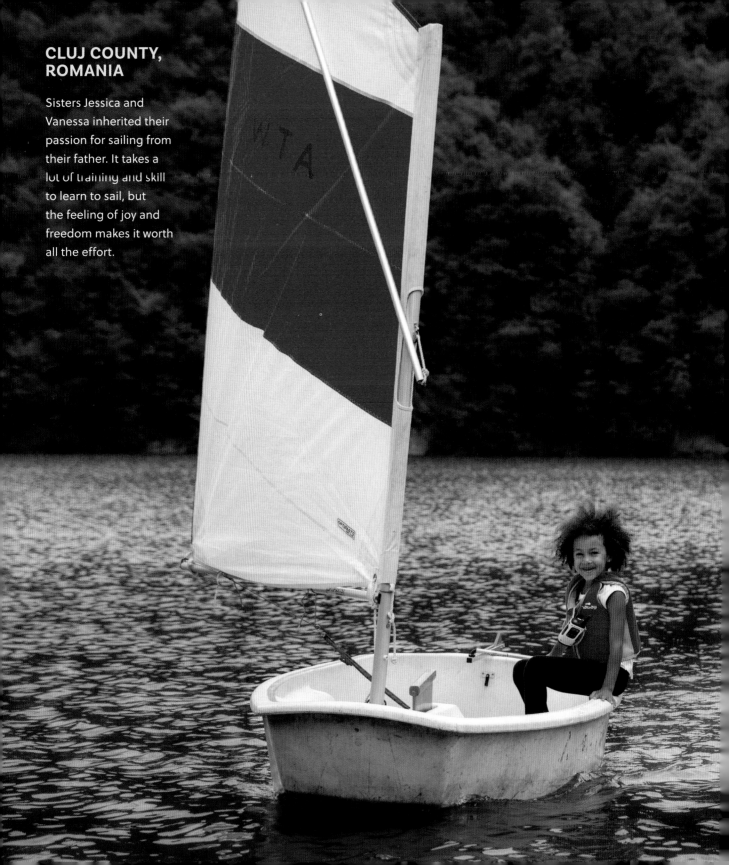

CLUJ COUNTY, ROMANIA

Sisters Jessica and Vanessa inherited their passion for sailing from their father. It takes a lot of training and skill to learn to sail, but the feeling of joy and freedom makes it worth all the effort.

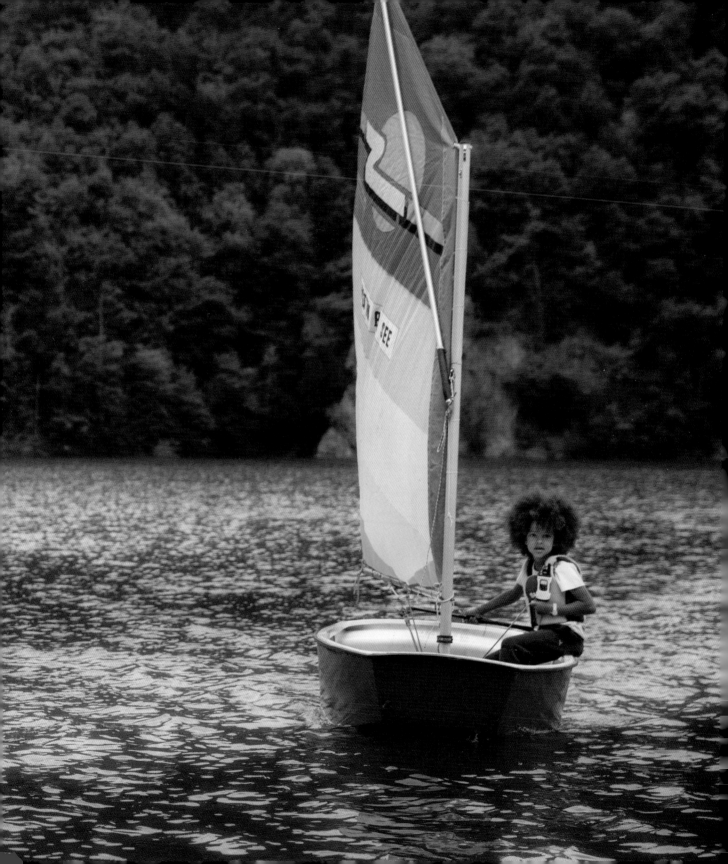

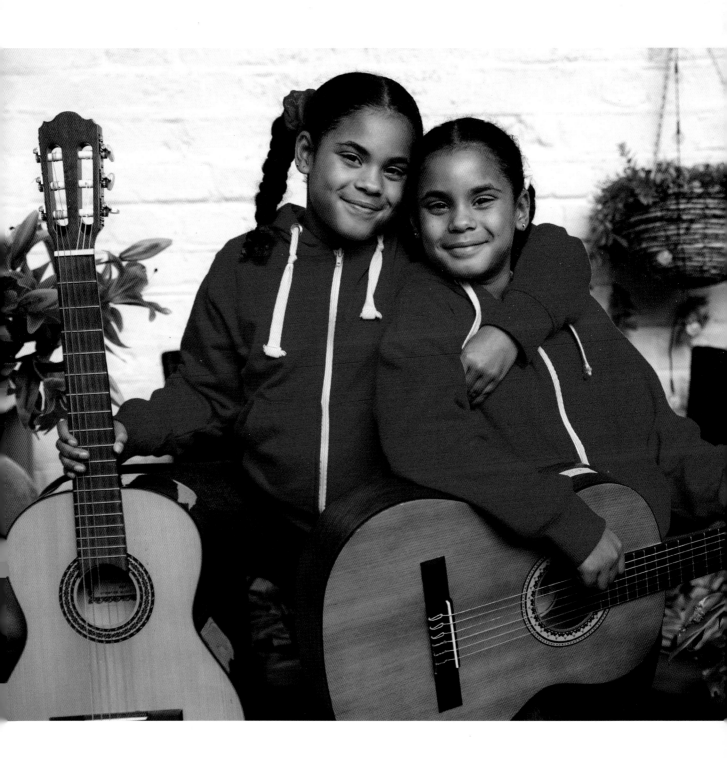

LONDON, UK

Twins Ariella and Anoushka love playing guitar. They dream to someday start a band and play all over the world. Although they have very different personalities, they complement each other perfectly.

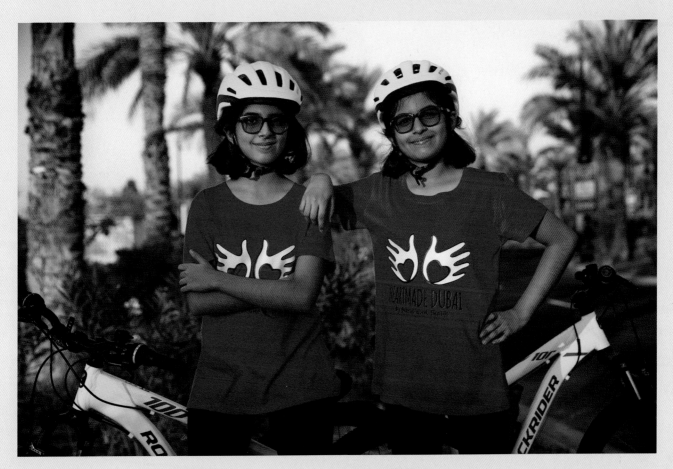

DUBAI, UNITED ARAB EMIRATES

At eleven years old, twins Sharvi and Shaivi are on a mission to make a difference in the lives of underprivileged children around the world.

Biking is just one of their many passions through which they fundraise for meaningful causes. They also run, play musical instruments, garden, and cook to help those in need. It all started when they were six years old and raised money for charity by creating and selling seven hundred postcards.

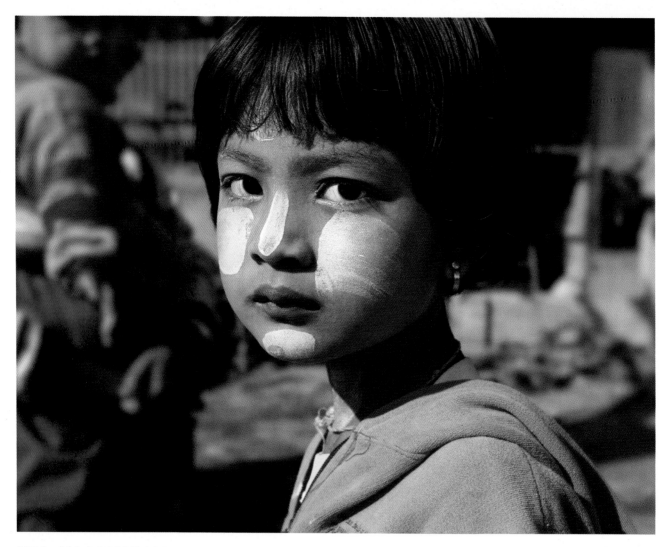

HPA-AN, MYANMAR

Hla wears a paste called thanaka on her face. This cream, which smells a little like sandalwood, is made by grinding tree bark and mixing with water. Thanaka has been extremely popular in Myanmar for millennia. Almost all women and girls apply this paste to their faces and bodies. Not only is it a beauty aid but it also provides a cooling sensation as well as protection from sunburn. The climate in Myanmar can get very hot, and thanaka is one of the natural ways that people have found to adapt.

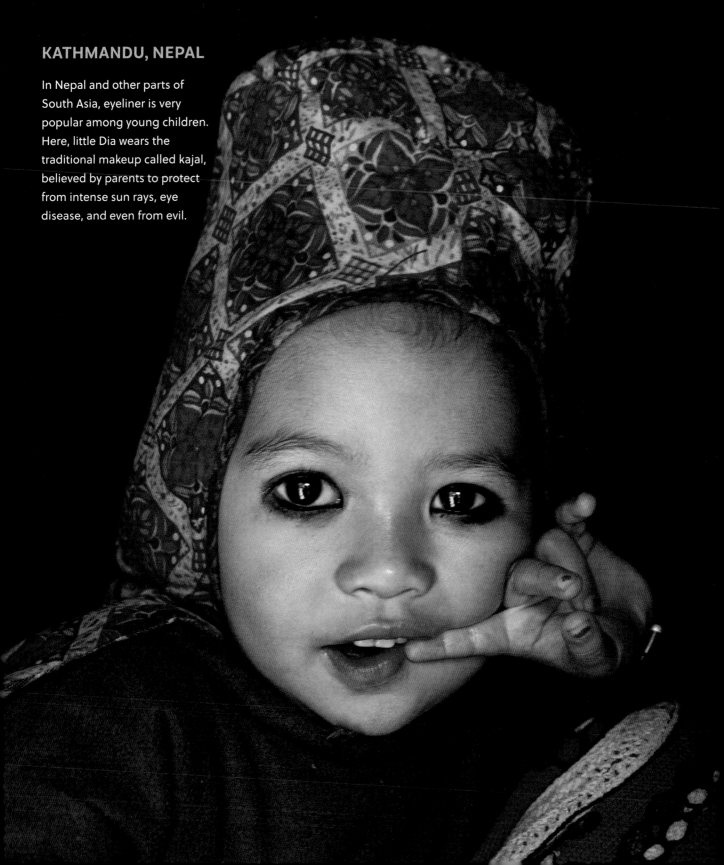

KATHMANDU, NEPAL

In Nepal and other parts of
South Asia, eyeliner is very
popular among young children.
Here, little Dia wears the
traditional makeup called kajal,
believed by parents to protect
from intense sun rays, eye
disease, and even from evil.

TEXAS, USA

These girls are part of an equestrian drill team called the Katy Cowgirls. Katy is the name of their town, and they represent it with pride at different events around Texas, riding in formation and performing choreography on their horses.

These routines require many skills, most importantly team spirit, which makes all the difference.

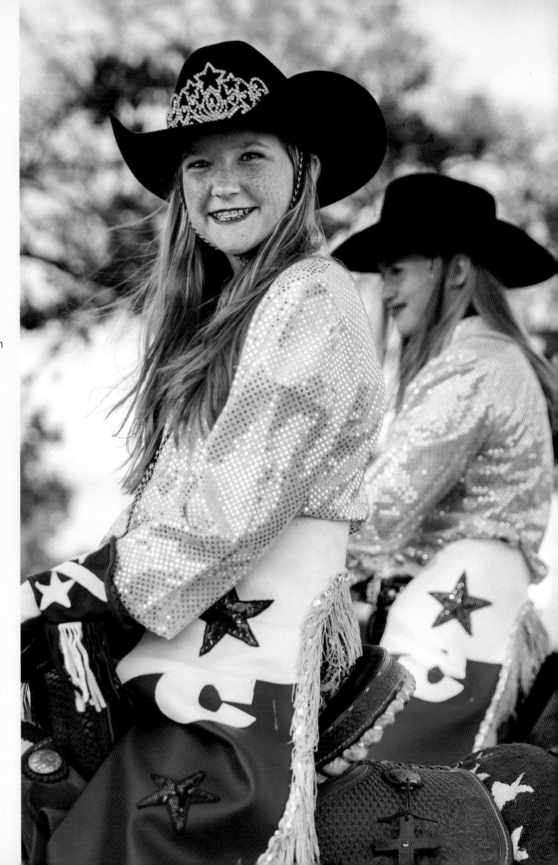

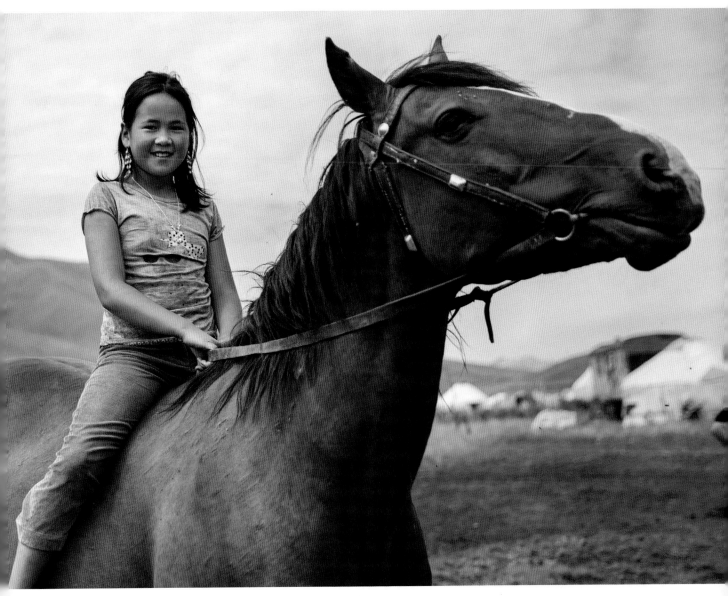

NORTHERN KYRGYZSTAN

Aidana is riding one of her family's horses. In this vast and spectacular country located in Central Asia, horses, instead of cows, are bred for milk. Aidana's family and other local farmers produce a fermented mare milk called kumis. People from all over Kyrgyzstan come here to drink it for its health benefits. Aidana loves it too; she's been drinking it since she was little.

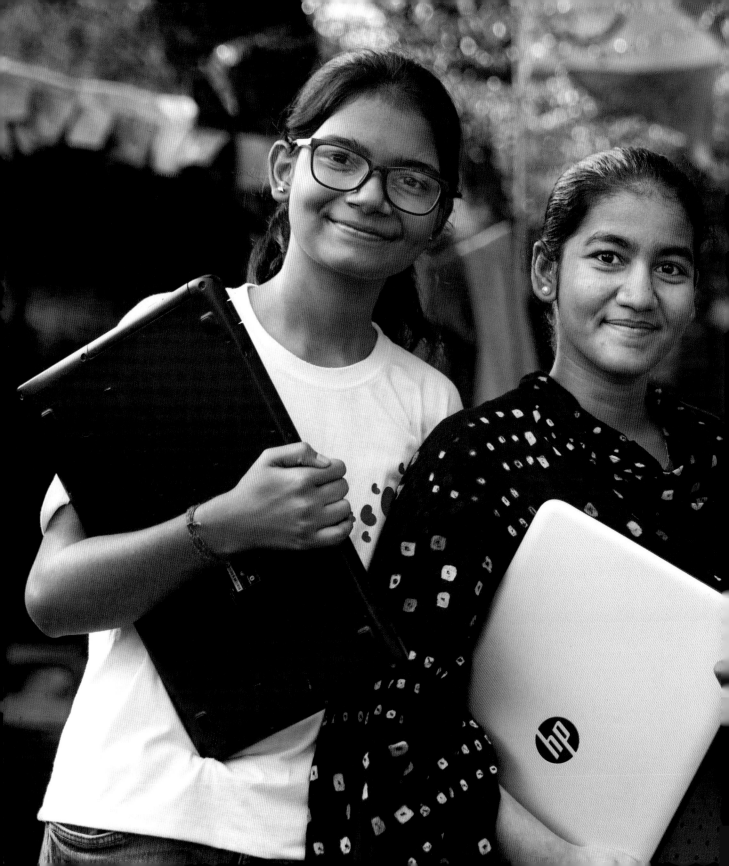

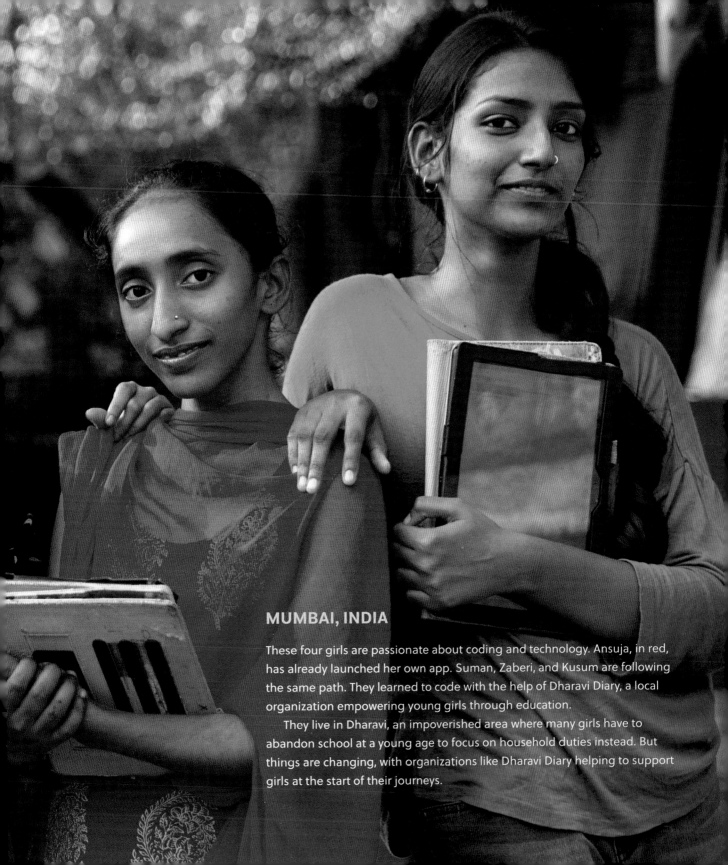

MUMBAI, INDIA

These four girls are passionate about coding and technology. Ansuja, in red, has already launched her own app. Suman, Zaberi, and Kusum are following the same path. They learned to code with the help of Dharavi Diary, a local organization empowering young girls through education.

They live in Dharavi, an impoverished area where many girls have to abandon school at a young age to focus on household duties instead. But things are changing, with organizations like Dharavi Diary helping to support girls at the start of their journeys.

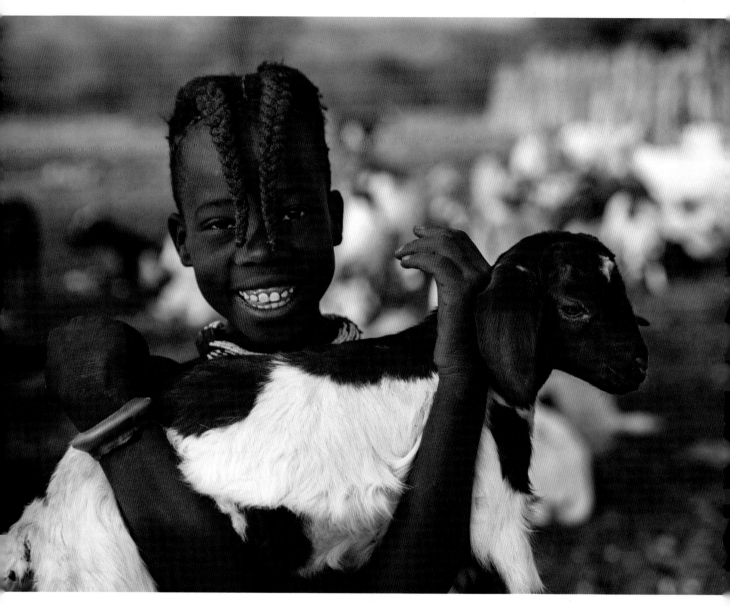

NORTHERN NAMIBIA

Zatumbiruaike is a Himba girl. The Himba people are seminomadic. This means they have a home base where they cultivate crops but also move from time to time with their cattle in search of water. Although Himba children typically help their parents take care of the cattle, they still find time to play with the adorable baby goats, or "kids."

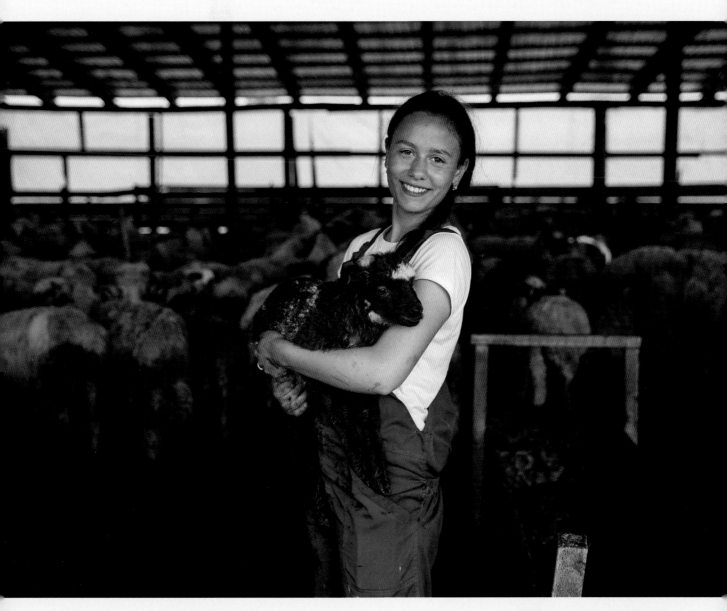

WESTERN ROMANIA

Simona is a farmer. Her parents work in the town, so she runs the family farm with her older sister. On their farm, they take care of five hundred sheep, eighty cows, and ten horses! Simona was so busy, she could barely find a spare minute to be photographed.

NEW YORK CITY, USA

Daisy is English and was visiting the United States when I met her. She's a double amputee and can walk with the help of prosthetics. She was actually the first double amputee child in the world to walk. It took a lot of practice and resilience, but Daisy beat all the odds and made the impossible possible.

Her courage and determination didn't go unnoticed. She has modeled for many famous brands on catwalks of the world, from Paris to New York. Daisy blooms every day, despite her challenges, largely due to her hope and persistence.

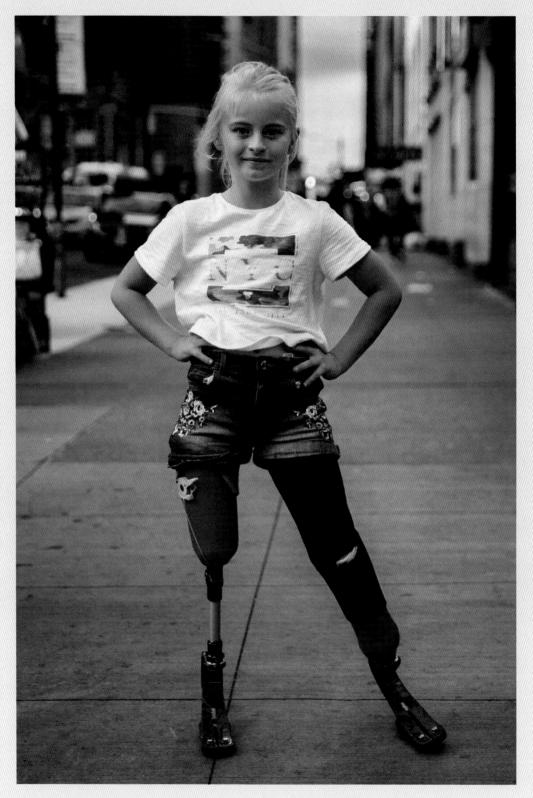

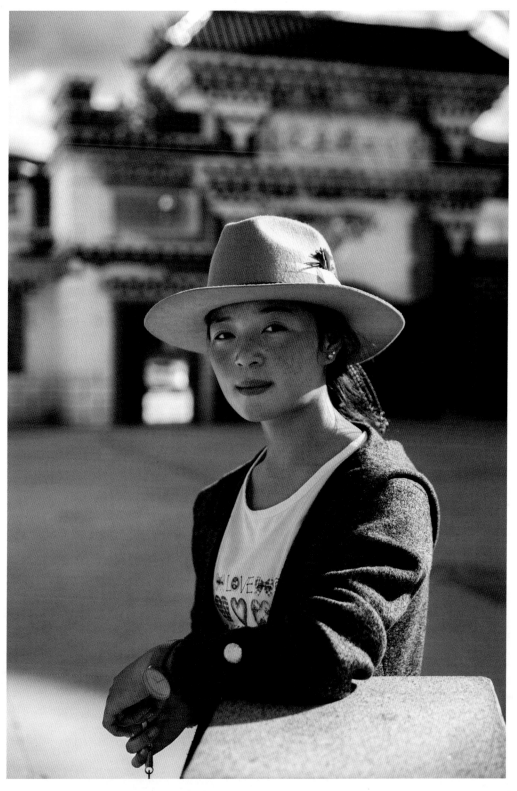

SICHUAN, CHINA

Dalha, who is Tibetan, was taking advantage of a sunny day to go out with some friends. In this part of the world, the climate is harsh. This kind of hat, worn by many Tibetans, protects against the sun and the cold.

Tibetans have a distinctive culture and lots of dialects. Many of them practice Tibetan Buddhism and live in the Himalayan region, around the highest mountain range in the world.

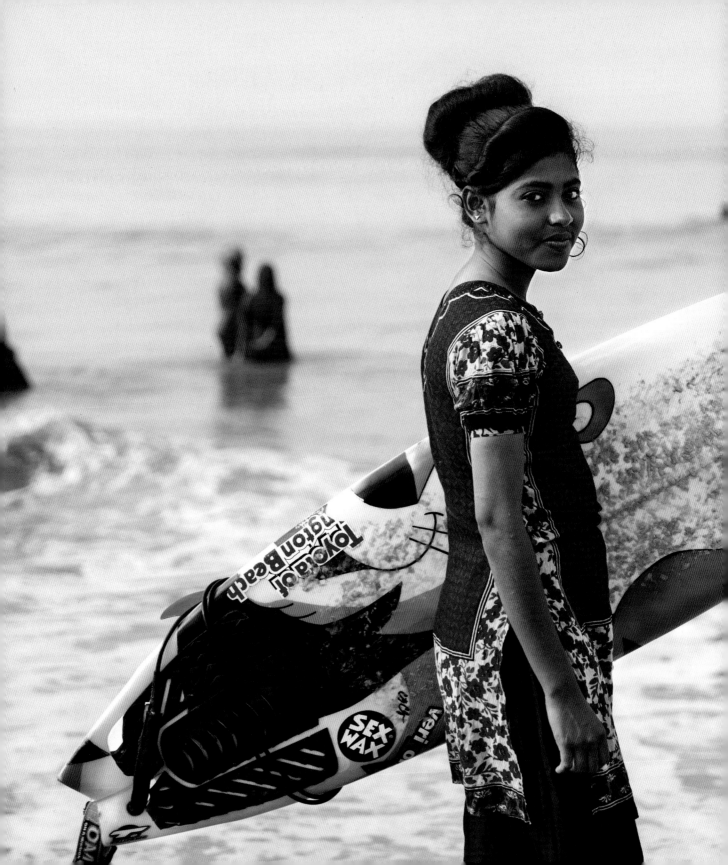

COX'S BAZAR, BANGLADESH

A few years ago, Nargis was selling handmade bracelets and other souvenirs on the beach. Her family relied on her income to survive.

One day, some surfers were taking their boards into the water, when one of them called out to Nargis, "Want to try?"

She had never seen a woman or girl surfing before, so she was hesitant, but the call to catch a wave was overwhelming. The surfers were opening the country's first surf club, Bangladesh Surf Girls & Boys, and invited Nargis to join it. She happily accepted! Since then, she has been practicing her surfing every day, for free, along with other girls from local communities.

CHIANG MAI, THAILAND

Mew plays in the train station, passing
the time until her train arrives.

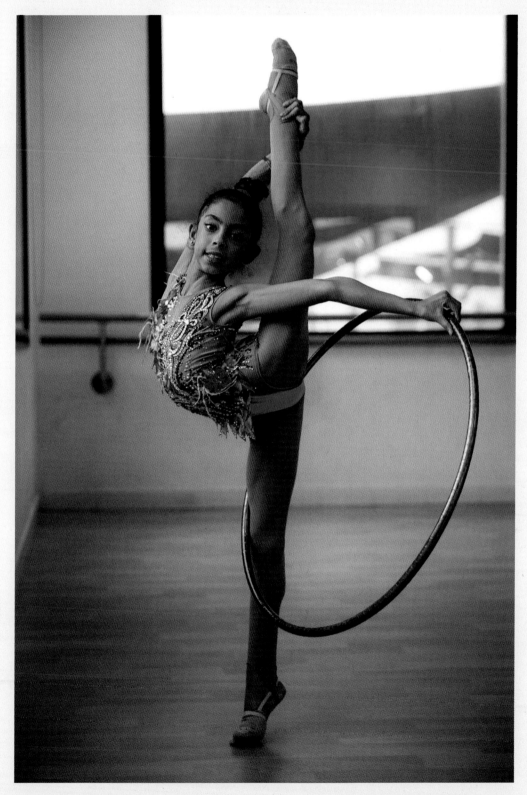

DUBAI, UNITED ARAB EMIRATES

Lamia practices rhythmic gymnastics and dreams to be the first Emirati gymnast to participate in the Olympics. Rhythmic gymnastics is a very difficult sport that typically requires intense training. The Covid-19 pandemic was a huge challenge, forcing Lamia to train at home and alone. But thanks to her passion and willpower, she still progressed, and now she feels stronger and better than ever.

COLOMBO, SRI LANKA

Sandali, whose name means "moonlight," fittingly dreams of exploring space someday. She lives in Colombo, the capital city of Sri Lanka, a small island country in southern Asia.

A few years ago, Sandali applied for, and received, a scholarship to attend a summer camp at the National Aeronautics and Space Administration in the United States. She needed money for the plane ticket, though, so she wrote a letter to the president of Sri Lanka, detailing her dream and her struggle. The president replied—and helped her get the ticket!

Then, her challenges continued as her visa application to the United States was denied three times. Though she was on the brink of losing her life-changing opportunity, she never gave up. On the fourth try, she finally got the visa and attended the NASA camp, thanks to her own dedication and perseverance.

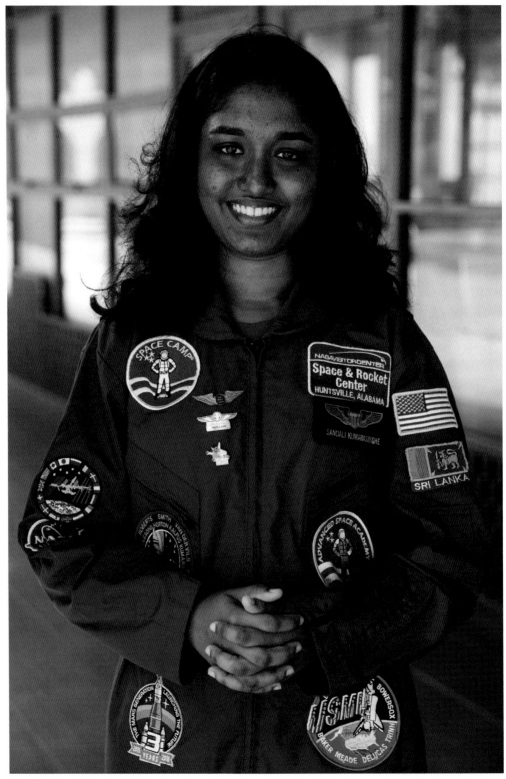

Ursa here is taking part in a public celebration, expressing her gratitude for teachers through her colorful handmade sign. She believes equally in learning and dreaming (as do I!).

I Believe in UNICORNS, FAIRIES & TEACHERS!!!

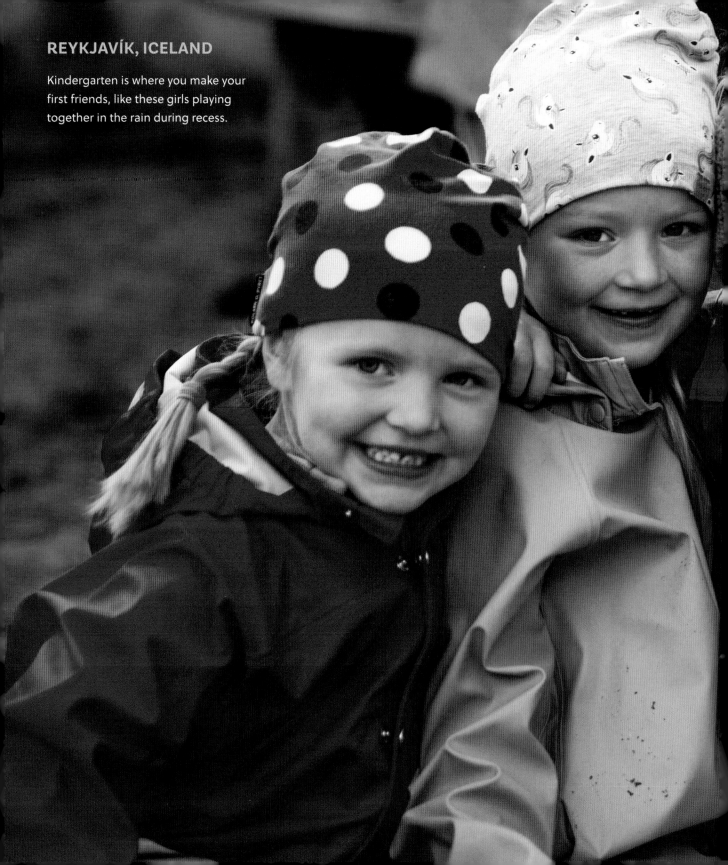

REYKJAVÍK, ICELAND

Kindergarten is where you make your first friends, like these girls playing together in the rain during recess.

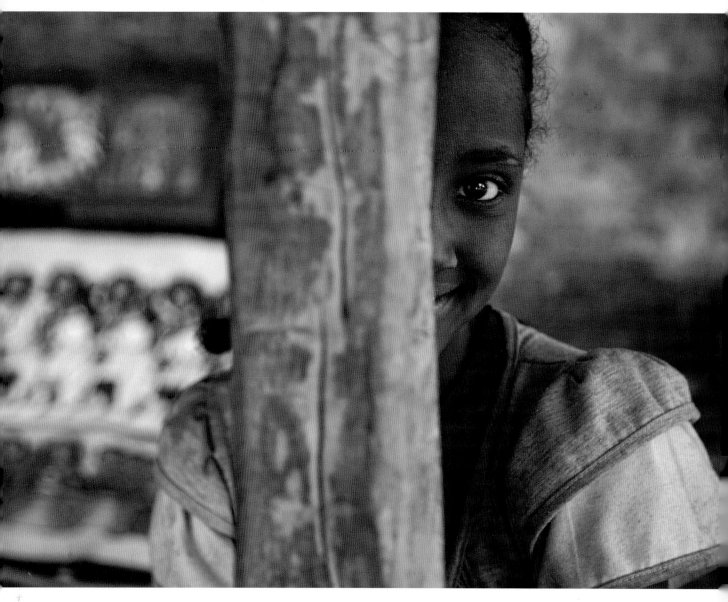

BAHIR DAR, ETHIOPIA

Haset loves playing peekaboo, one of the most
popular games in the world for young children.

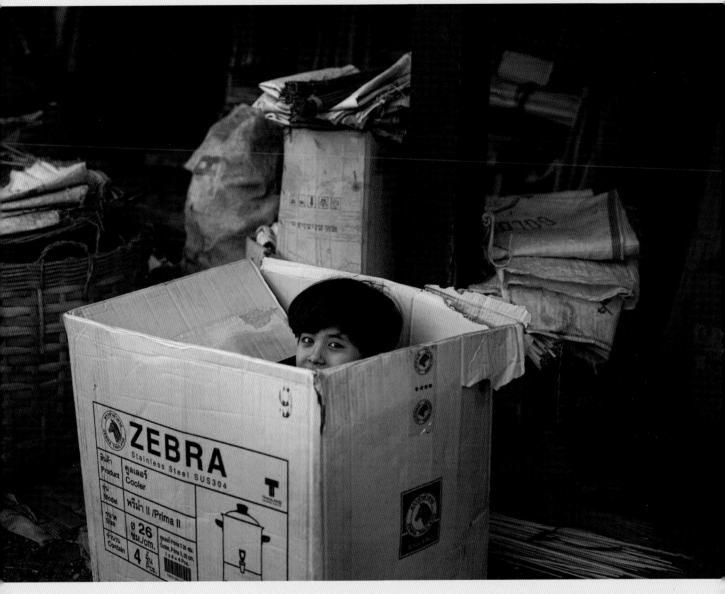

MAWLAMYINE, MYANMAR

Htet loves to hide in boxes when she plays
hide-and-seek with her friends.

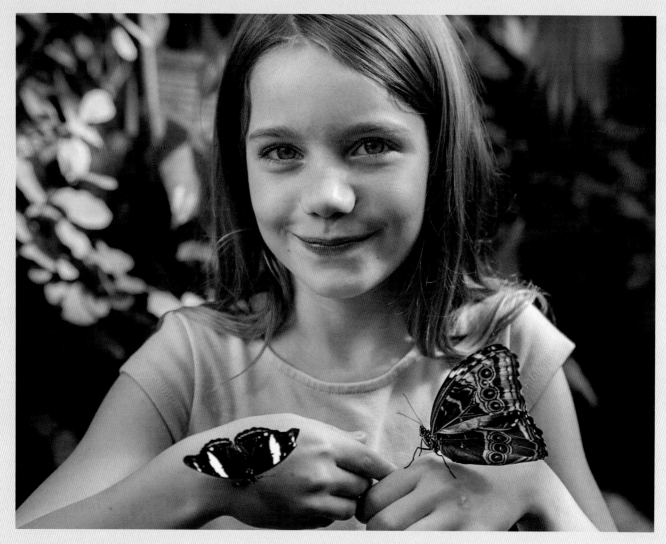

VIENNA, AUSTRIA

Elli comes from a family of biologists. Ever since she was little, she has been fascinated by all insects, especially butterflies.

She likes to visit the Butterfly House, a tropical rainforest setting in the middle of Vienna that's home to thousands of butterflies. Elli is familiar with each species, and she knows exactly how to interact with them. Watching her with the butterflies, you'd think they could communicate back and forth!

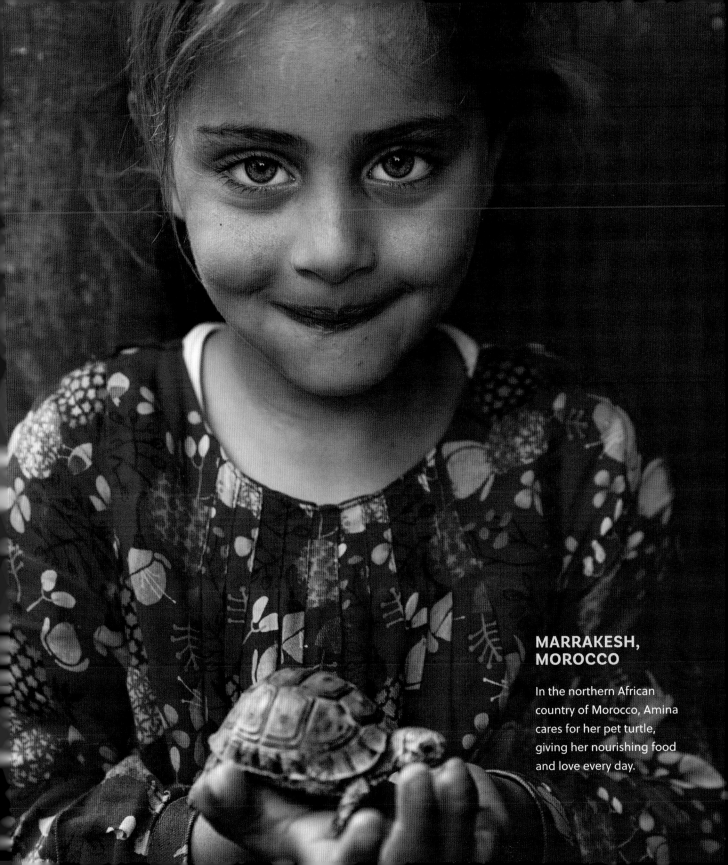

MARRAKESH, MOROCCO

In the northern African country of Morocco, Amina cares for her pet turtle, giving her nourishing food and love every day.

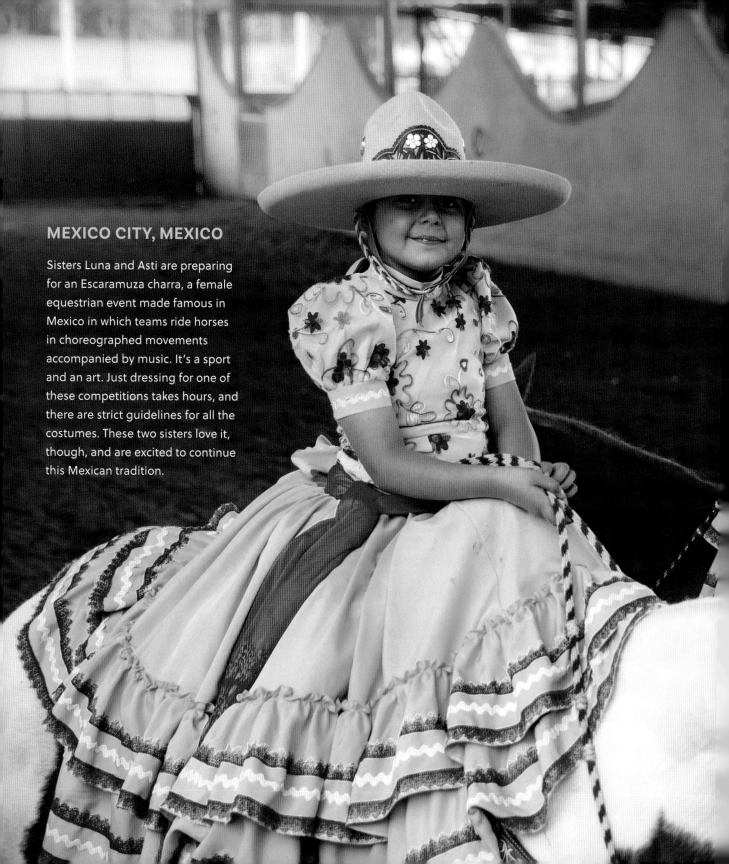

MEXICO CITY, MEXICO

Sisters Luna and Asti are preparing
for an Escaramuza charra, a female
equestrian event made famous in
Mexico in which teams ride horses
in choreographed movements
accompanied by music. It's a sport
and an art. Just dressing for one of
these competitions takes hours, and
there are strict guidelines for all the
costumes. These two sisters love it,
though, and are excited to continue
this Mexican tradition.

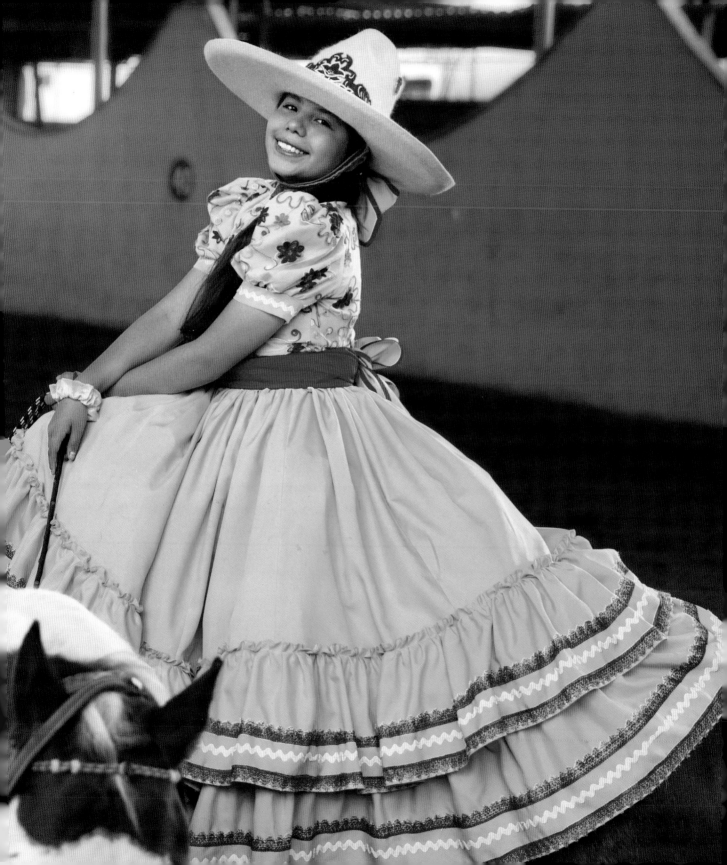

CENTRAL MONGOLIA

This is Enkhmaa, and she's a young, proud Mongolian woman. Situated in East Asia, Mongolia is one of the most isolated countries in the world. Most people living in rural Mongolia are nomads, moving from one place to another with their cattle. I met Enkhmaa after hours of driving through the vast steppe. When I finally saw a yurt, I stopped and befriended her and her family.

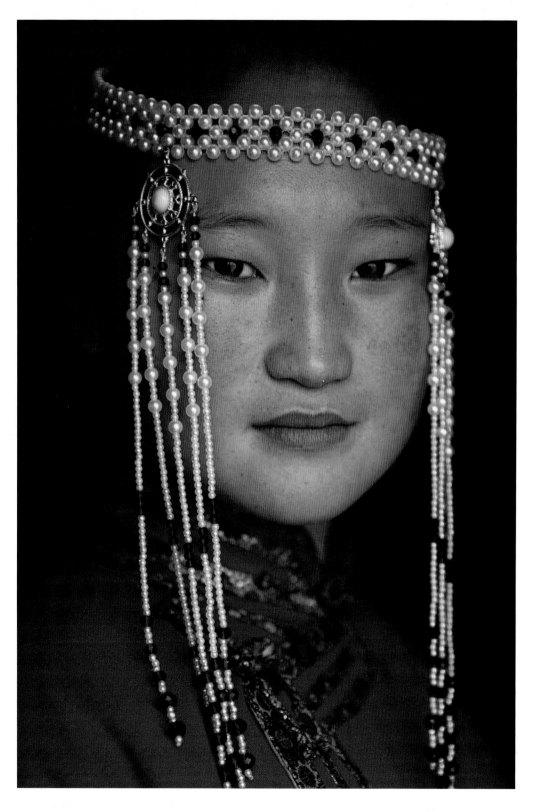

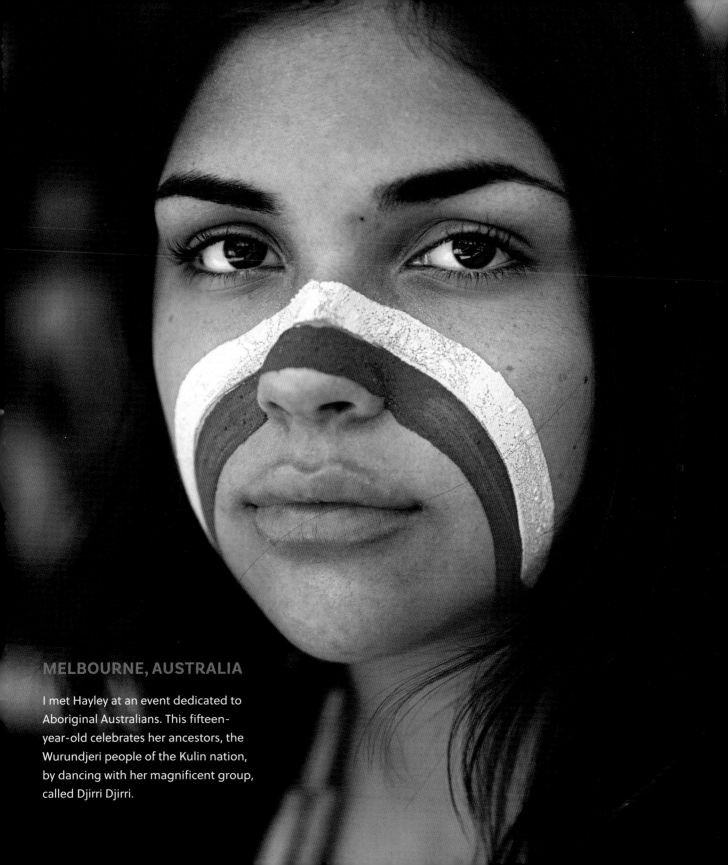

MELBOURNE, AUSTRALIA

I met Hayley at an event dedicated to
Aboriginal Australians. This fifteen-
year-old celebrates her ancestors, the
Wurundjeri people of the Kulin nation,
by dancing with her magnificent group,
called Djirri Djirri.

LONDON, UK

Connie is eight years old and already has a fabulous business idea. She dreams of opening a grooming salon for dogs one day and wants to sell matching clothes for owners and their pets!

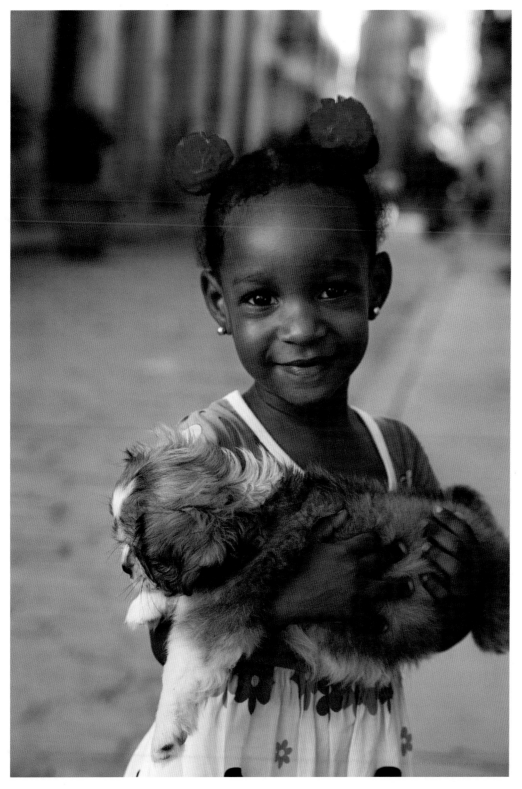

HAVANA, CUBA

Ahinoa received a special gift a few days ago, when she turned three: a little puppy she called Choki. Since then, she hasn't gone anywhere without him. When they go out, Ahinoa always holds Choki in her arms, because she wants to keep him safe.

PÉCS, HUNGARY

Charlotte, who was born with a medical condition called Down syndrome, is learning acrobatics and loves it. She's getting better and better every single day.

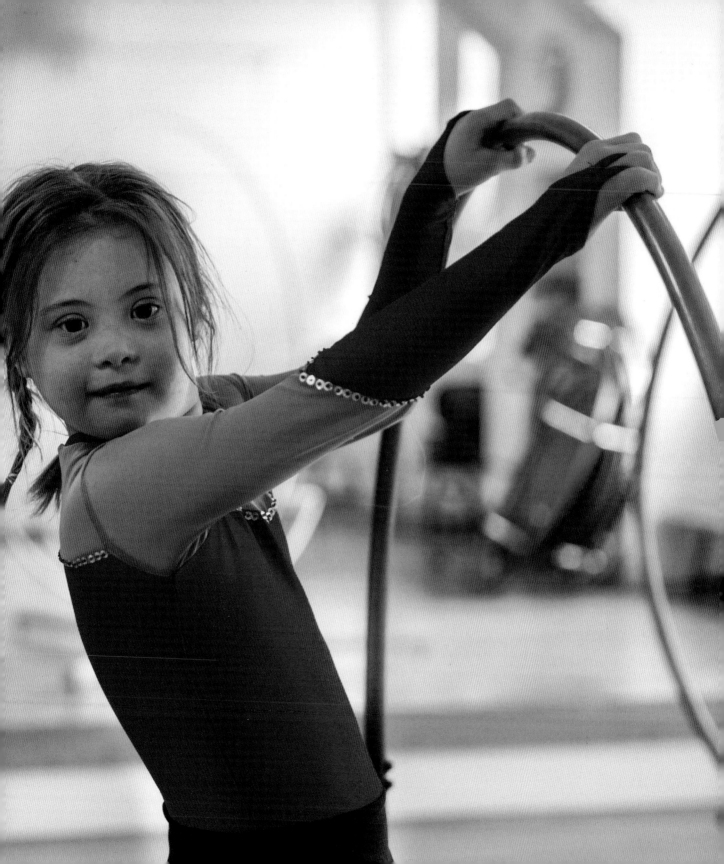

ATACAMA DESERT, CHILE

Catalina and Sofia love climbing the few trees in their town. They live in an oasis, which is a small microclimate within the desert where you can find water and plants.

The Atacama Desert is the world's driest area, apart from the north and south poles, and is a place with warm days and chilly nights.

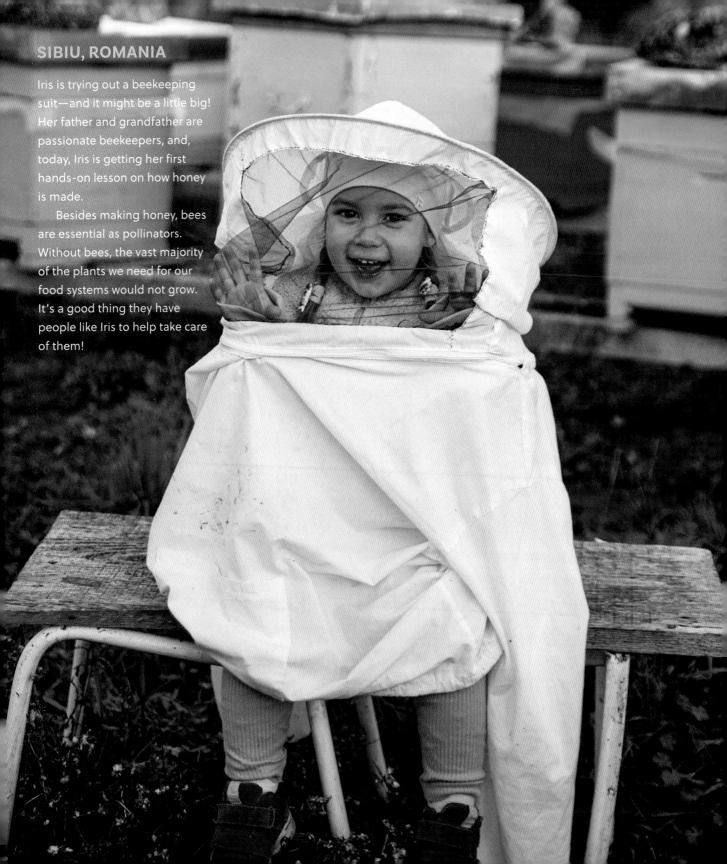

SIBIU, ROMANIA

Iris is trying out a beekeeping suit—and it might be a little big! Her father and grandfather are passionate beekeepers, and, today, Iris is getting her first hands-on lesson on how honey is made.

Besides making honey, bees are essential as pollinators. Without bees, the vast majority of the plants we need for our food systems would not grow. It's a good thing they have people like Iris to help take care of them!

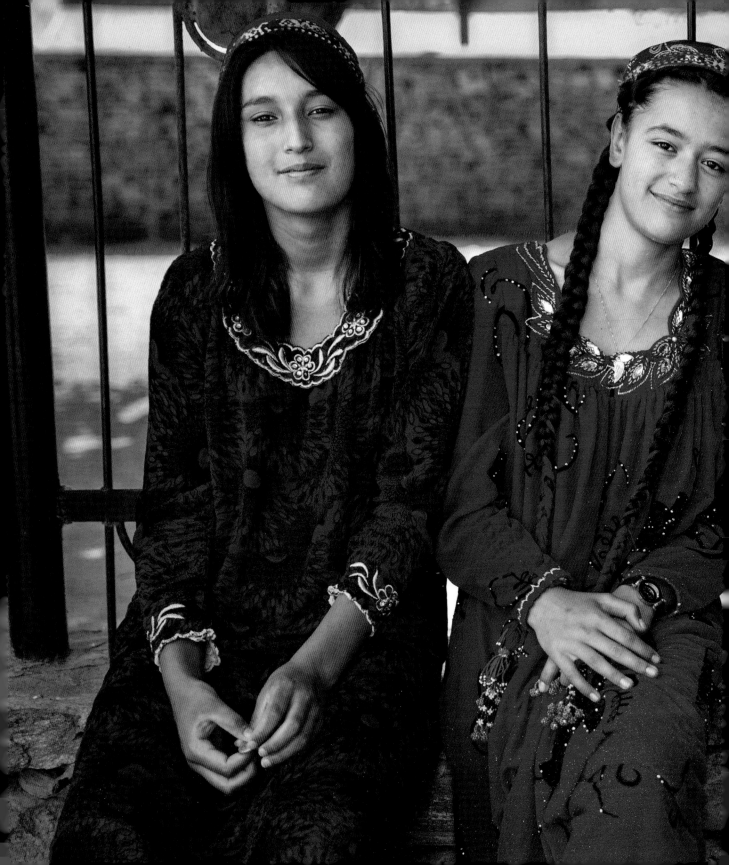

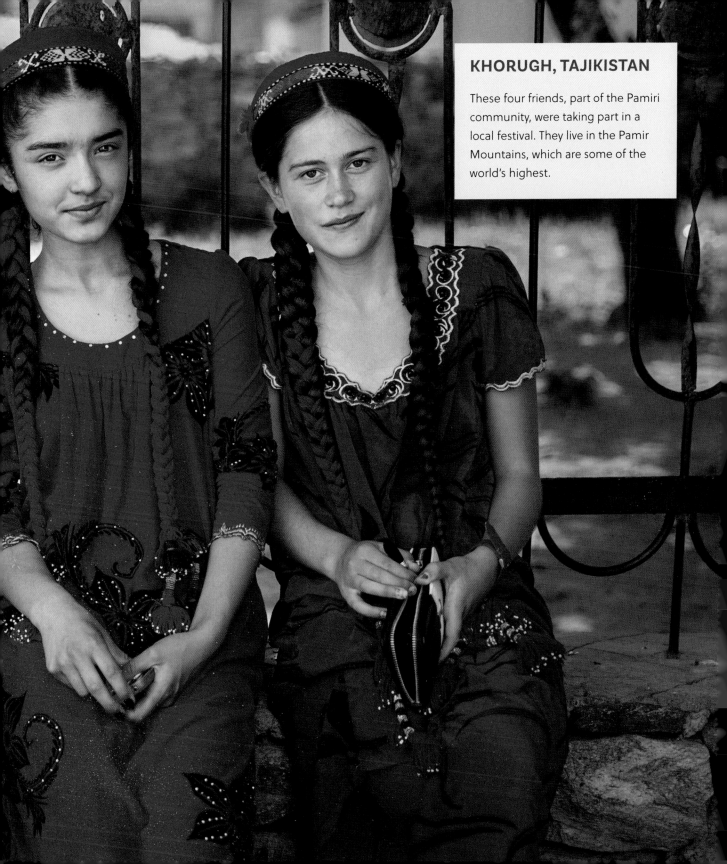

KHORUGH, TAJIKISTAN

These four friends, part of the Pamiri community, were taking part in a local festival. They live in the Pamir Mountains, which are some of the world's highest.

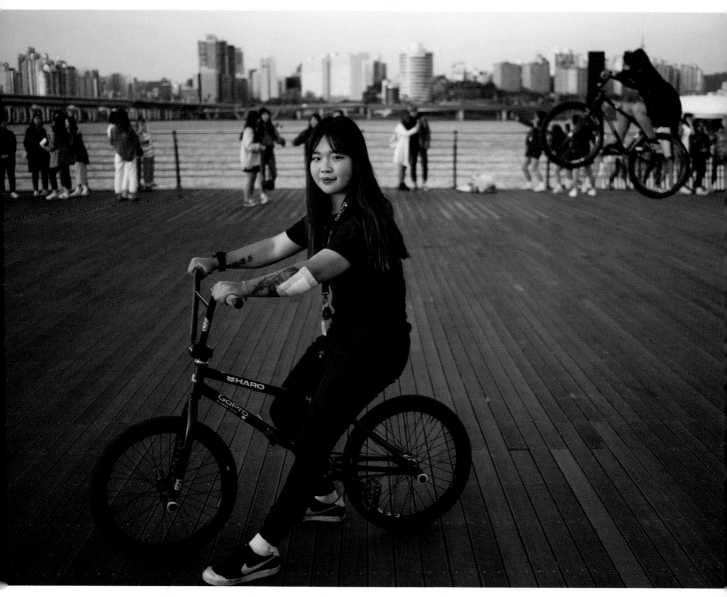

SEOUL, SOUTH KOREA

At thirteen, Chori Jung is already an experienced BMX freestyler. That means that she does all kinds of spectacular tricks, jumps, and flips on her specially designed bicycle. She is the only girl in her freestyle group, and she's one of the best. Sometimes she falls, and sometimes she fails, but she never gives up.

MUMBAI, INDIA

From the age of ten, Divya has had to ride an adult-sized bicycle. It was the only bike in the family, but she absolutely loves cycling, so she found her balance in the end! When I met her, she was already incredibly skillful, maneuvering among people in the crowded marketplace.

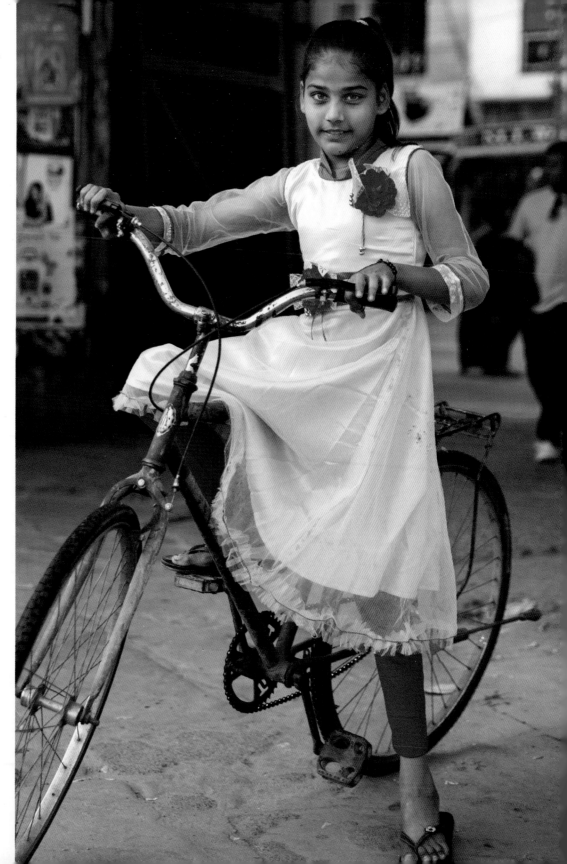

BERLIN, GERMANY

Sisters Alyn and Celine love to see the world from different perspectives.

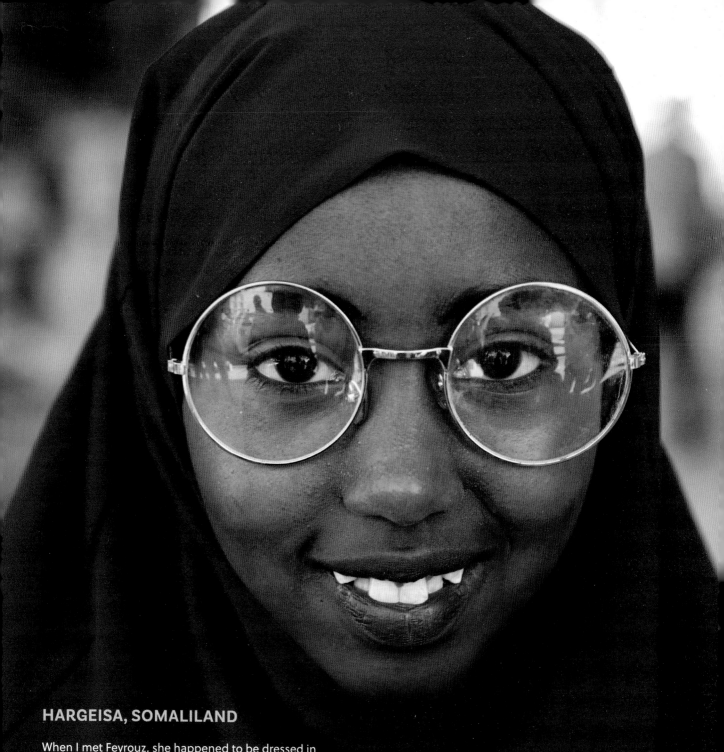

HARGEISA, SOMALILAND

When I met Feyrouz, she happened to be dressed in purple, her favorite color. So, she was delighted to be photographed and have this picture as a memory of feeling great in her outfit.

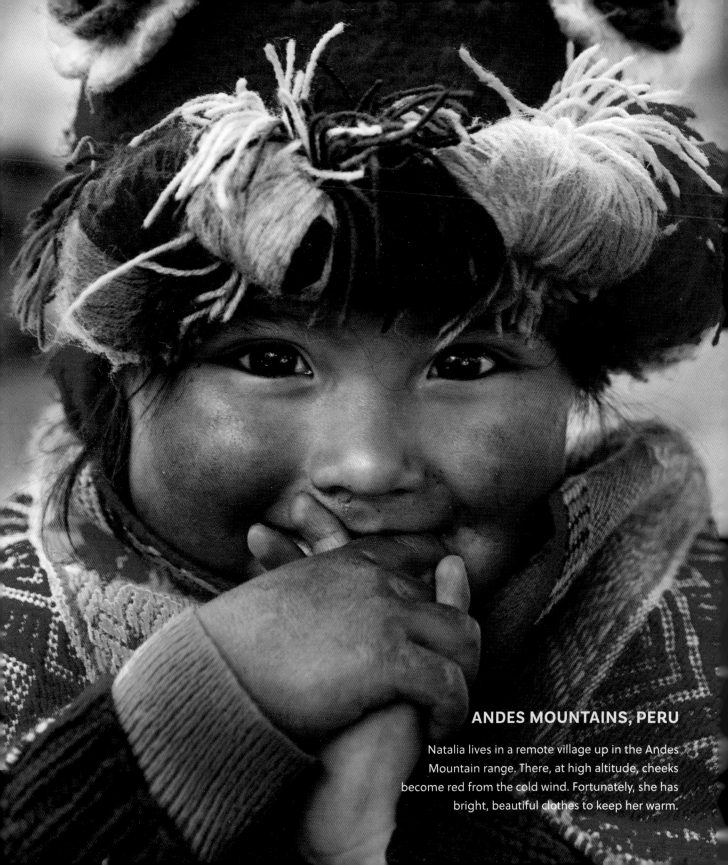

ANDES MOUNTAINS, PERU

Natalia lives in a remote village up in the Andes
Mountain range. There, at high altitude, cheeks
become red from the cold wind. Fortunately, she has
bright, beautiful clothes to keep her warm.

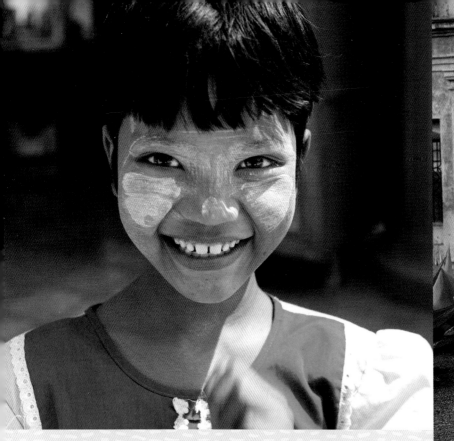

BE HAPPY

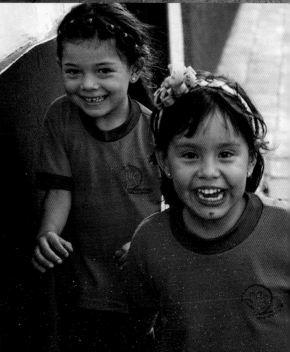

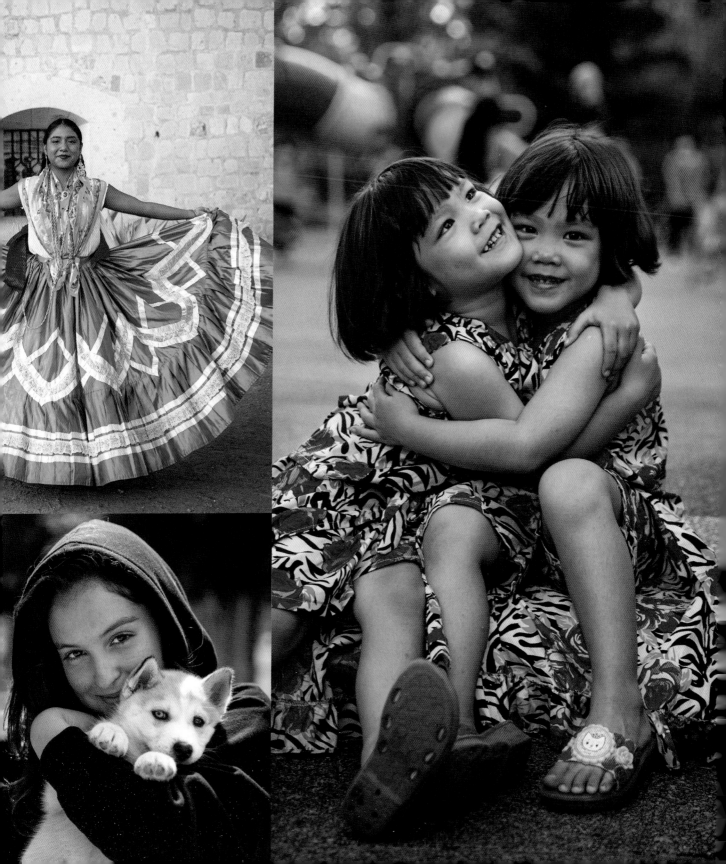

BE HAPPY

Happiness! People talk about it, and it already sounds like a cliché. You can't simply clap your hands and be happy, on demand. So how do we get there for real? Well, let me tell you a secret. Happiness is not a destination, it's a journey.

Try to experience new things every day. When you're interested and learning, you'll find your true passions, your true self, and your true mission. At least, that was how it worked for me!

Your path of what you enjoy and what you succeed in will emerge when you take chances. When you choose to focus on this path, your life will feel like a vacation, even when you're working hard.

Sure, life comes with many obligations and constraints. We're not always able to do whatever we want. But, for the most part, it's up to us to find the keys to fulfilment.

One of those keys might surprise you. It's failure. Sometimes you'll fail, cry, and doubt. Not only is it normal but it's necessary. It's a reminder to take a step back for a few days.

Imagine that, because of a stumbling block, you're not going to do your passion ever again. You'll put down the thing that's been your path, forever. Does this thought hurt, or do you finally feel relief? This is the only question you need to ask. If it hurts, it means you were on the right path. If it feels good, open yourself up to new beginnings. And, no matter what the answer was, enjoy the ride and be happy!

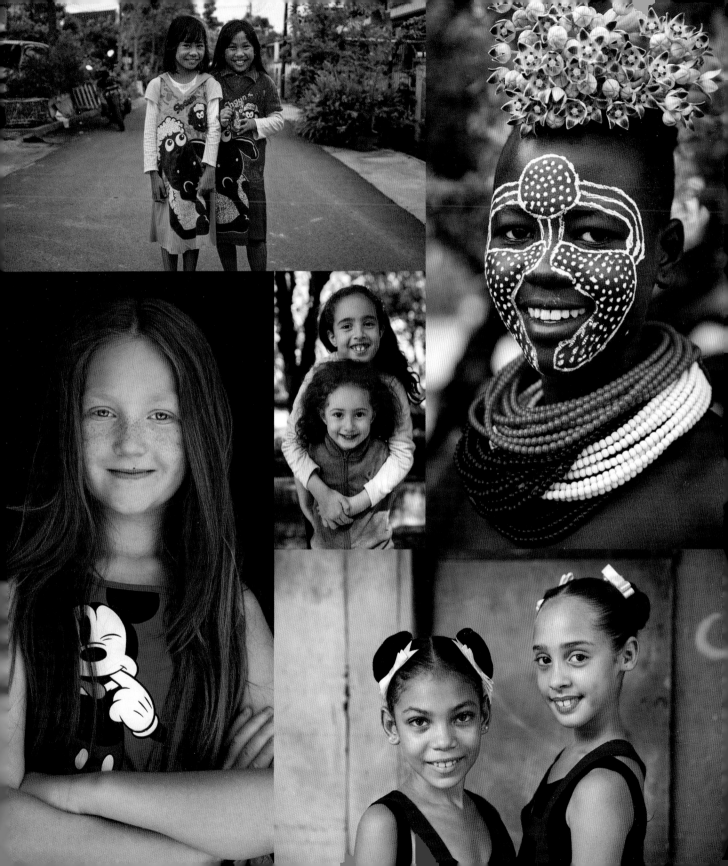

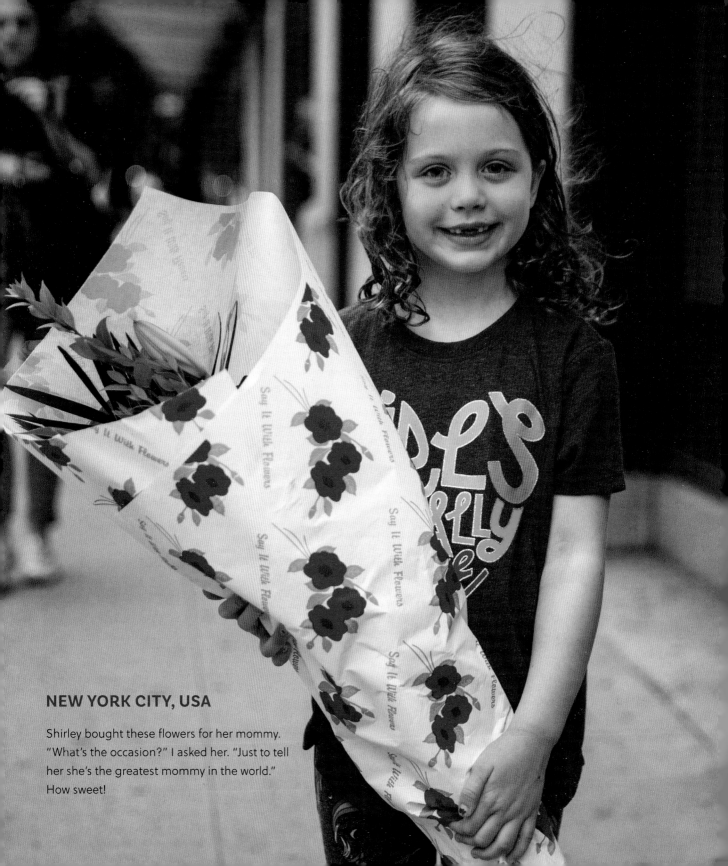

NEW YORK CITY, USA

Shirley bought these flowers for her mommy.
"What's the occasion?" I asked her. "Just to tell
her she's the greatest mommy in the world."
How sweet!

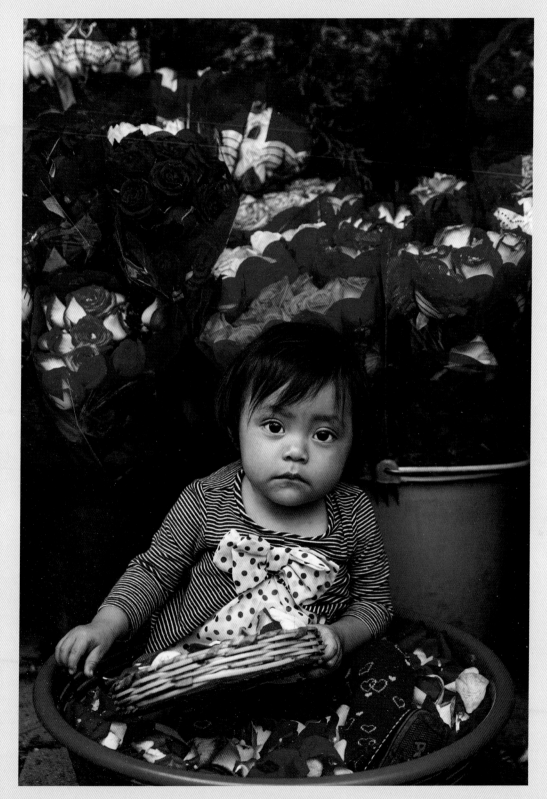

ANTIGUA, GUATEMALA

Clarita's parents are flower vendors. Almost every day, the young girl treats herself to a bath in the petals. It must smell lovely!

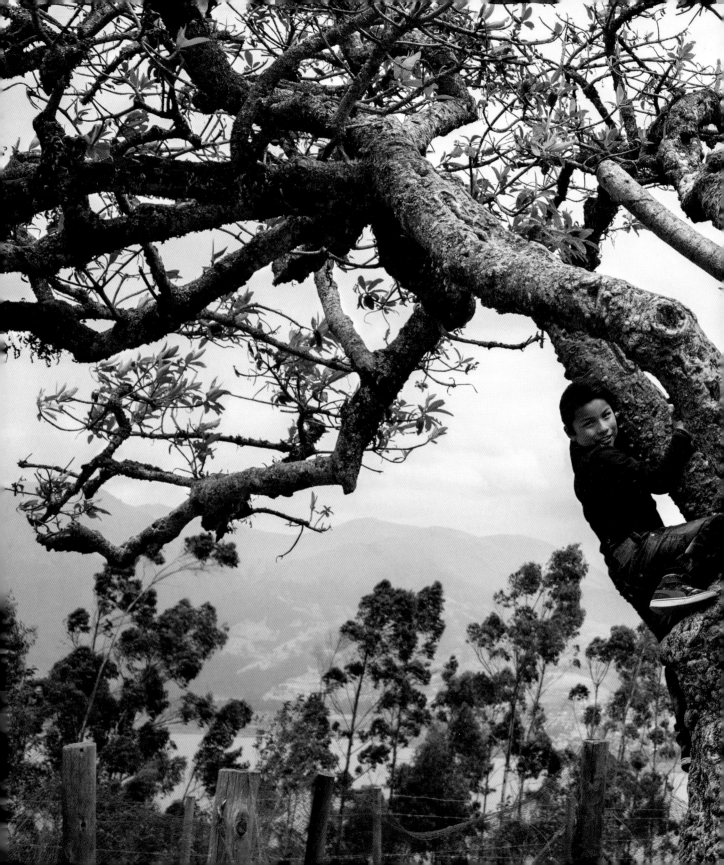

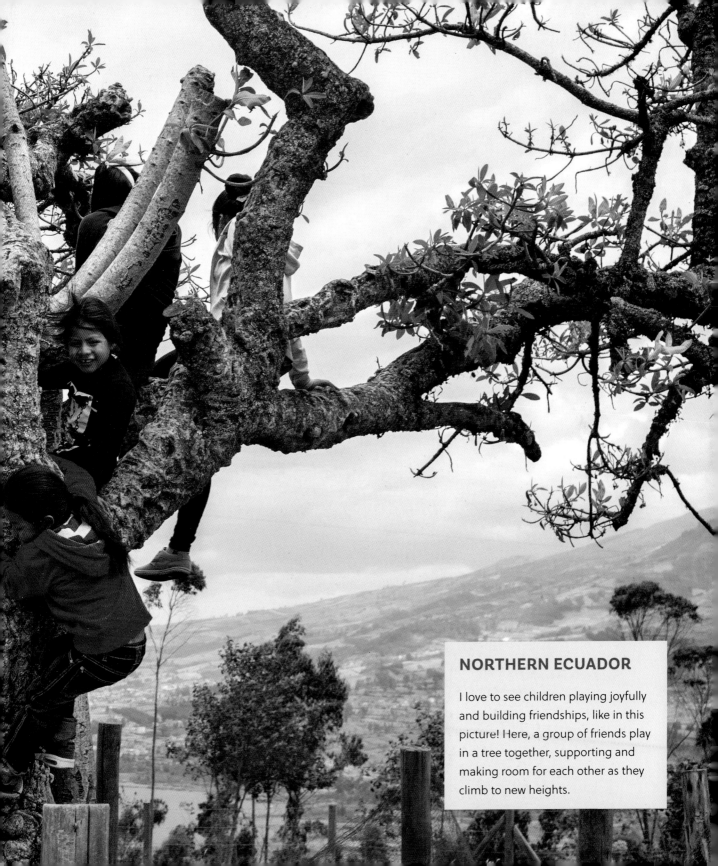

NORTHERN ECUADOR

I love to see children playing joyfully and building friendships, like in this picture! Here, a group of friends play in a tree together, supporting and making room for each other as they climb to new heights.

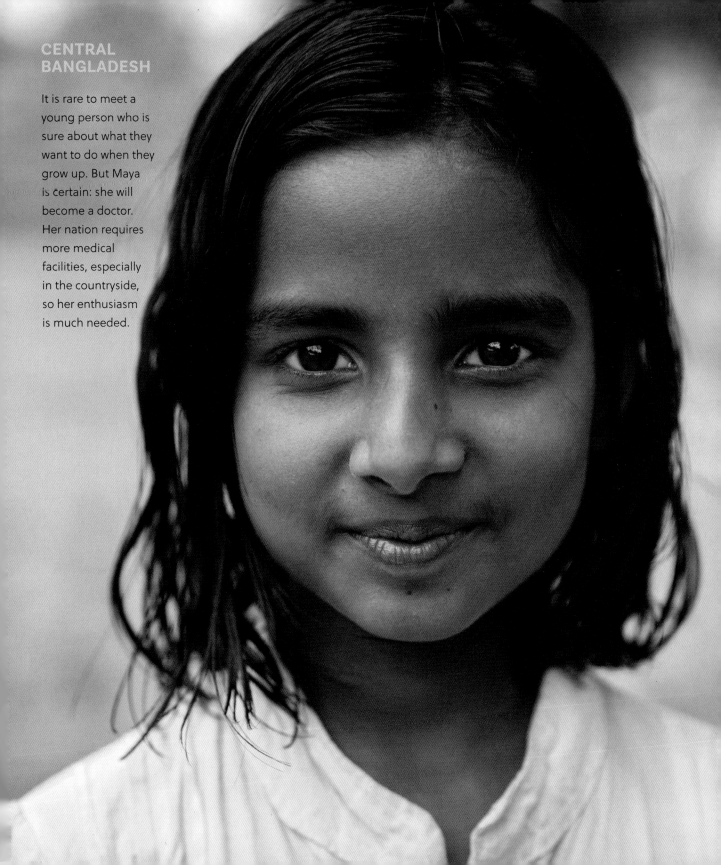

CENTRAL BANGLADESH

It is rare to meet a young person who is sure about what they want to do when they grow up. But Maya is certain: she will become a doctor. Her nation requires more medical facilities, especially in the countryside, so her enthusiasm is much needed.

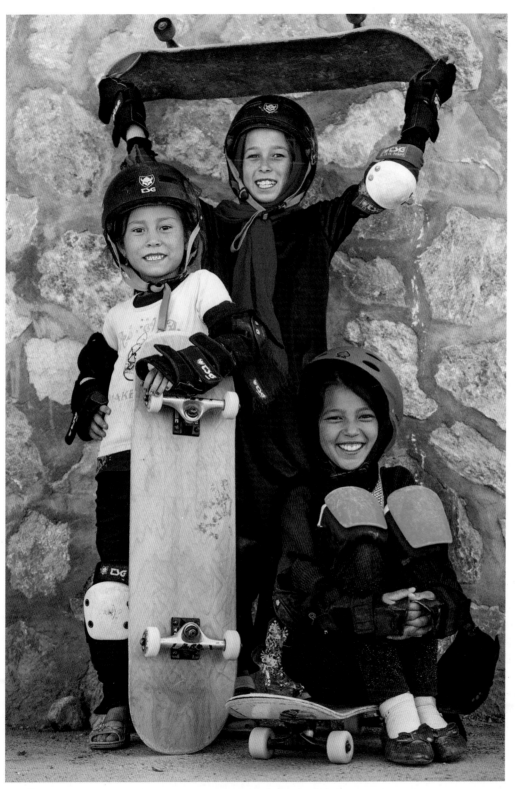

AFGHANISTAN

Life comes with many challenges around here, but Zainab, Fatemah, and Arezo are happiest when they go to skate.

This course was organized by Skateistan, an organization that empowers children from all different places of the world through skateboarding and education.

BEIRUT, LEBANON

Sisters Malak and Samira are ready for Halloween, dressed up as witches. They started an annual tradition of putting on playful shows in front of their parents before going out to take in the sights of the holiday.

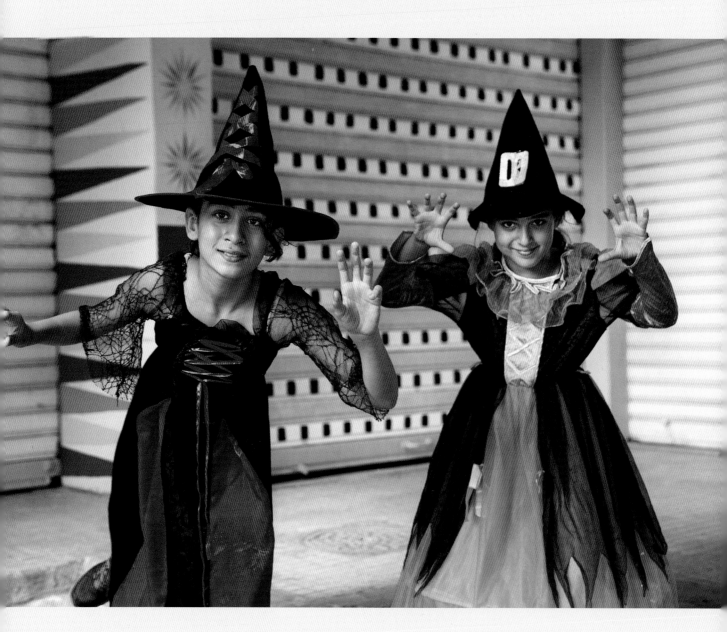

SACRED VALLEY, PERU

Gabriela and Rafaela are attending a celebration dedicated to firefighters. They hope to become firefighters themselves someday. They know just how hard it is, because their own father works as a firefighter, but they are bold and fearless.

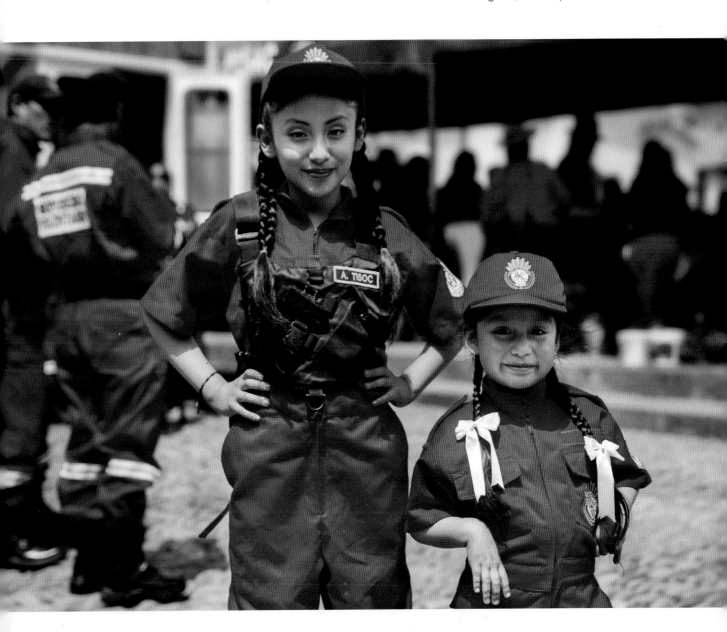

OSLO, NORWAY

Norway is a country in northern Europe famous for its spectacular fjords. But these magnificent features of nature are under threat due to climate change.

Lily is committed to protecting her home and its landscape. Together with her school friends, she goes to protests, demanding action be taken against climate change. She creates her placards by herself; even when it rains or snows, she's there to make her voice heard.

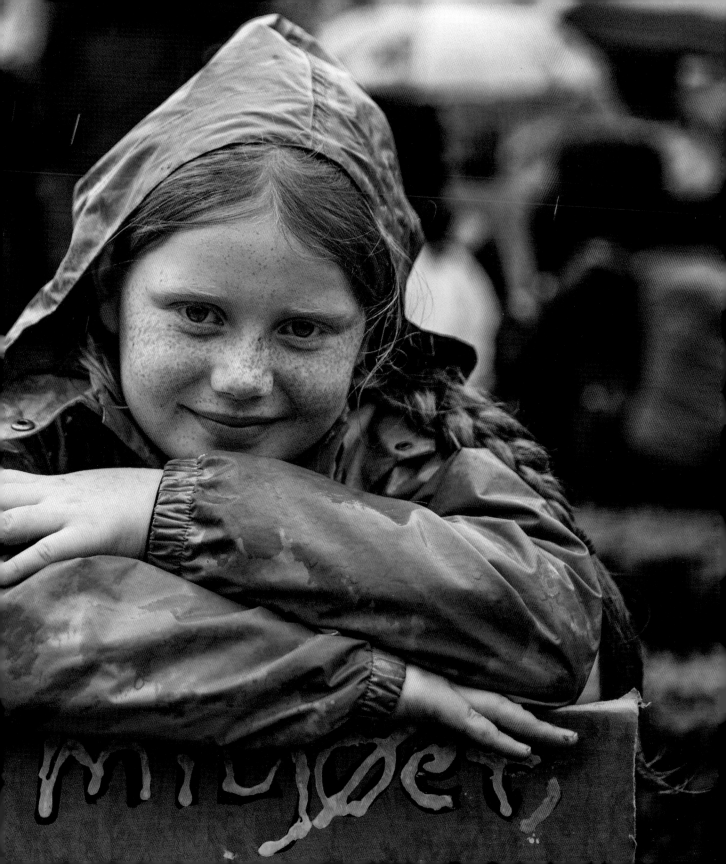

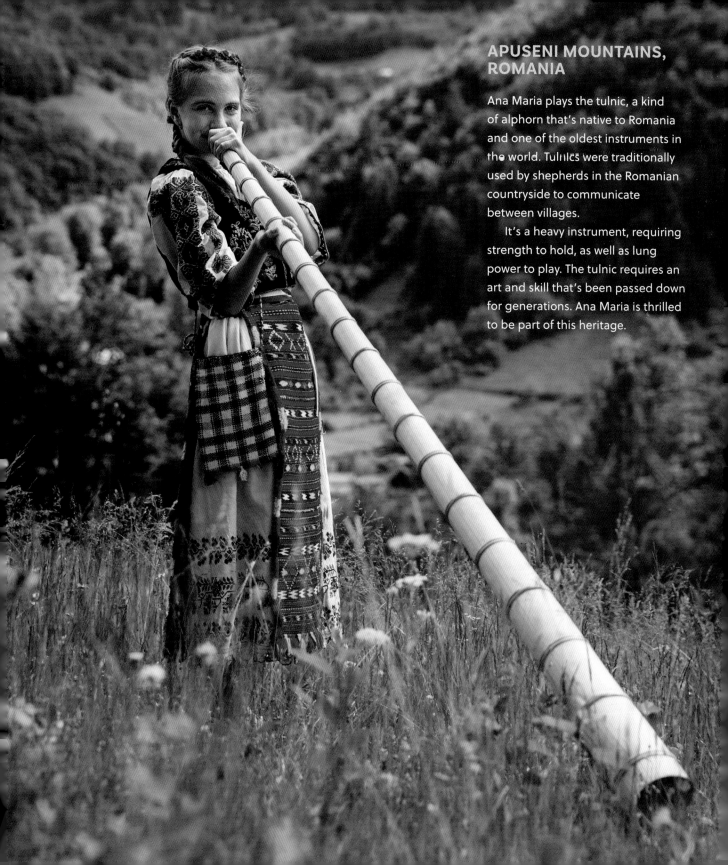

APUSENI MOUNTAINS, ROMANIA

Ana Maria plays the tulnic, a kind of alphorn that's native to Romania and one of the oldest instruments in the world. Tulnics were traditionally used by shepherds in the Romanian countryside to communicate between villages.

It's a heavy instrument, requiring strength to hold, as well as lung power to play. The tulnic requires an art and skill that's been passed down for generations. Ana Maria is thrilled to be part of this heritage.

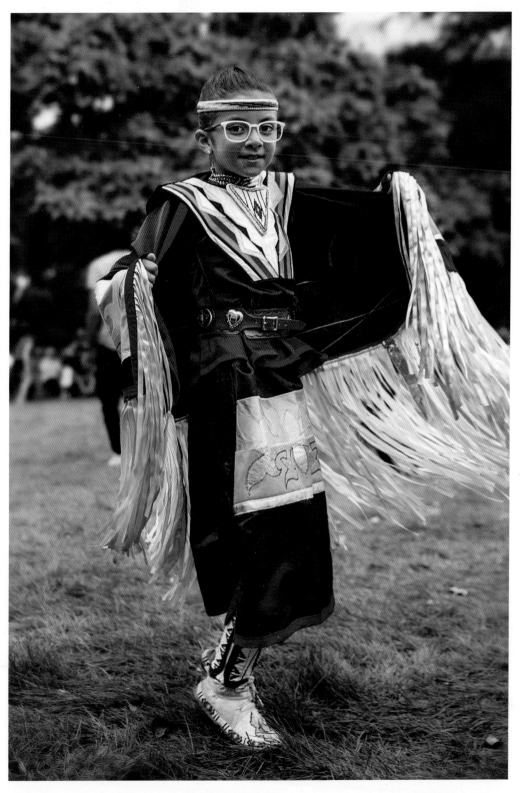

CHICAGO, USA

Ember Skye is dancing and celebrating her Native American ancestors, the Ho-Chunk. She loves going to powwows, sacred social gatherings held by Indigenous peoples of North America. By celebrating her roots, she is celebrating herself, her people, and their future, too.

COX'S BAZAR, BANGLADESH

Aisha is part of the Rohingya community. Her people used to live in Myanmar but were forced to flee to escape war. Aisha is living in a crowded refugee camp, along with thousands of other refugees. The weather is extremely hot here, and the living conditions are harsh. When I asked Aisha what she most wants, she said, "Peace, so I can return back home."

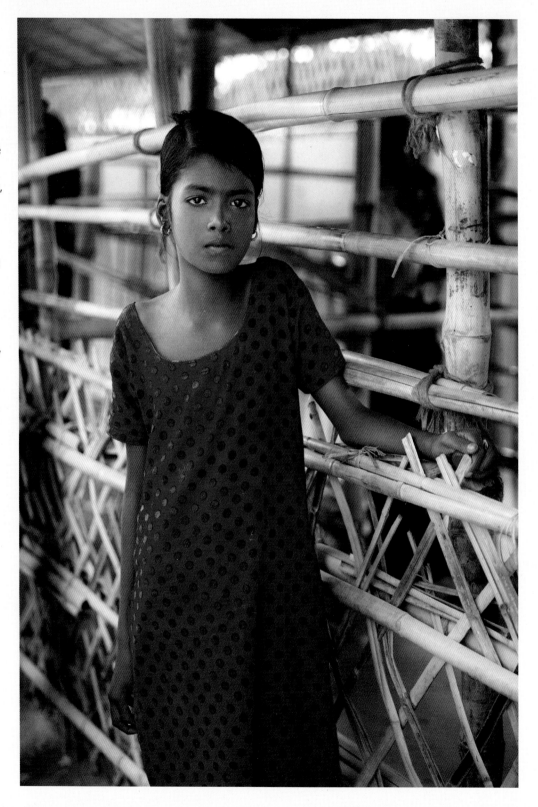

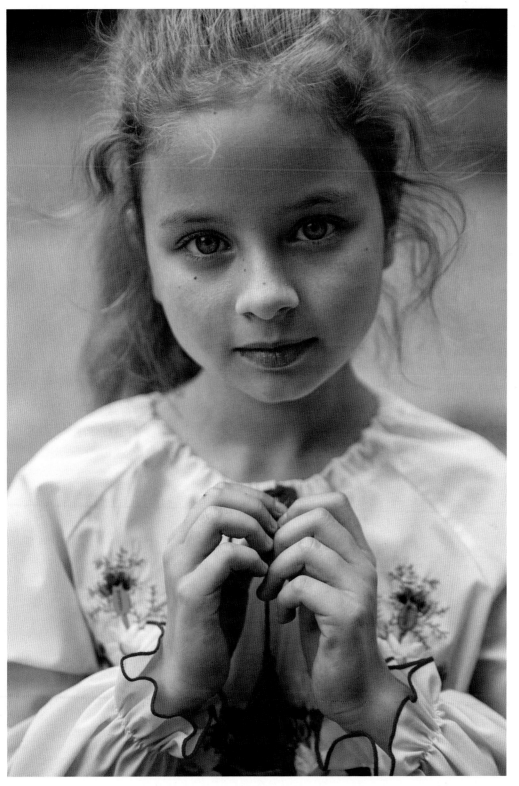

CHIȘINĂU, MOLDOVA

Larisa is from Ukraine, but she and her family had to leave the country due to war. She's missing her home very much, and this traditional Ukrainian costume she's wearing reminds her of her village. She used to enjoy performing traditional dance in a group. Now, all she dreams of is going back home to dance with her friends again.

KOLKATA, INDIA

Payal was taking part in a religious ceremony with her mother when I noticed her. All along the banks of a river, hundreds of people were entering the water and making offerings to Hindu gods and goddesses. This turned out to be Payal's first ceremony. I was amazed to see the passing of ritual and tradition from generation to generation.

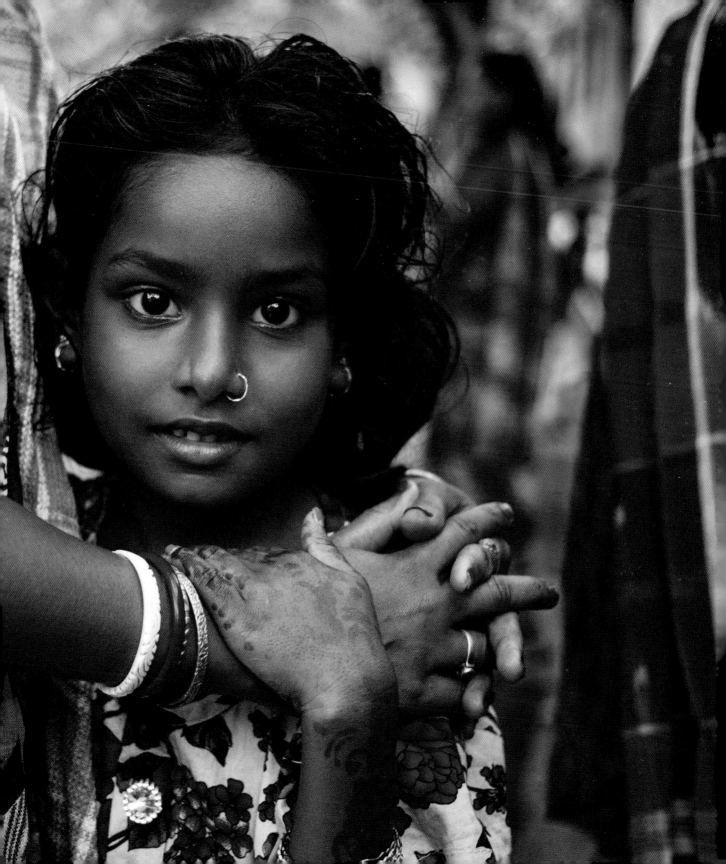

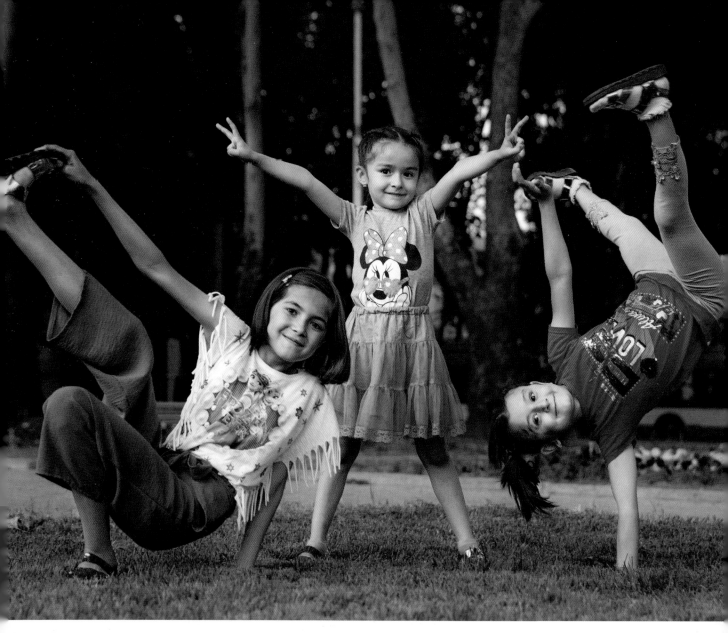

DUSHANBE, TAJIKISTAN

In many traditional parts of the world, girls and women are expected to behave in a reserved manner.

But these three friends are break dancing in public, and breaking stereotypes, too! People around them may not know about breaking and may find it unfamiliar, but these girls are having the time of their lives, and that's all that matters.

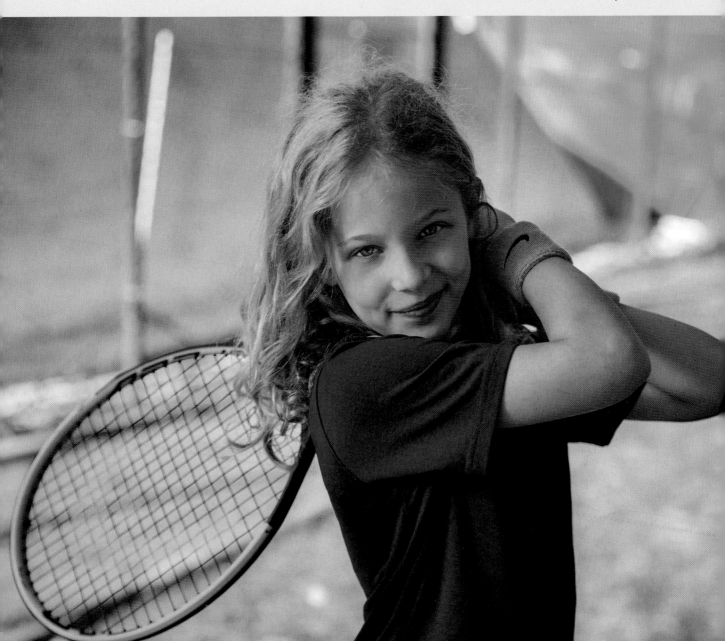

BRUSSELS, BELGIUM

Olivia is a natural athlete and believes that sports make people happy. She likes swimming and cycling, but the first time she tried tennis, she knew it was the sport for her.

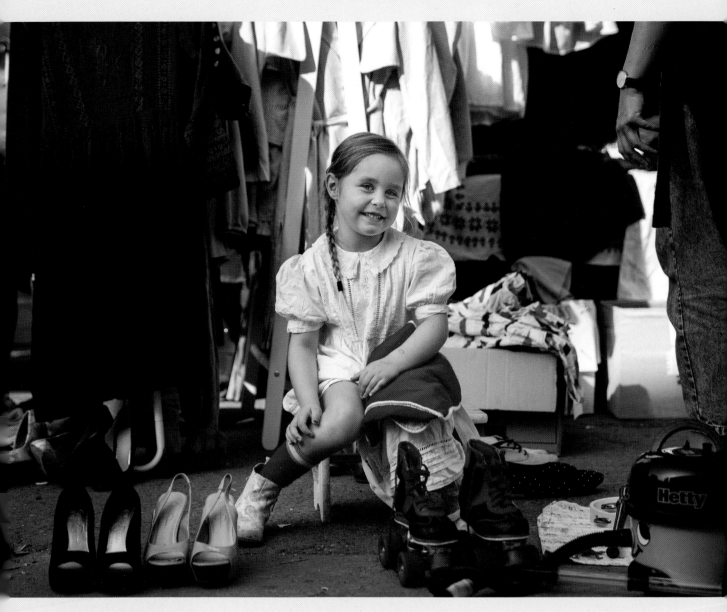

BERLIN, GERMANY

When she grows up, Junes wants to be either a ballerina or a unicorn.
In the meantime, she is selling some of her old toys at a flea market.
She doesn't need the money, but rather she's learning about sustainability
and the value that her things might bring to another child.

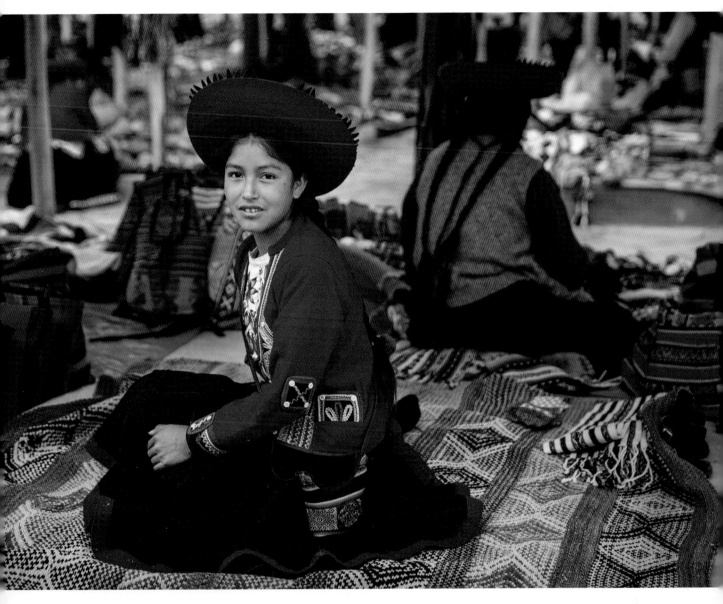

SACRED VALLEY, PERU

This is Munay Tika. Her name means "beautiful flower" in her language. She's selling handmade textiles to tourists in a local market. Her dream is to become a tour guide, because she loves telling visitors all about her native land of Peru.

SUMATRA, INDONESIA

Citra grew up next to this lake, so jumping in it every day feels like the most natural thing in the world. There, in the water, she feels like a mermaid!

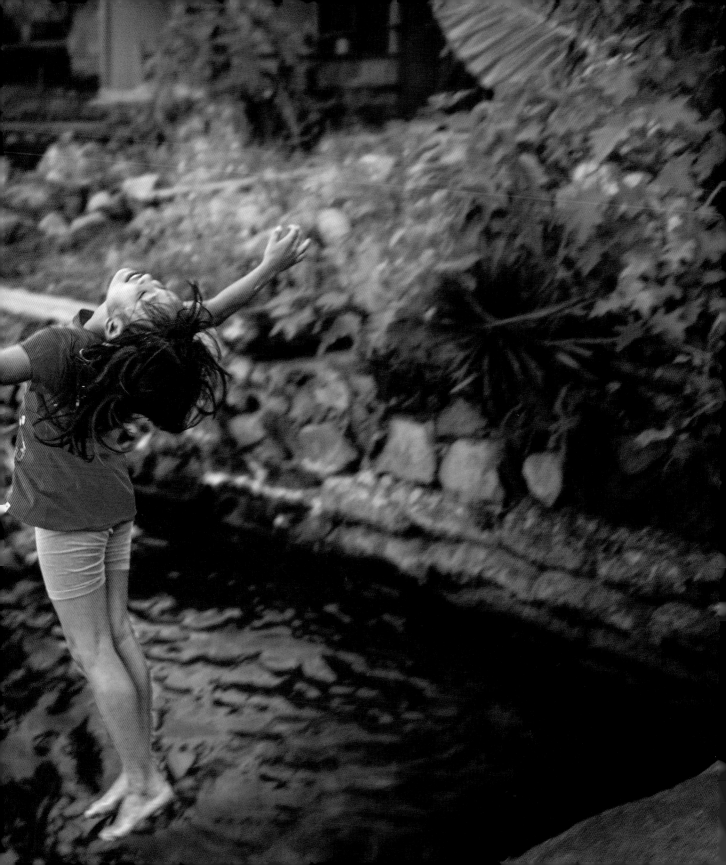

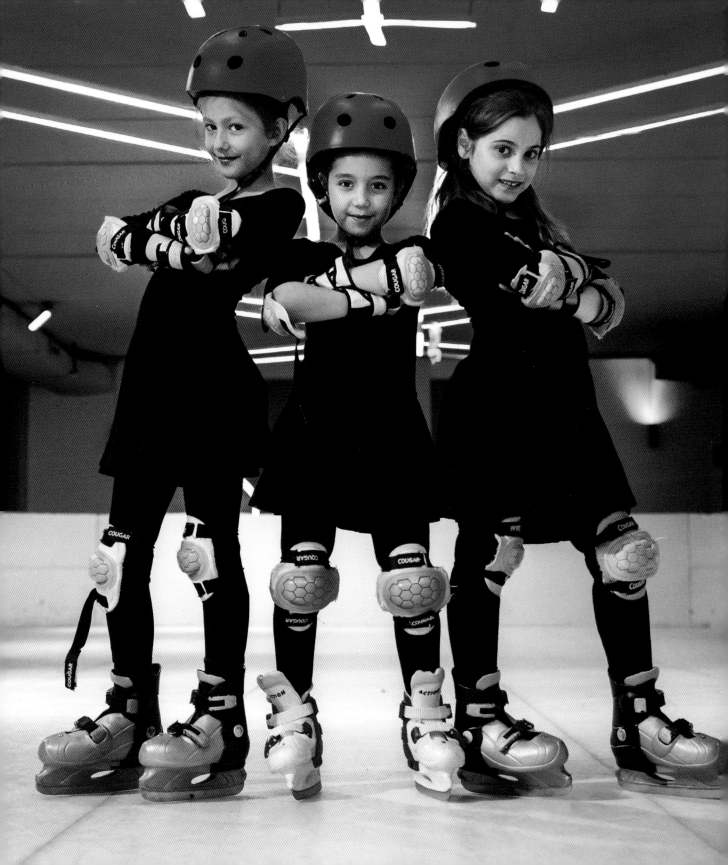

DAMASCUS, SYRIA

Hana, Ala, and Rafah are awesome ice-skaters. Life certainly isn't easy in a country devastated by war, but ice skating allows them to focus on the positive side of life, despite all challenges.

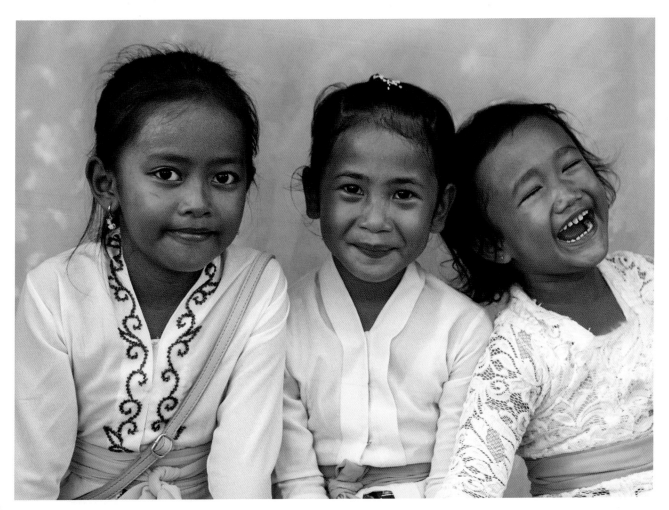

BALI, INDONESIA

Dressed in traditional Balinese outfits, these girls were having fun in the courtyard of a Hindu temple. The religious ceremony was over, so it was the perfect time for playing.

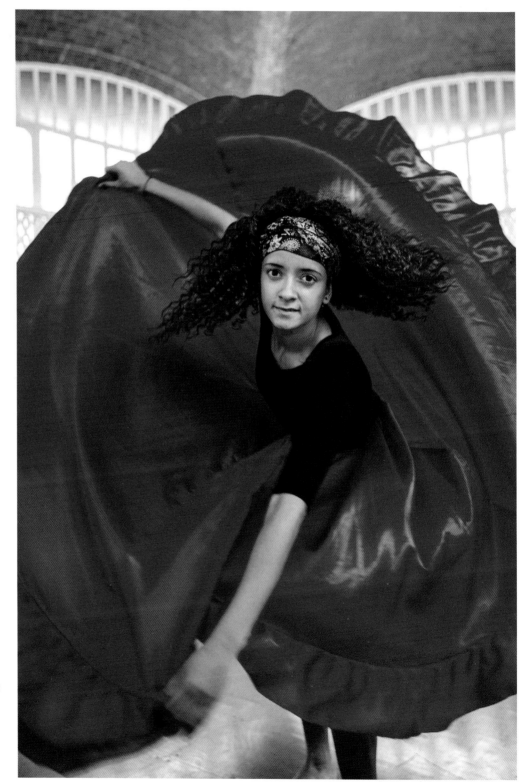

HAVANA, CUBA

Adriana is performing a
beautiful dance called
the Cuban rumba.

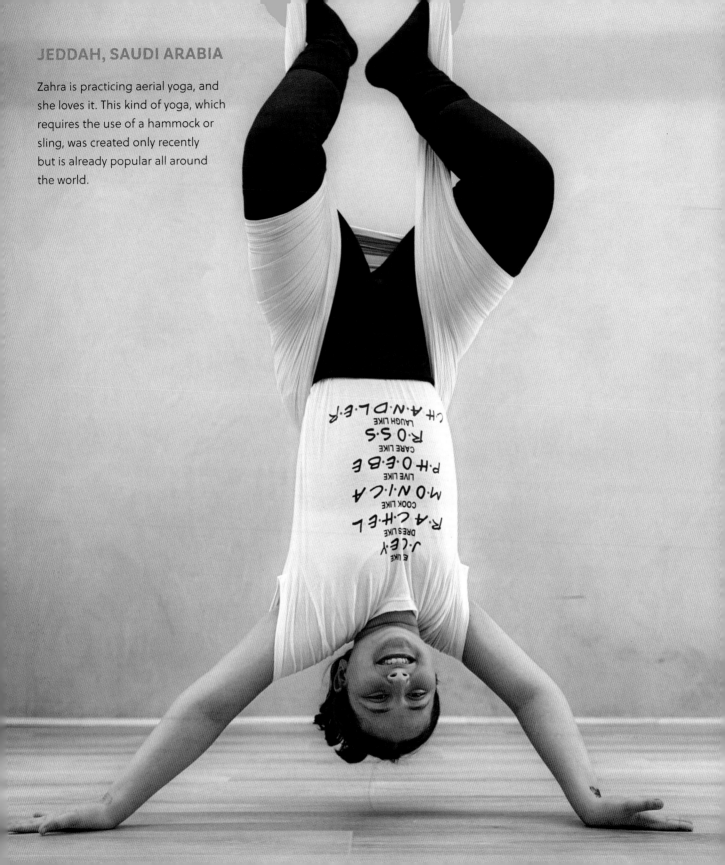

JEDDAH, SAUDI ARABIA

Zahra is practicing aerial yoga, and she loves it. This kind of yoga, which requires the use of a hammock or sling, was created only recently but is already popular all around the world.

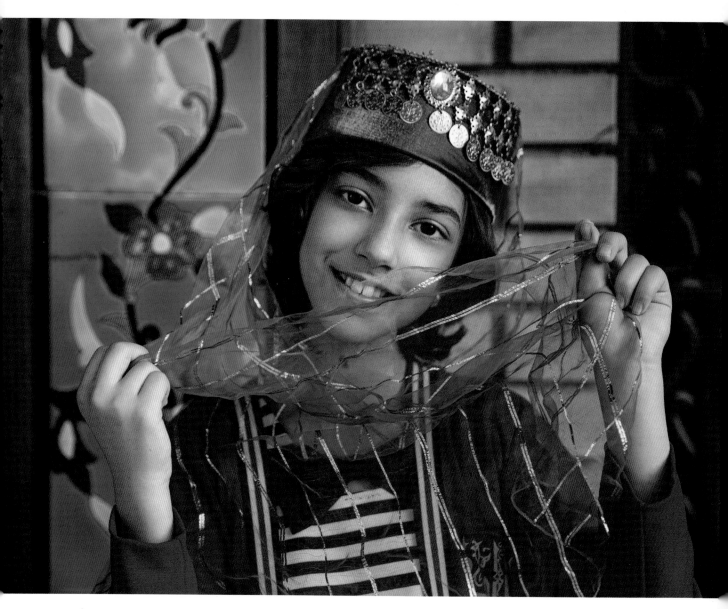

BAGHDAD, IRAQ

Tala is a born storyteller. At twelve years old, she narrates
all sorts of tales for children on her YouTube channel. In her
fairy-tale digital land, she dresses like a princess and uses the
pseudonym "Miss Nujum" (*nujum* means "star" in Arabic).
Indeed, Tala is a star, spreading stories across her own universe.

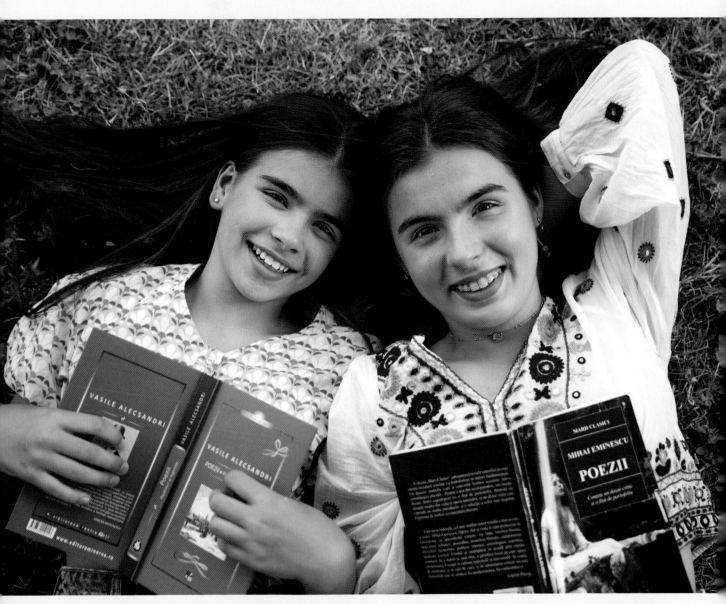

CHIȘINĂU, MOLDOVA

Alexandra and Bianca love poetry so much that they started giving recitations to their friends. Then, they went a step further and started an online channel so more people could enjoy their performances!

PALERMO, ITALY

This is little Luce, right at the beginning of the beautiful journey we call life. Her name means "light" in Italian.

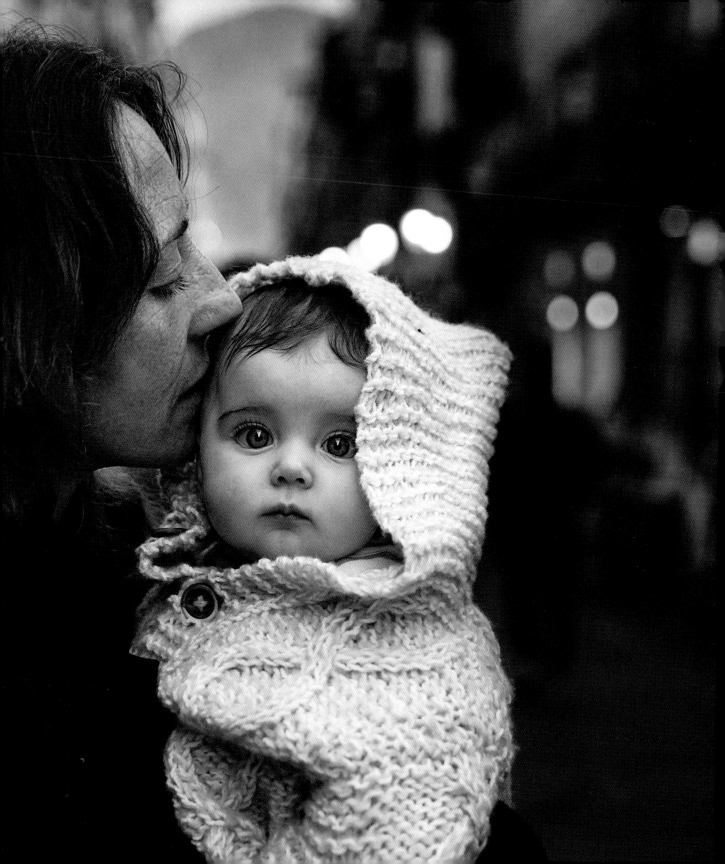

ANTIGUA, GUATEMALA

Introducing Dulce, whose name means "sweet" in Spanish. Dulce is very protective of her long hair and told me she never wants to cut it!

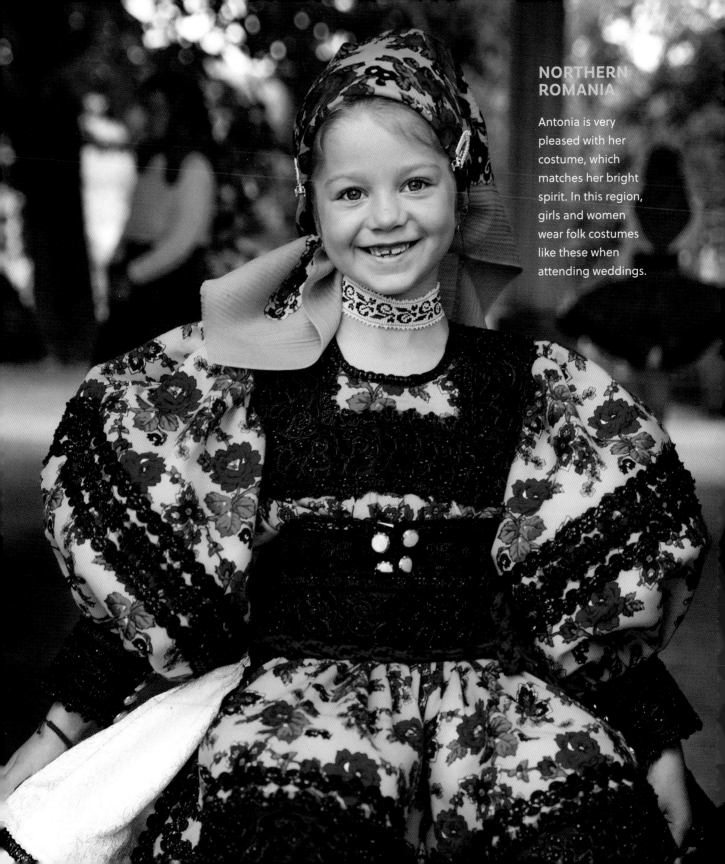

Antonia is very
pleased with her
costume, which
matches her bright
spirit. In this region,
girls and women
wear folk costumes
like these when
attending weddings.

HAVANA, CUBA

Paola was coming home from school when I met her. She's good at math and great at French. She dreams of becoming an airline crew member in the future, so she can travel to France. Her grandma visited the country once and told her it was the most beautiful place on Earth.

For most Cubans, traveling abroad can be difficult and expensive. But Paola will find a way. *A plus tard, Paola!*

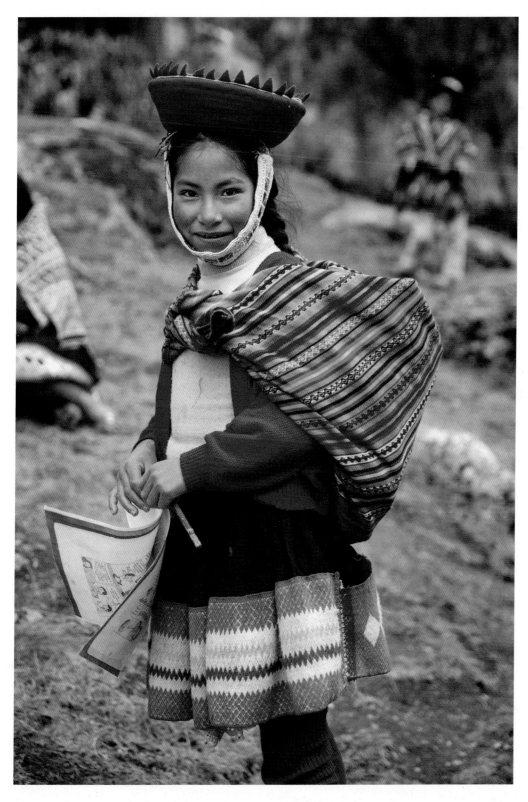

ANDES MOUNTAINS, PERU

Elisabeth lives in an isolated village in the Andes Mountain range. Her route to and from school includes a very steep climb. Since she loves school, she doesn't find this to be a problem. In fact, her dream is to become a teacher.

She carries her homemade schoolbag on the journey. In her small and remote village, far from mainstream clothing shops, everybody wears traditional homemade clothes and accessories.

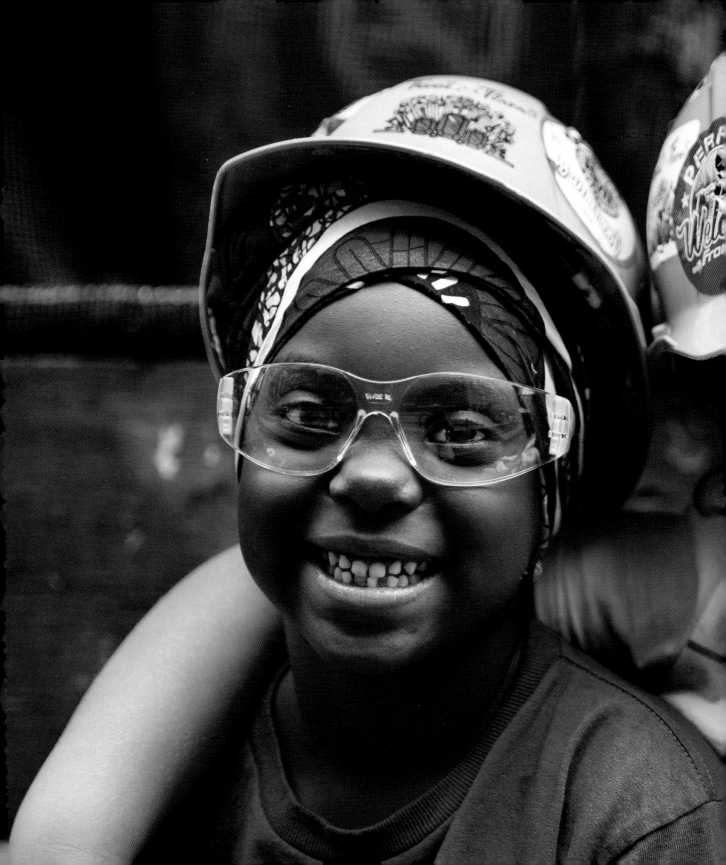

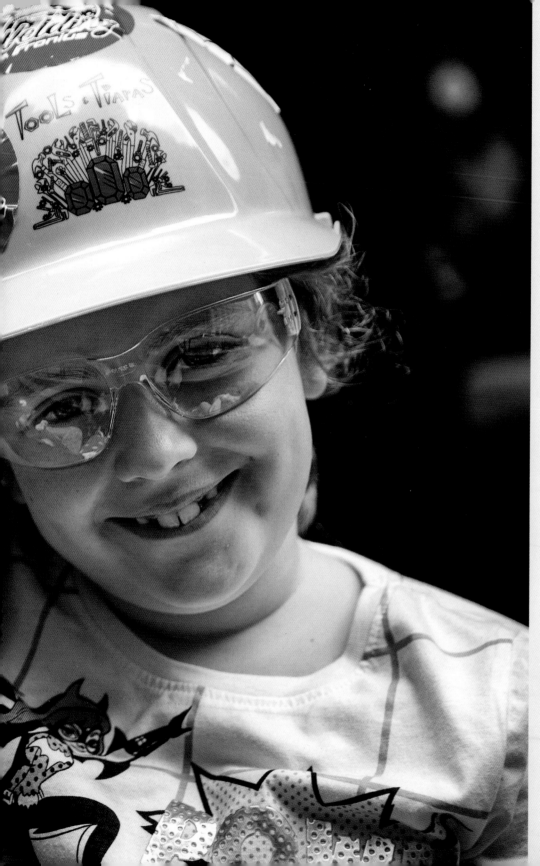

NEW YORK CITY, USA

Sophia and Parker are learning construction as a hobby, and they love it. Tools & Tiaras is an organization that teaches young girls the construction trade. This hobby could even become their profession—Sophia told me she sees herself using her trade skills as a boss someday.

BEIRUT, LEBANON

Ivy is passionate about drawing. Her home looks like a gallery, with her work all over the walls. Ivy dreams of becoming a professional painter when she grows up. Besides her native Arabic, she also speaks French and English. However, her favorite mode of expression remains drawing, through which she can communicate her thoughts and feelings without words.

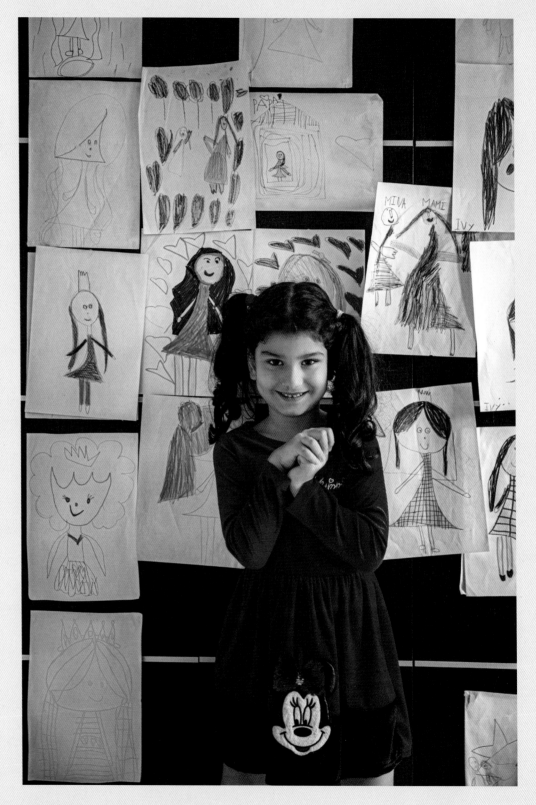

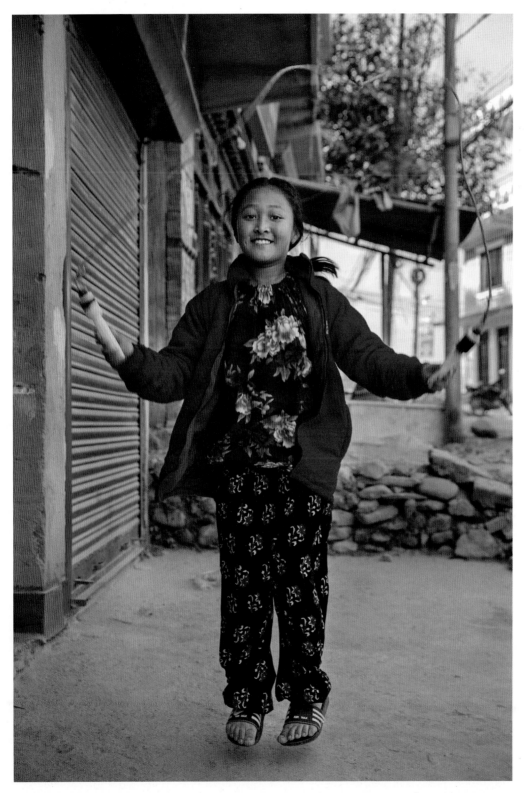

KATHMANDU, NEPAL

Idha loves jumping rope, competing with her friends almost every day. Sometimes she wins, sometimes she doesn't, but she always has fun.

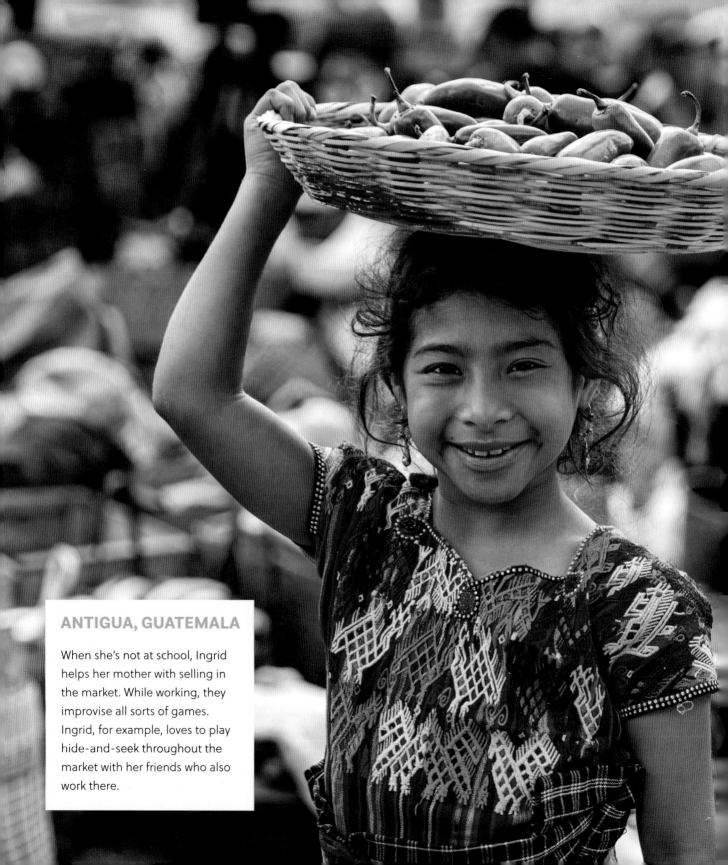

ANTIGUA, GUATEMALA

When she's not at school, Ingrid helps her mother with selling in the market. While working, they improvise all sorts of games. Ingrid, for example, loves to play hide-and-seek throughout the market with her friends who also work there.

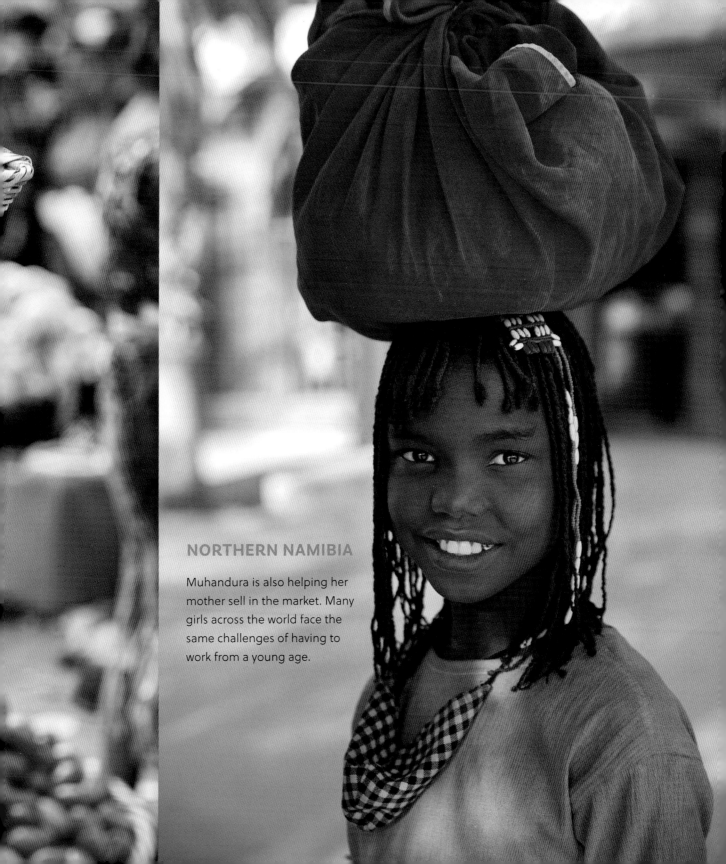

NORTHERN NAMIBIA

Muhandura is also helping her mother sell in the market. Many girls across the world face the same challenges of having to work from a young age.

When she grows up, Elena wants to be a pediatrician, a doctor for children.

Elena was born with a rare condition that caused a tumor to grow and affect her vision. In the first years of her life, she spent a lot of time in the hospital.

Being surrounded by talented and dedicated doctors and nurses inspired her. That's how she became passionate about caring for babies and children. She's started playing dress-up as a doctor, and her play medical kits have gotten to be quite big and complex!

Elena's life was saved by her doctors. In the future, she plans to save other children's lives.

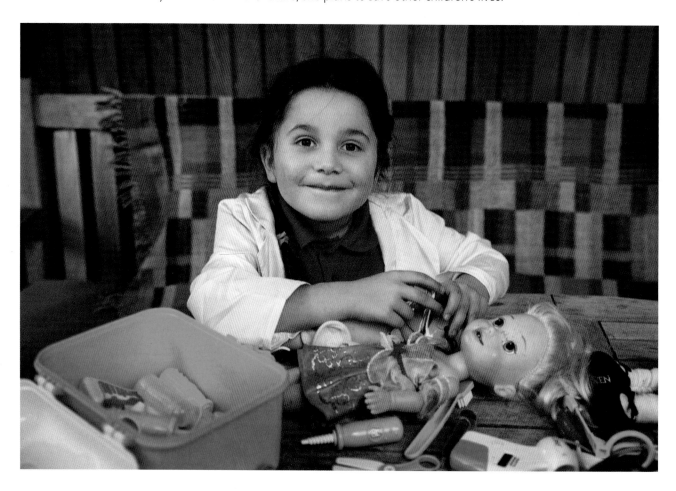

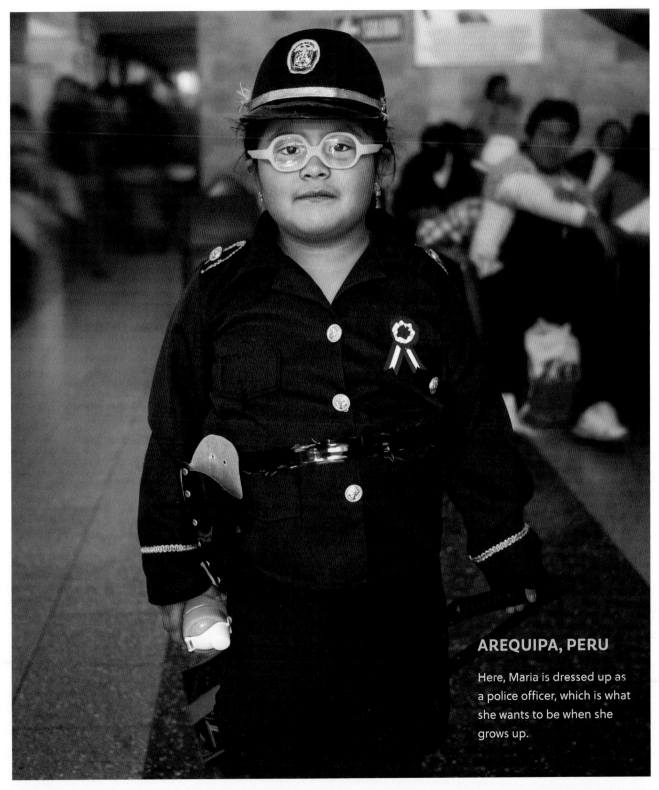

AREQUIPA, PERU

Here, Maria is dressed up as a police officer, which is what she wants to be when she grows up.

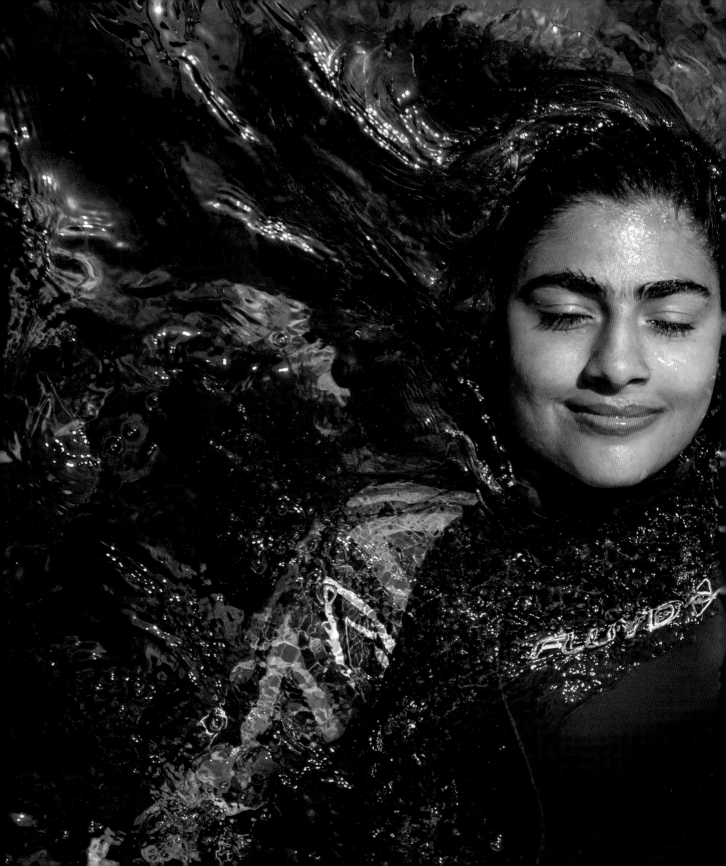

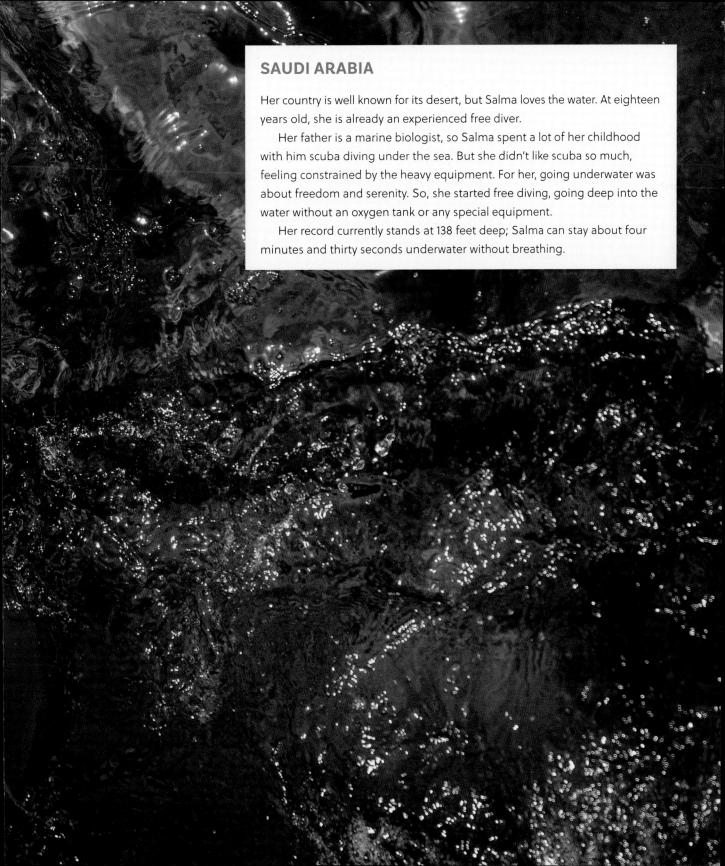

SAUDI ARABIA

Her country is well known for its desert, but Salma loves the water. At eighteen years old, she is already an experienced free diver.

Her father is a marine biologist, so Salma spent a lot of her childhood with him scuba diving under the sea. But she didn't like scuba so much, feeling constrained by the heavy equipment. For her, going underwater was about freedom and serenity. So, she started free diving, going deep into the water without an oxygen tank or any special equipment.

Her record currently stands at 138 feet deep; Salma can stay about four minutes and thirty seconds underwater without breathing.

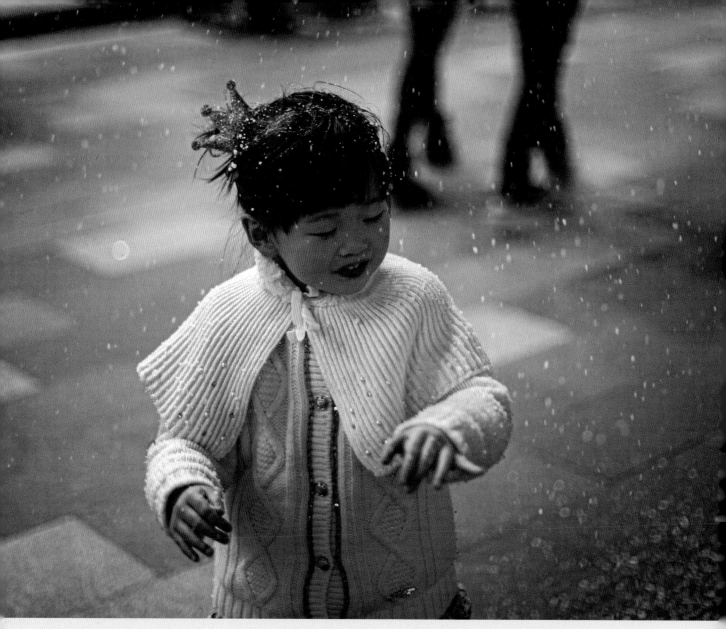

SHANGHAI, CHINA

There's rarely snow in Shanghai, because of the warm climate. These artificial
snowflakes give local children like Hua the chance to play in the snow. She doesn't
seem to mind the difference, enjoying her own snowy wonderland.

PARIS, FRANCE

Constance loves reading; she started to read when she was three years old. She and her family quickly learned that she is both hyperlexic and autistic, which are two examples of neurodiversity. This simply means that those who experience these conditions take in information and express themselves differently. For Constance, this also means that she was able to learn to read at an earlier age and quicker rate than most other kids.

Besides reading, Constance also loves drawing. She's always excited to go out with her parents and visit the beautiful bookstores and museums of Paris.

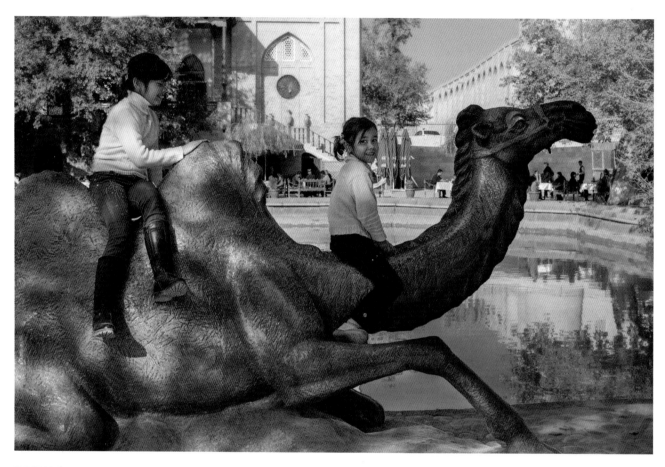

BUKHARA, UZBEKISTAN

Afsana and Sahar love to come here and play on this camel statue.

Their city used to be one of the main stops on the Silk Road, an ancient network of trade routes that connected Asia and Europe for hundreds of years. Besides silks and fabrics, merchants would also trade many other goods, including books, medicines, and culinary ingredients. On this part of the Silk Road, camels used to be the most important means of transportation.

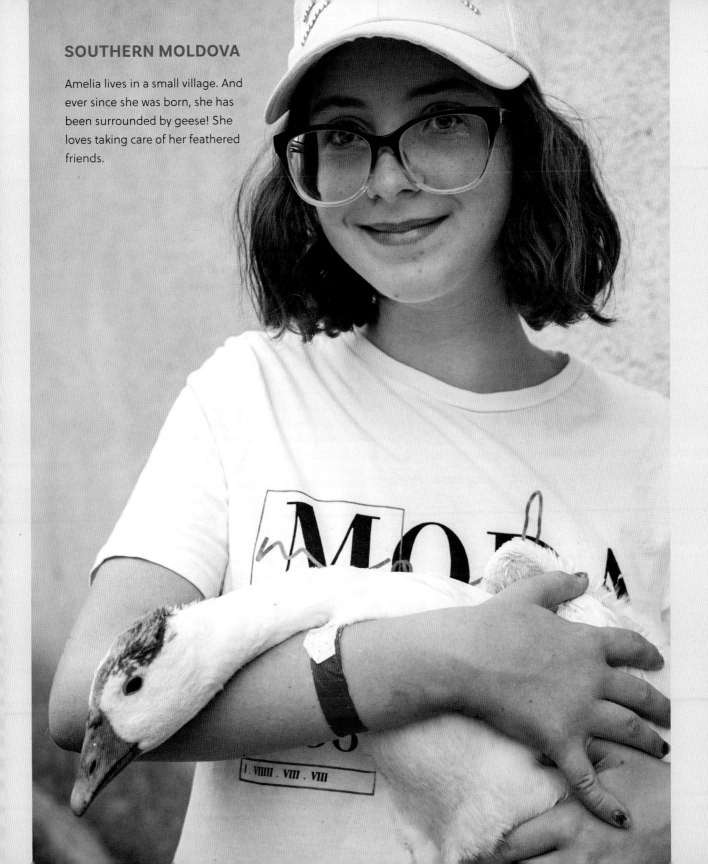

SOUTHERN MOLDOVA

Amelia lives in a small village. And ever since she was born, she has been surrounded by geese! She loves taking care of her feathered friends.

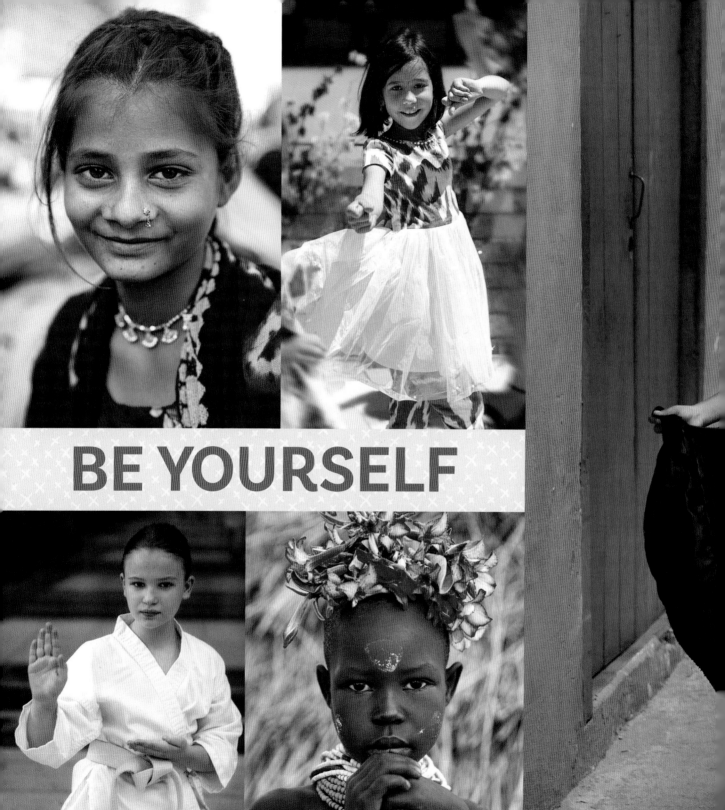

BE YOURSELF

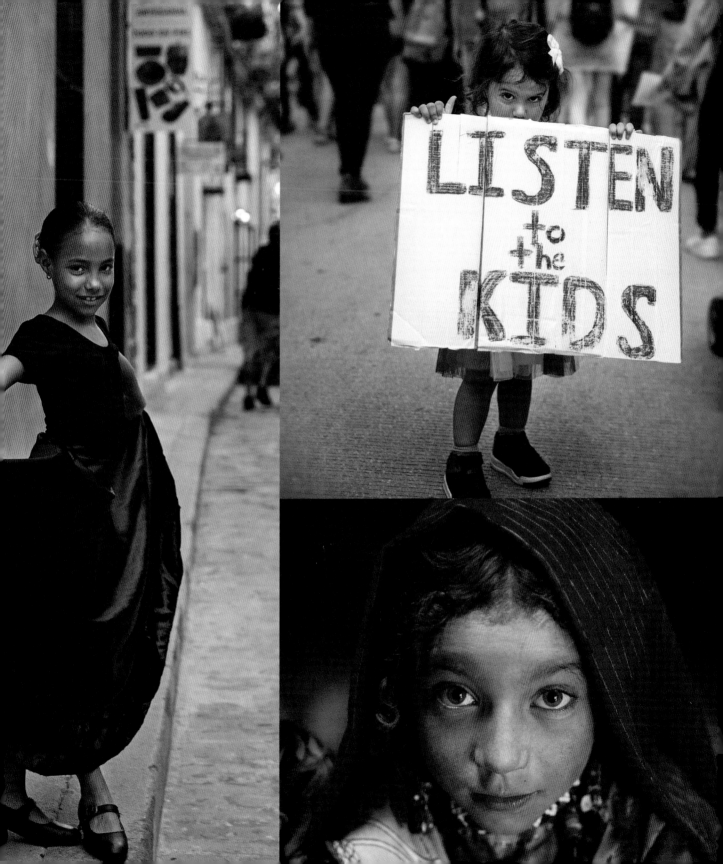

BE YOURSELF

We are all very different, and we all have our own superpowers. That's why, when we work together, each one of us brings unique qualities to the team. And guess what . . . that's the whole point! We are all needed.

Don't try to be somebody else, because you can already be great just the way you are. Work on the best version of yourself.

A lot of the time, we are exposed to limited (and limiting!) standards for success, role models, beauty, lifestyle choices. When we all try to be the same thing by taking the same path, most of us will fail.

Let me tell you a secret. I have traveled to almost one hundred countries, I have photographed thousands of girls and women, and I found out what real beauty and success both mean.

Real beauty is about being yourself, natural and authentic. It's about celebrating and loving every inch of your body, just the way it is. Not despite anything but because of everything.

Real success is not about being rich or famous. It's about a sense of fulfilment that you can only achieve by living your potential. It means doing what you love and enjoying yourself. Don't get me wrong. Sometimes, your natural talents might make you rich and famous. Good for you! But that shouldn't be the goal in and of itself. You should always focus on developing the best version of you.

Look in the mirror. You are beautiful just the way you are, and you have the keys to success. Be yourself, harness your superpowers, and you'll be very proud of yourself indeed.

Never forget you are unique and special! Celebrate yourself! You are a gift to humanity!

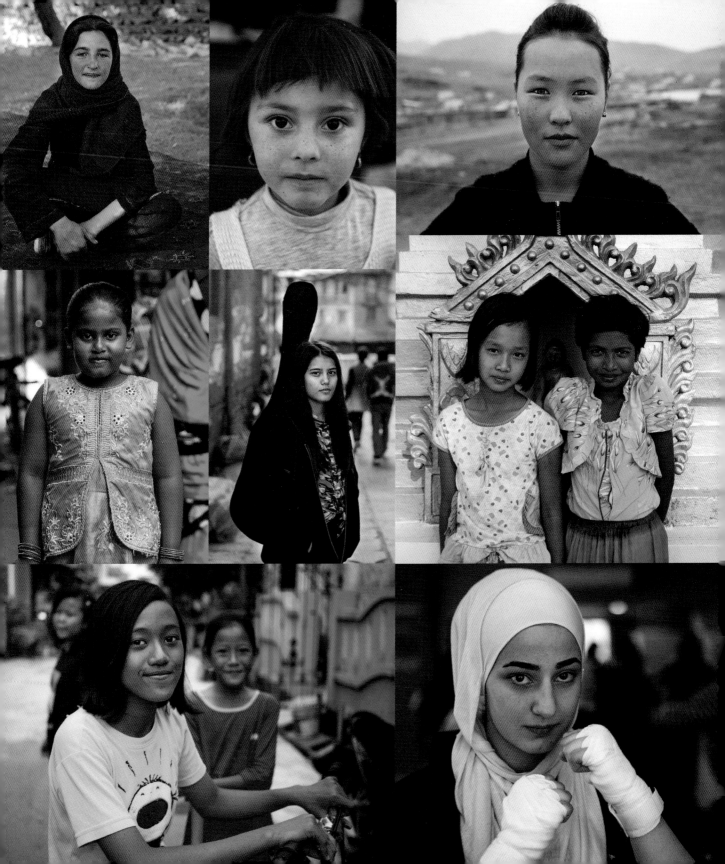

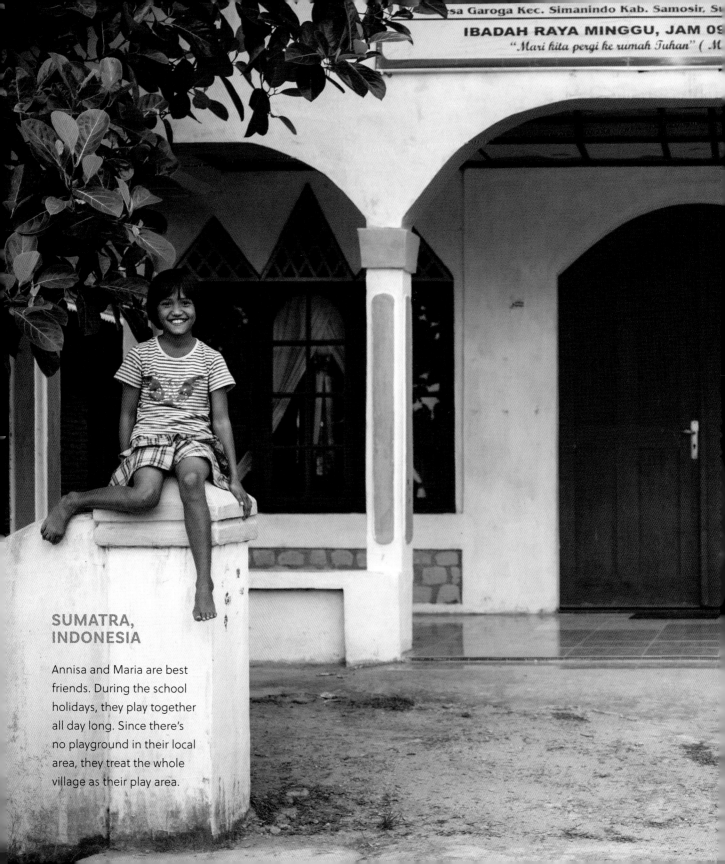

sa Garoga Kec. Simanindo Kab. Samosir, Su

IBADAH RAYA MINGGU, JAM 09

"Mari kita pergi ke rumah Tuhan" (M

SUMATRA, INDONESIA

Annisa and Maria are best
friends. During the school
holidays, they play together
all day long. Since there's
no playground in their local
area, they treat the whole
village as their play area.

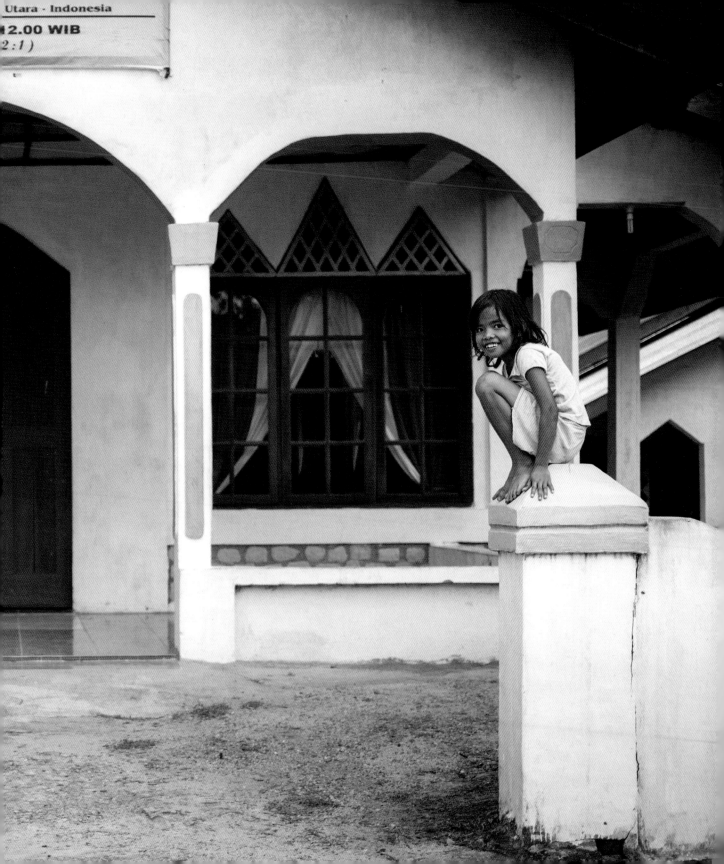

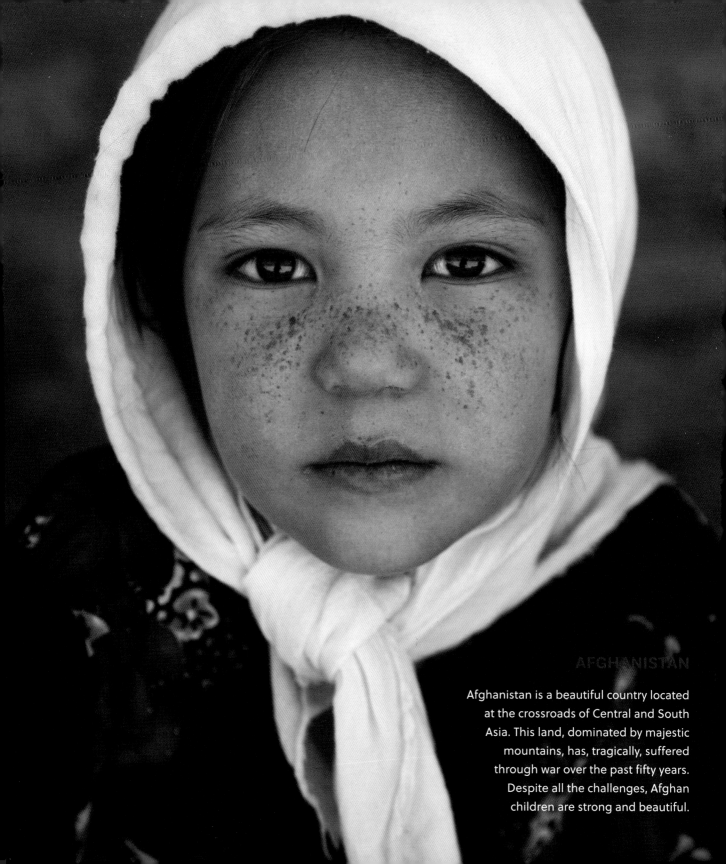

AFGHANISTAN

Afghanistan is a beautiful country located
at the crossroads of Central and South
Asia. This land, dominated by majestic
mountains, has, tragically, suffered
through war over the past fifty years.
Despite all the challenges, Afghan
children are strong and beautiful.

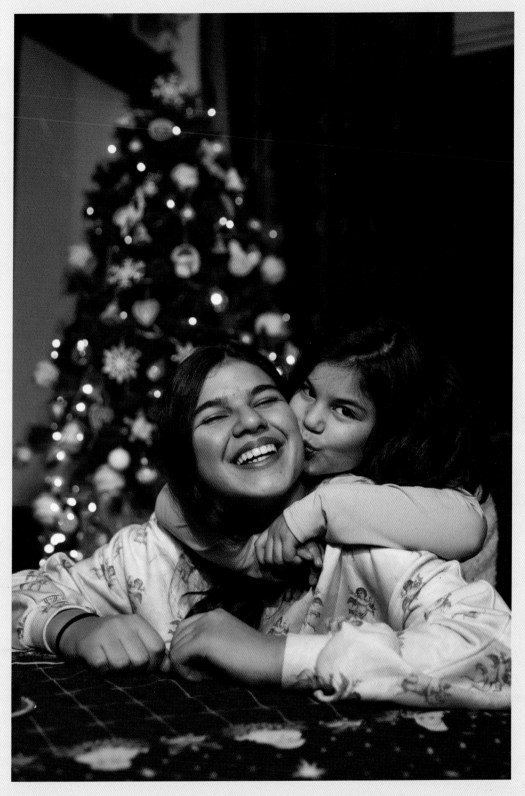

DAMASCUS, SYRIA

Sisters Sara (left) and Syria invited me to spend Christmas at their home. They are Christians, so this is a very important holiday for their family. Their country was devastated by war, and life here comes with many challenges. While their father used a small electric generator to light the house and the Christmas tree, the girls themselves were so full of love and light that their home was radiant!

Although their native language is Arabic, they loved chatting to me in English. The tradition here is to write your wishes for Santa on a paper star and place it on the Christmas tree. Sara's message to Santa was very mature and warmhearted: "I don't know what to wish for. I have many wishes, but they are kind of expensive. So, all I want is peace and love."

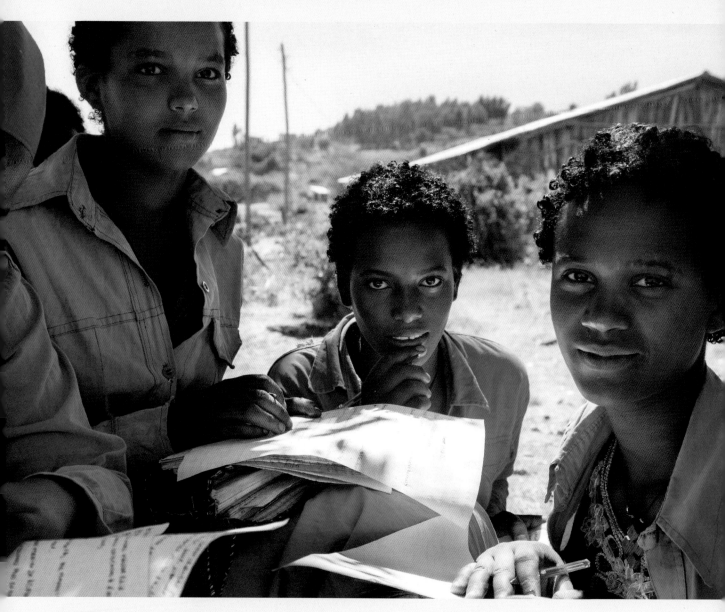

LALIBELA, ETHIOPIA

These girls were working on a school project together.

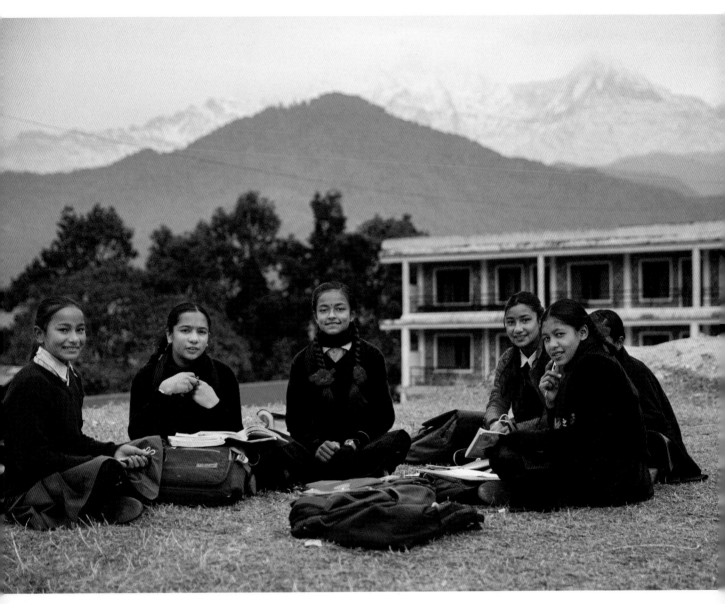

POKHARA, NEPAL

All these girls take a long mountain walk, every day, just to get to school. But they know it's worth all the effort to earn their education.

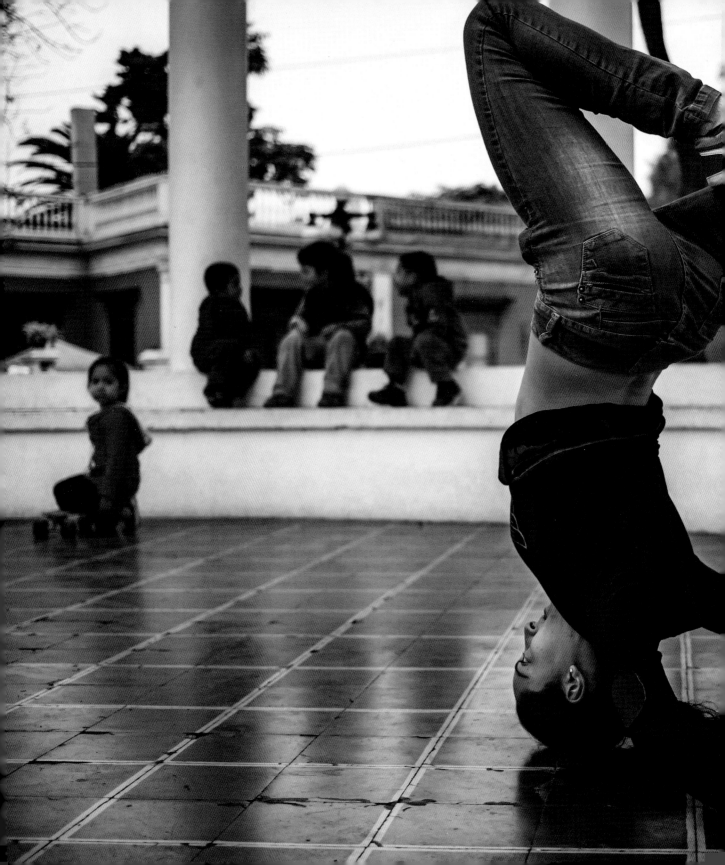

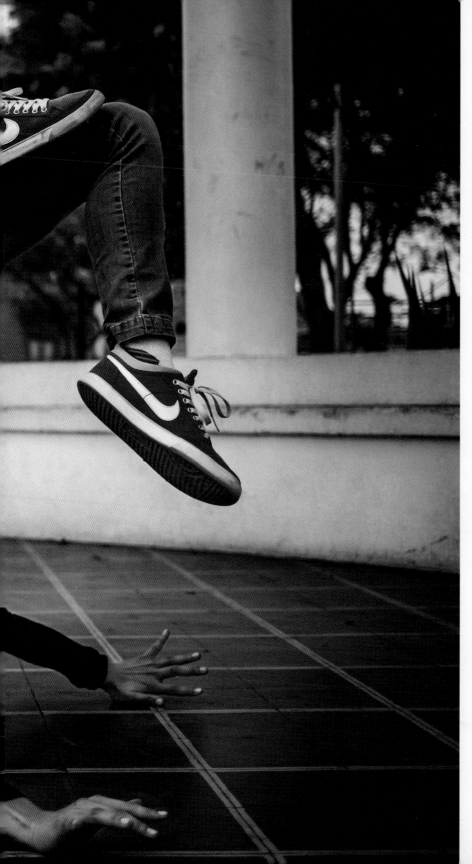

LIMA, PERU

Camila is a B-girl. This means a girl who does breaking, or break dancing. This is not just a dance form that involves tricks but an entire culture. Originating from hip-hop culture in the United States in the '70s, breaking has spread all over the world, thanks to many talented B-girls and B-boys.

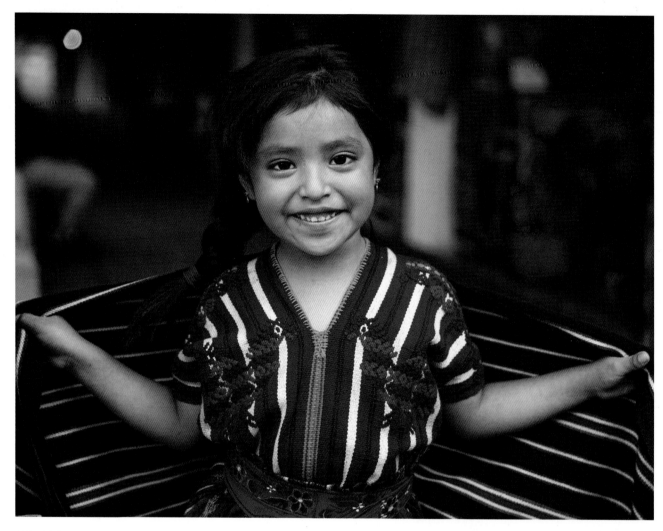

ANTIGUA, GUATEMALA

Astrid cut her hair when she was home alone. She regrets it a bit, but time solves everything. Every new experience can lead to learning something new.

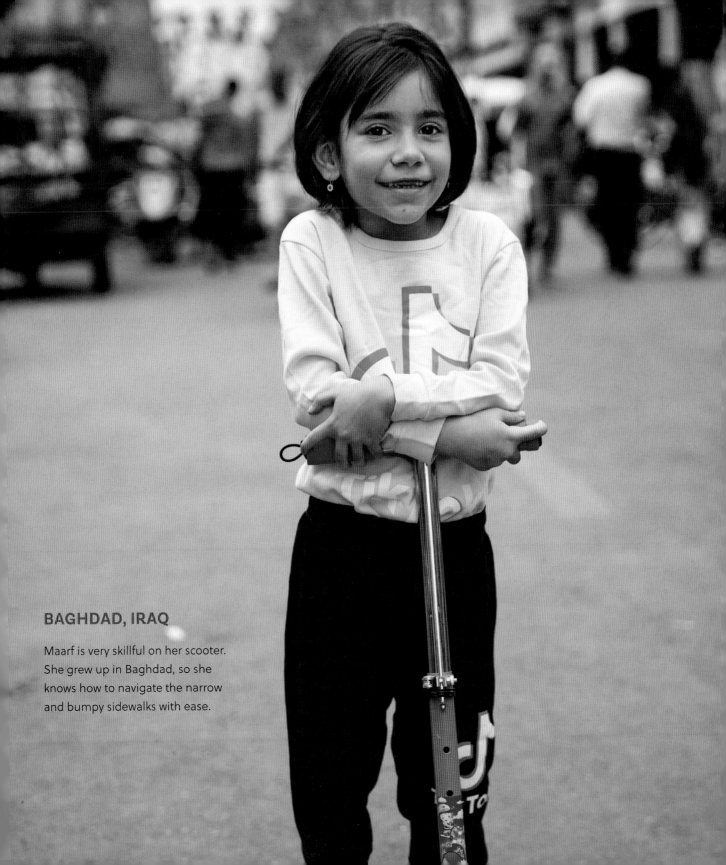

BAGHDAD, IRAQ

Maarf is very skillful on her scooter. She grew up in Baghdad, so she knows how to navigate the narrow and bumpy sidewalks with ease.

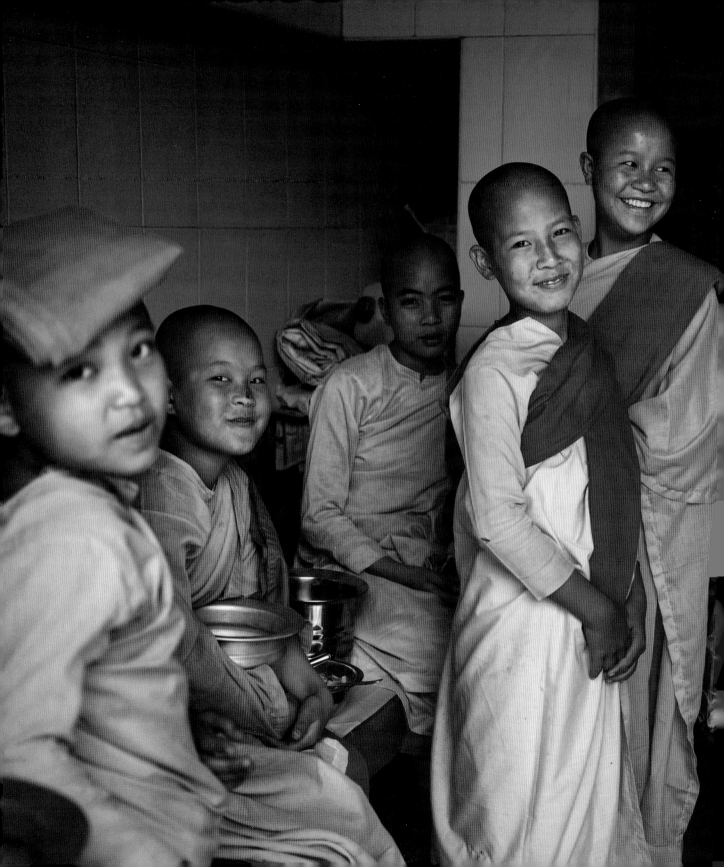

SOUTHERN MYANMAR

These girls are Buddhist nuns. They dress in pink robes and shave their heads.

Most girls who are nuns come from conflict zones or poor areas where parents can't afford to raise them anymore. Some of them will remain nuns for life, while others will choose another path.

The nunnery is their school and also their home. Here, they study, meditate, eat, sleep, and play. It's not an easy life, but it's often the best lifestyle available to them, so they try to make the most if it.

CHIȘINĂU, MOLDOVA

Smaranda works hard at studying piano—but this is just the beginning of her journey with music. In the future, she wants to learn guitar and take singing lessons, too.

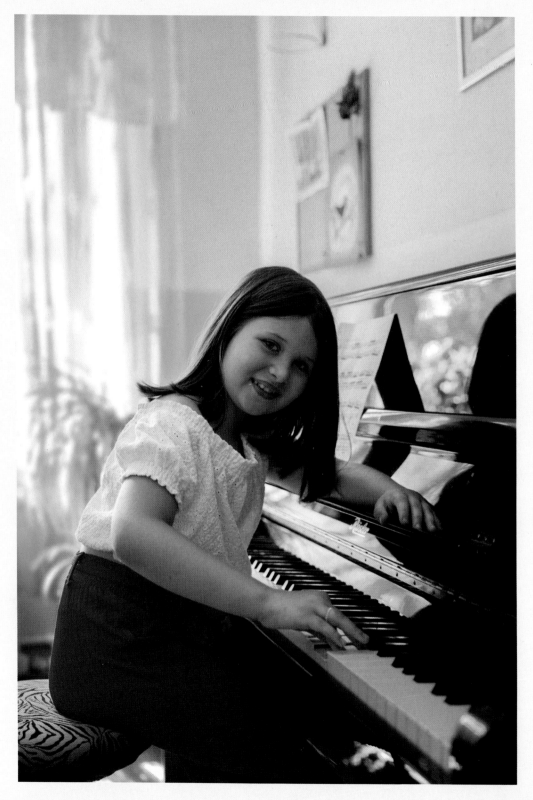

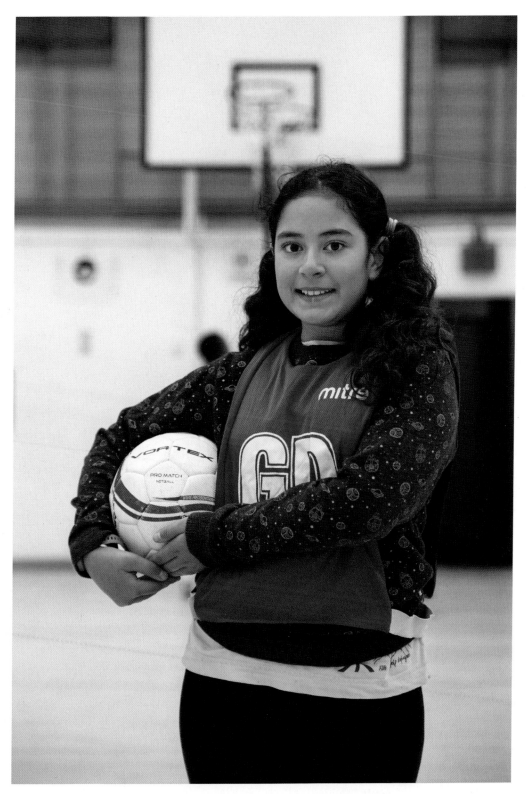

LONDON, UK

Sophie is playing a sport called netball, taught in schools across the United Kingdom. Although the goal, to put the ball into the hoop, is similar to basketball, it has its own set of rules. You can't run with the ball, and there's no dribbling.

Besides netball, Sophie also trains in swimming and gymnastics. But her favorite is netball, because it's a team sport that she can play with her friends.

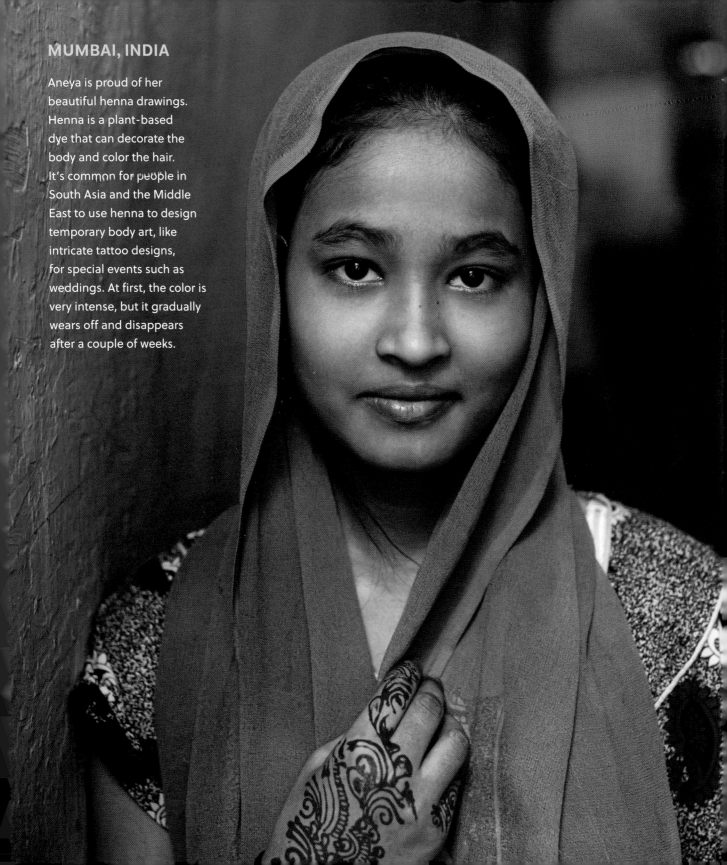

MUMBAI, INDIA

Aneya is proud of her beautiful henna drawings. Henna is a plant-based dye that can decorate the body and color the hair. It's common for people in South Asia and the Middle East to use henna to design temporary body art, like intricate tattoo designs, for special events such as weddings. At first, the color is very intense, but it gradually wears off and disappears after a couple of weeks.

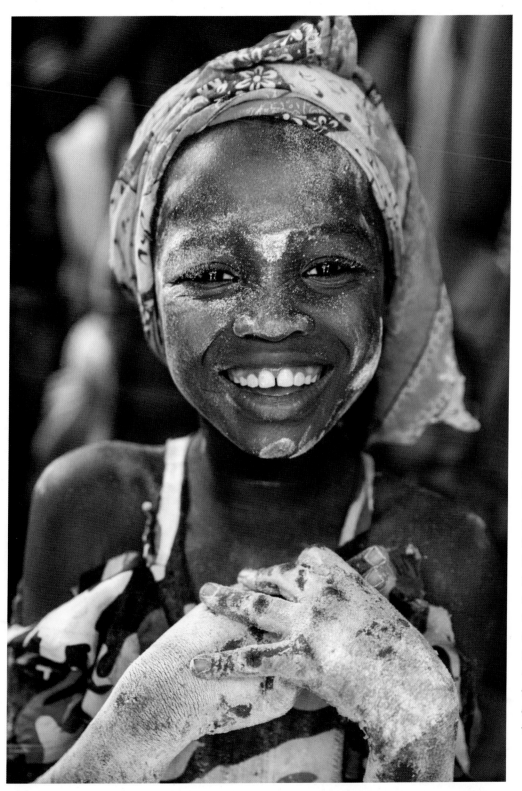

OMO VALLEY, ETHIOPIA

Namucho is part of the Daasanach people. I photographed her inside a mill that she and her parents use to turn their harvested sorghum into flour. Sorghum is a popular cereal in this part of the world where wheat and corn don't grow well in the dry climate.

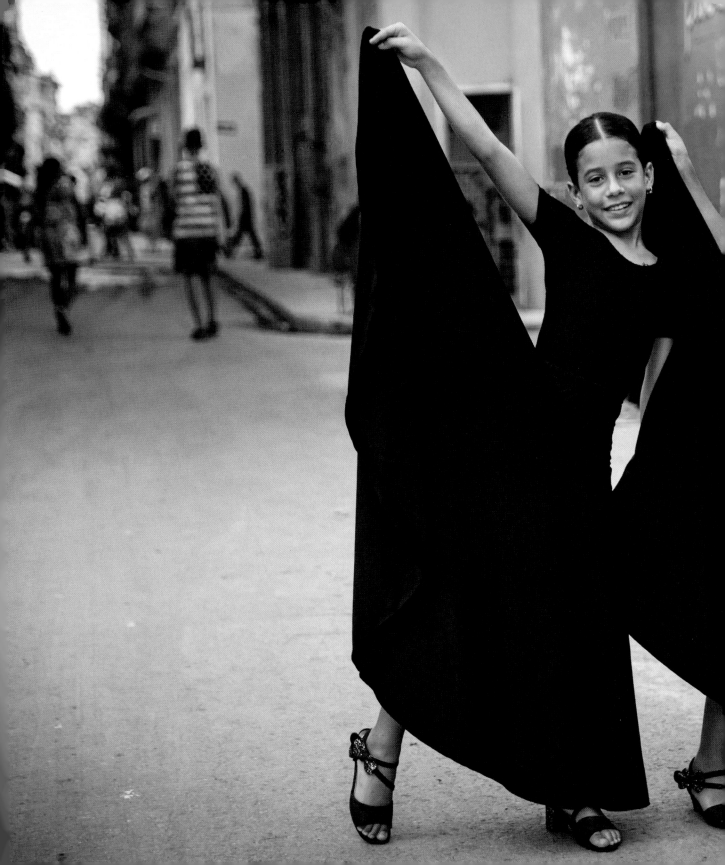

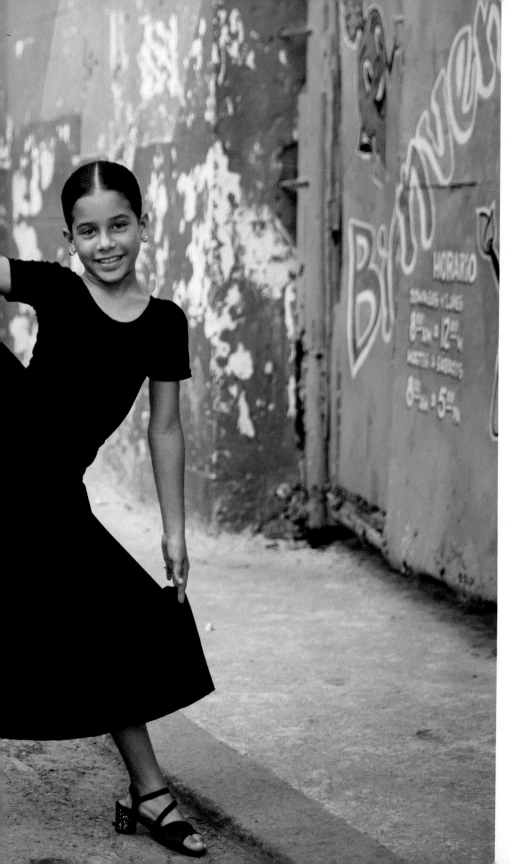

HAVANA, CUBA

Twins Mia and Lia were on their way to a flamenco dance class when I noticed them, and they were happy to show me some moves! Flamenco music and dancing originated in southern Spain in the eighteenth century. The dancers create part of the accompanying music, tapping and stamping their feet to create percussion.

RIO DE JANEIRO, BRAZIL

Twins Camila and Bruna told me that although they have different personalities, they have a "very special connection." When one of them feels an intense emotion, like joy or despair, the other one will instantly experience the same feeling, even when they are far away from one another.

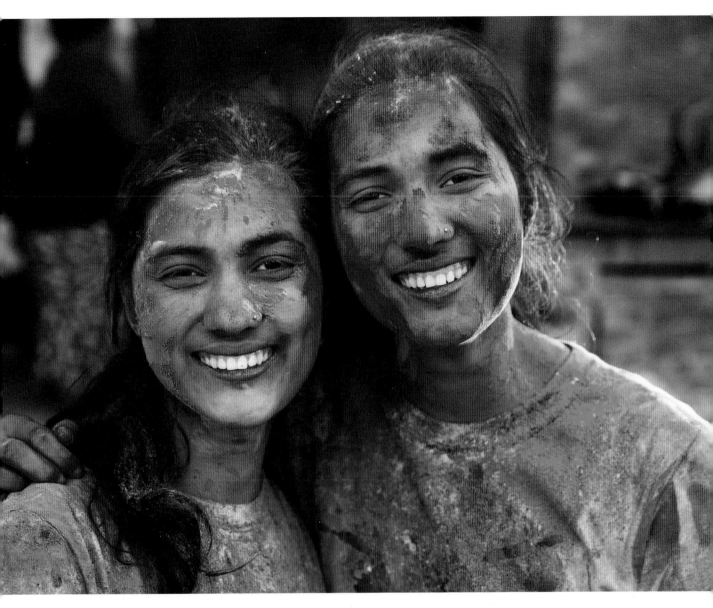

KATHMANDU, NEPAL

There's only one day per year when twins Brinda and Dipali look very different, and that's the day of Holi.

Holi is one of the biggest Hindu celebrations and one of the most visually spectacular festivals celebrated in the world. Here, it's considered to be the day when spring comes and good triumphs over evil and a moment to forgive and to be forgiven. People go out in the streets throwing colored pigments on one another and end up looking fantastically vibrant!

BRUSSELS, BELGIUM

Olimpia cooks both savory food and sweet treats, her favorite being muffins, especially with blueberries. Believe me, her muffins are delicious. She's the kind of cook who pays attention to every single detail, and it pays off!

SIBIU, ROMANIA

Andreea has lots of passions. She loves to write her own stories, draw manga, play the piano, and do crafts. She also loves biking, learning French, and caring for her cats! Here, she's sharing the notebooks in which she writes down her many ideas.

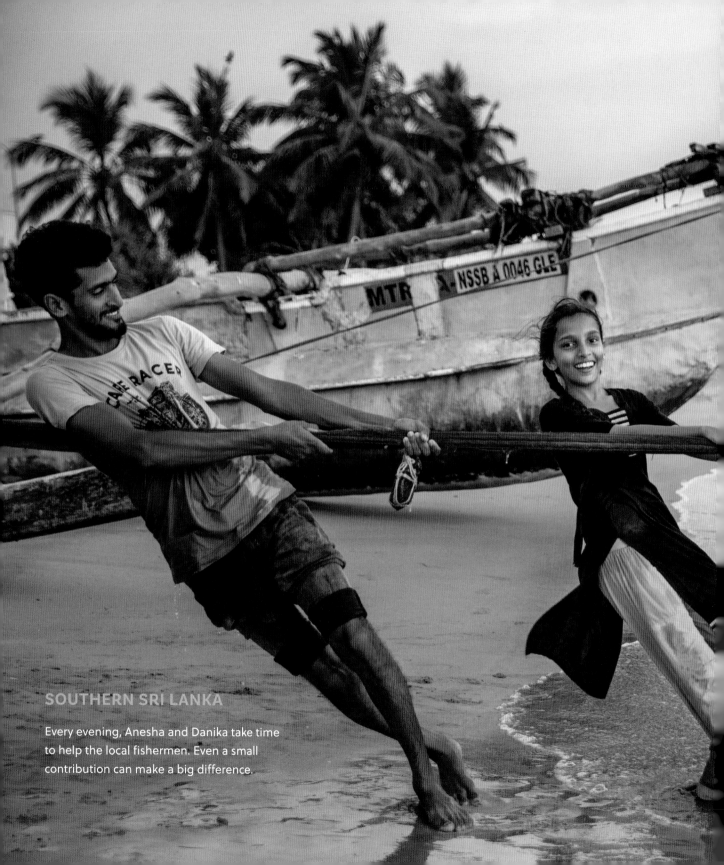

SOUTHERN SRI LANKA

Every evening, Anesha and Danika take time
to help the local fishermen. Even a small
contribution can make a big difference.

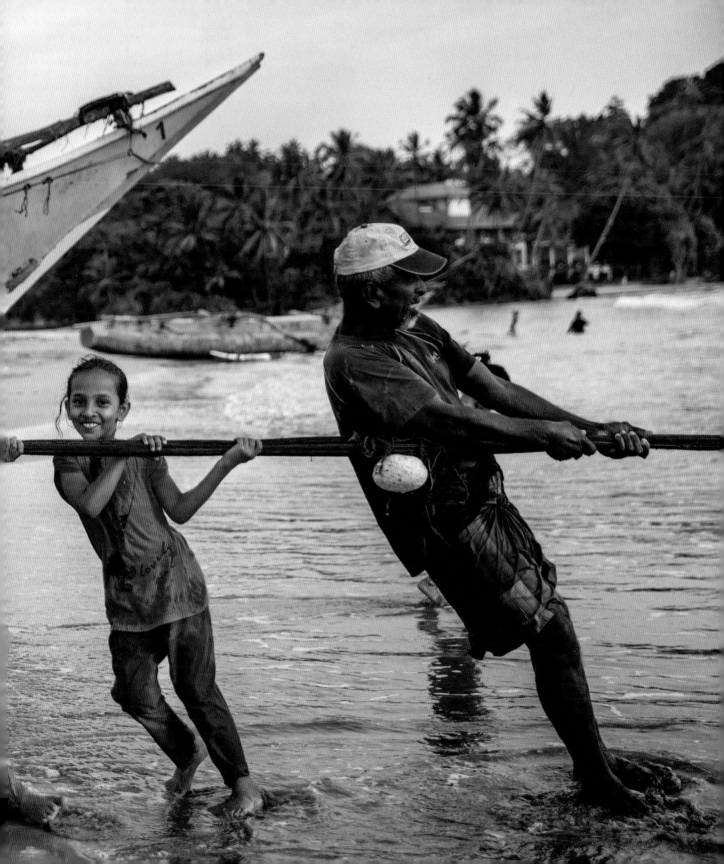

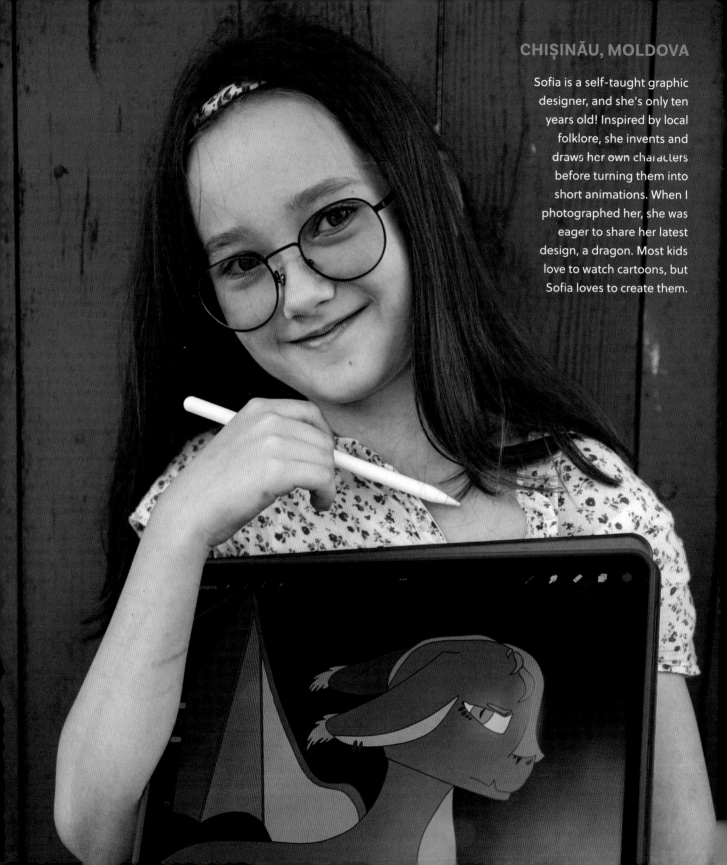

Sofia is a self-taught graphic designer, and she's only ten years old! Inspired by local folklore, she invents and draws her own characters before turning them into short animations. When I photographed her, she was eager to share her latest design, a dragon. Most kids love to watch cartoons, but Sofia loves to create them.

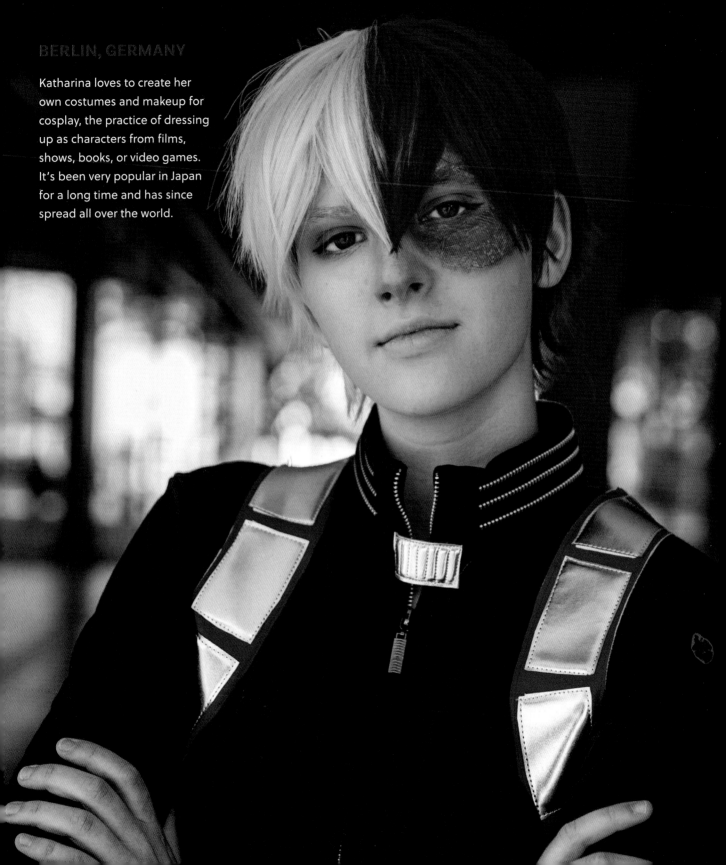

BERLIN, GERMANY

Katharina loves to create her
own costumes and makeup for
cosplay, the practice of dressing
up as characters from films,
shows, books, or video games.
It's been very popular in Japan
for a long time and has since
spread all over the world.

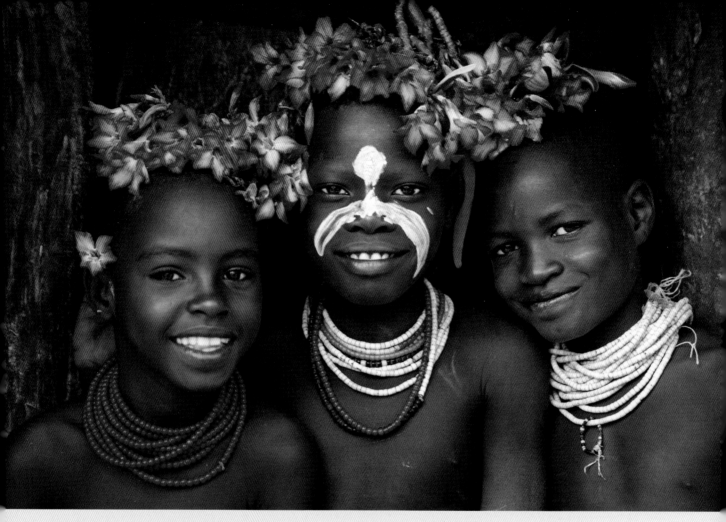

OMO VALLEY, ETHIOPIA

Before rituals and ceremonies, the Karo people decorate themselves by painting their skin and wearing splendid flowers. These three young friends were ready for a ceremonial dance when I met them. Sacred events are very important in their community, and they were excited to participate.

KATHMANDU, NEPAL

These girls are part of an ethnic group called the Gurung people, and they were celebrating New Year's Eve when I took this picture. Most cultures celebrate the New Year on different dates, with different traditions, and the Gurung tradition is called Tamu Lhosar.

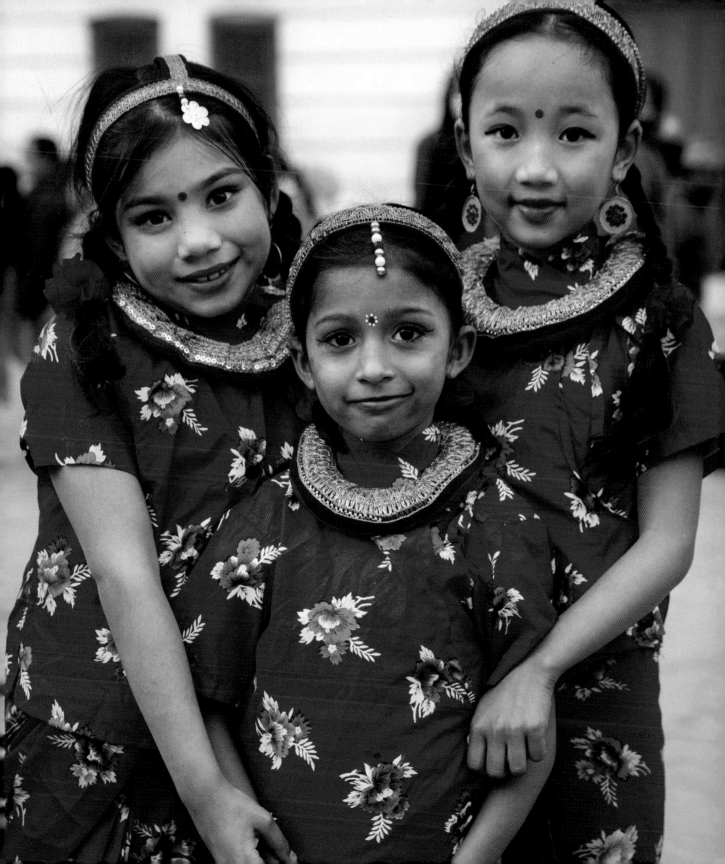

NORTHERN LAOS

Laos is a small nation in Southeast Asia, and the people here value friendliness and warm hospitality. Little Phueng and her family graciously invited me into their home when I met her in her Laotian village.

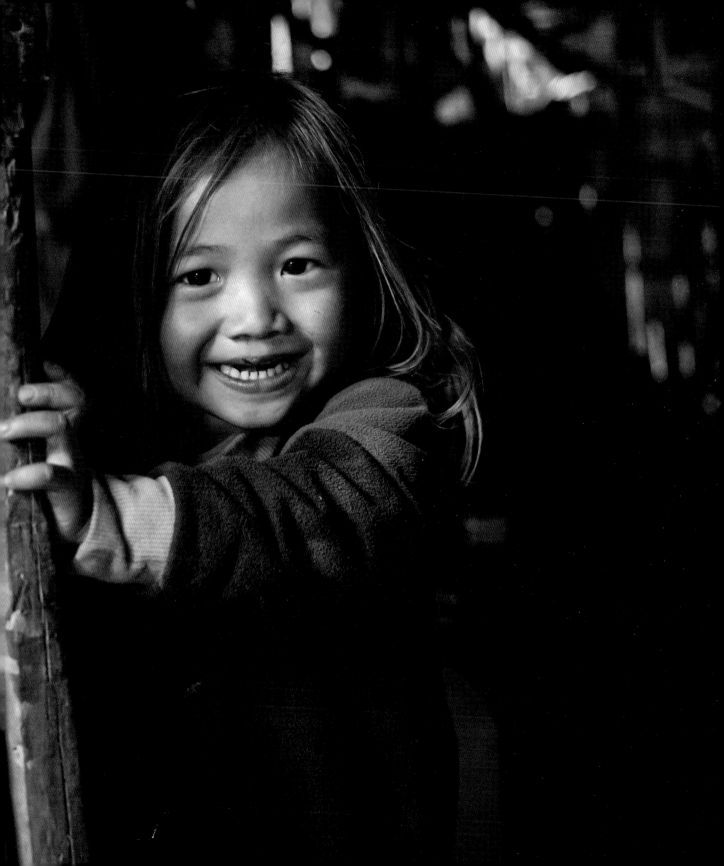

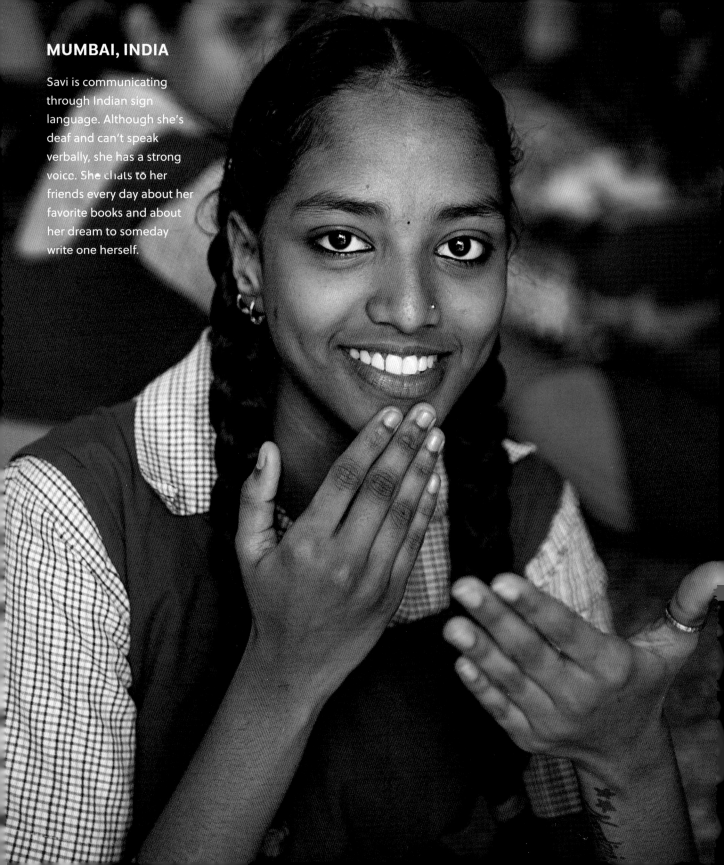

MUMBAI, INDIA

Savi is communicating through Indian sign language. Although she's deaf and can't speak verbally, she has a strong voice. She chats to her friends every day about her favorite books and about her dream to someday write one herself.

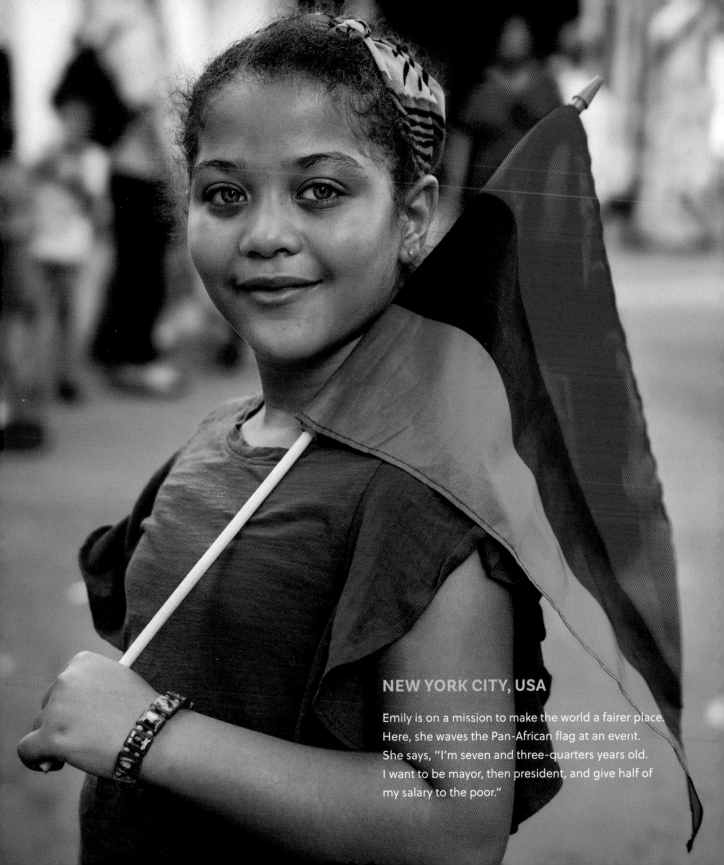

NEW YORK CITY, USA

Emily is on a mission to make the world a fairer place. Here, she waves the Pan-African flag at an event. She says, "I'm seven and three-quarters years old. I want to be mayor, then president, and give half of my salary to the poor."

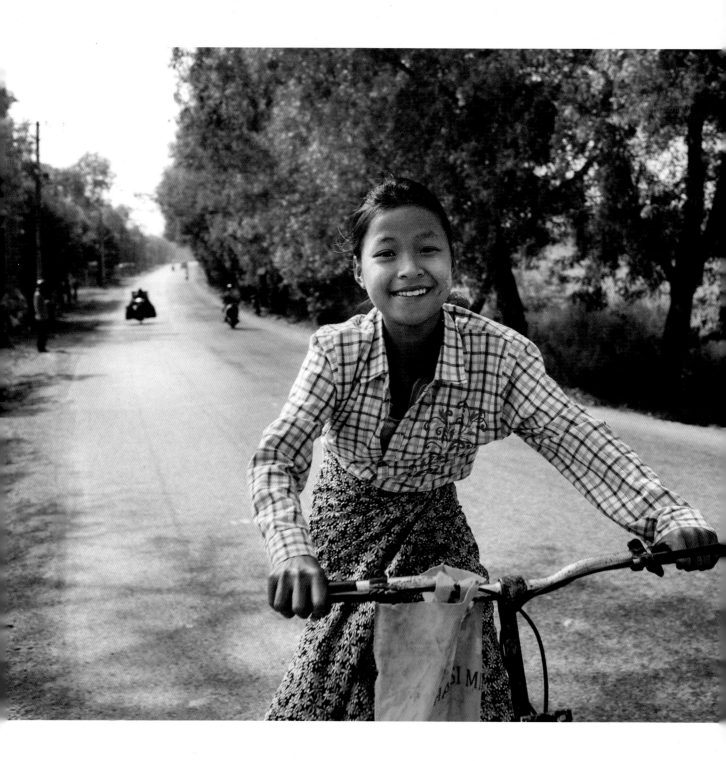

SOUTHERN MYANMAR

Thandar is going to the shop on her bike to buy some rice for her family. This village is a great place to ride a bike—there are just a few cars, and the weather is warm year-round.

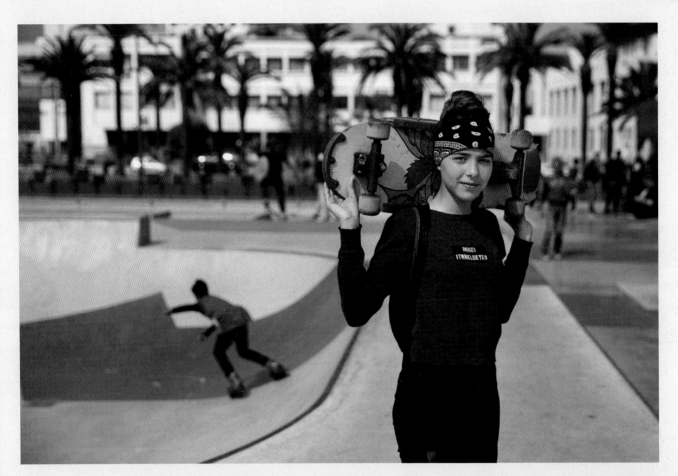

CASABLANCA, MOROCCO

Zara practices her skateboarding every day. She's not alone; skateboarding has become increasingly popular in Casablanca, Morocco's biggest city.

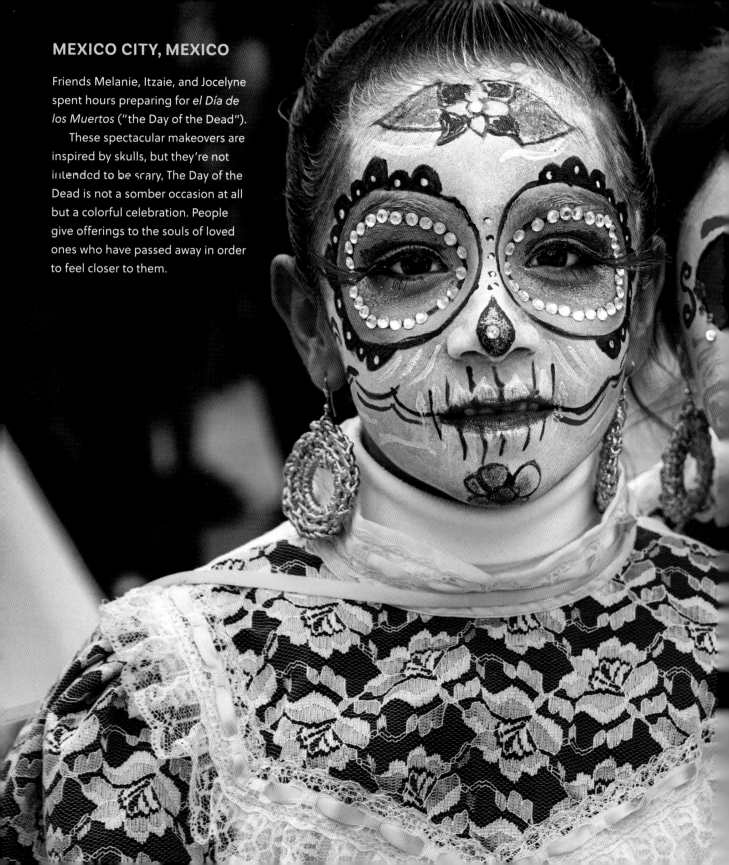

MEXICO CITY, MEXICO

Friends Melanie, Itzaie, and Jocelyne spent hours preparing for *el Día de los Muertos* ("the Day of the Dead").

These spectacular makeovers are inspired by skulls, but they're not intended to be scary. The Day of the Dead is not a somber occasion at all but a colorful celebration. People give offerings to the souls of loved ones who have passed away in order to feel closer to them.

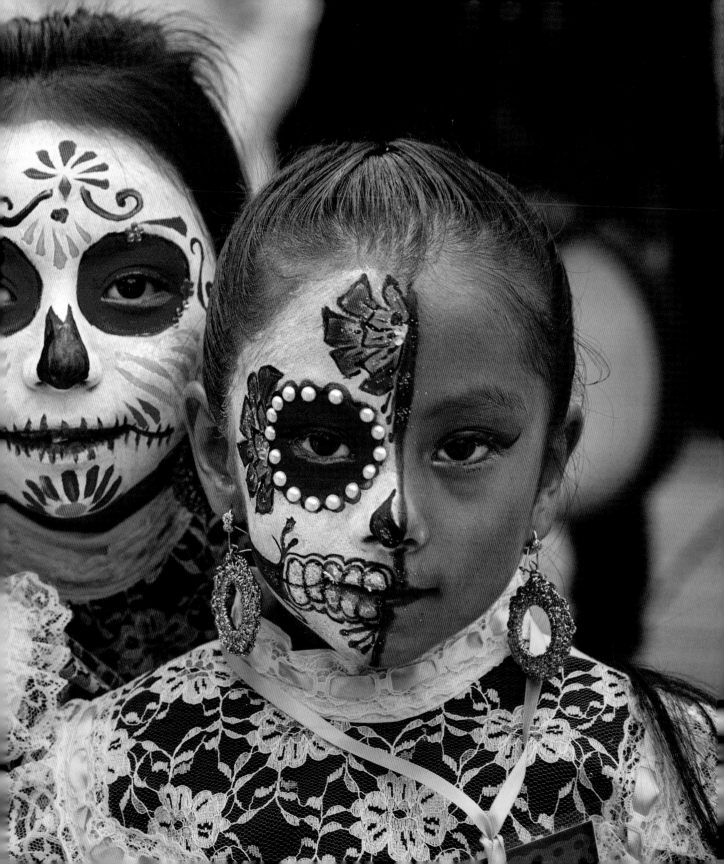

OMO VALLEY, ETHIOPIA

In this area, children don't play with manufactured toys; they create their own games using whatever they find around them. Reshni's home is surrounded by animals, so she always likes to play with them, too.

TEXAS, USA

Charlie is showing off her teddy bear that she won at a darts contest at the county fair.

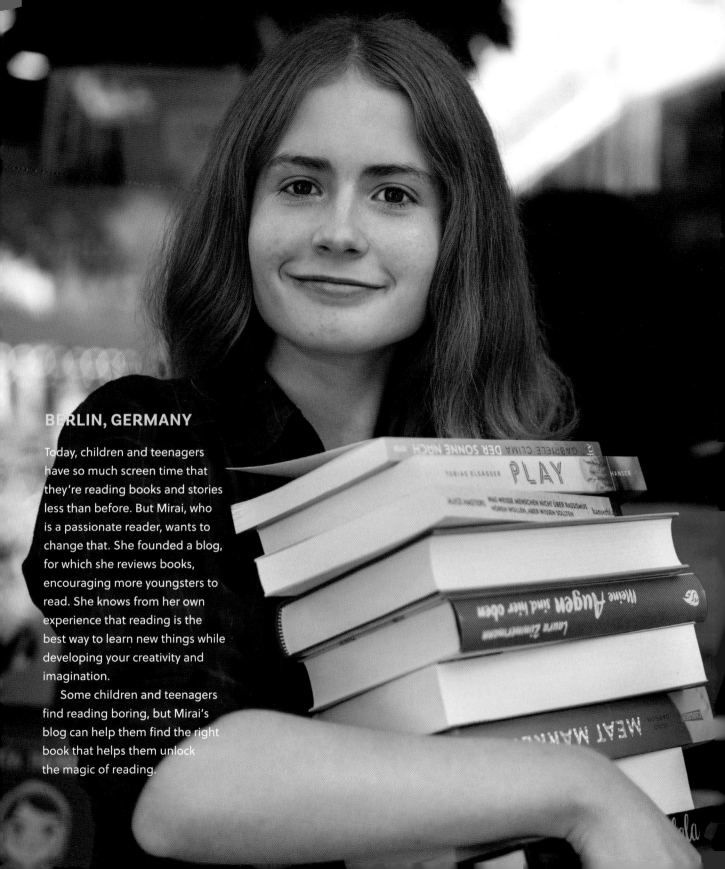

BERLIN, GERMANY

Today, children and teenagers have so much screen time that they're reading books and stories less than before. But Mirai, who is a passionate reader, wants to change that. She founded a blog, for which she reviews books, encouraging more youngsters to read. She knows from her own experience that reading is the best way to learn new things while developing your creativity and imagination.

Some children and teenagers find reading boring, but Mirai's blog can help them find the right book that helps them unlock the magic of reading.

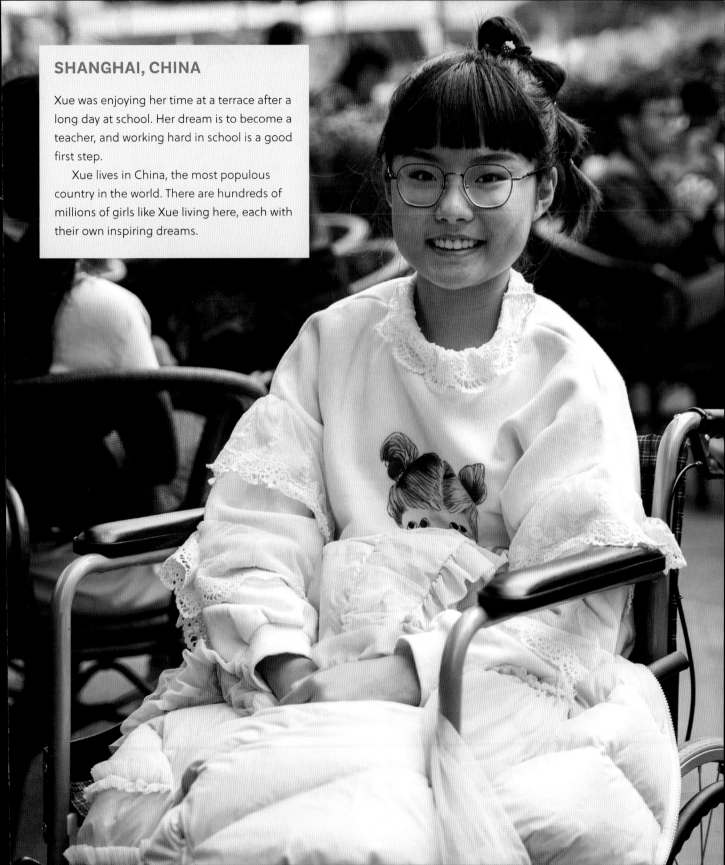

SHANGHAI, CHINA

Xue was enjoying her time at a terrace after a long day at school. Her dream is to become a teacher, and working hard in school is a good first step.

Xue lives in China, the most populous country in the world. There are hundreds of millions of girls like Xue living here, each with their own inspiring dreams.

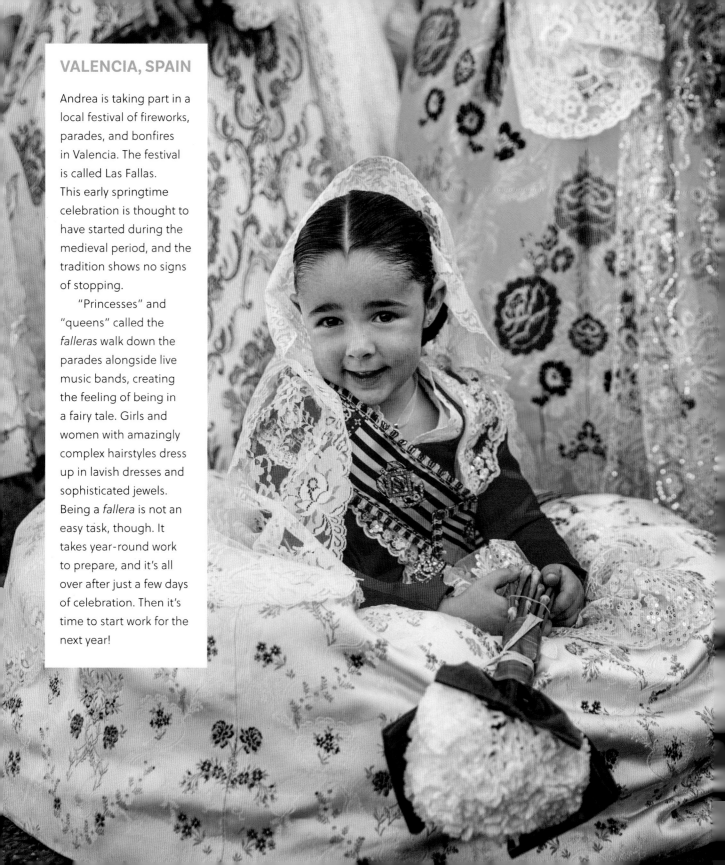

VALENCIA, SPAIN

Andrea is taking part in a local festival of fireworks, parades, and bonfires in Valencia. The festival is called Las Fallas. This early springtime celebration is thought to have started during the medieval period, and the tradition shows no signs of stopping.

"Princesses" and "queens" called the *falleras* walk down the parades alongside live music bands, creating the feeling of being in a fairy tale. Girls and women with amazingly complex hairstyles dress up in lavish dresses and sophisticated jewels. Being a *fallera* is not an easy task, though. It takes year-round work to prepare, and it's all over after just a few days of celebration. Then it's time to start work for the next year!

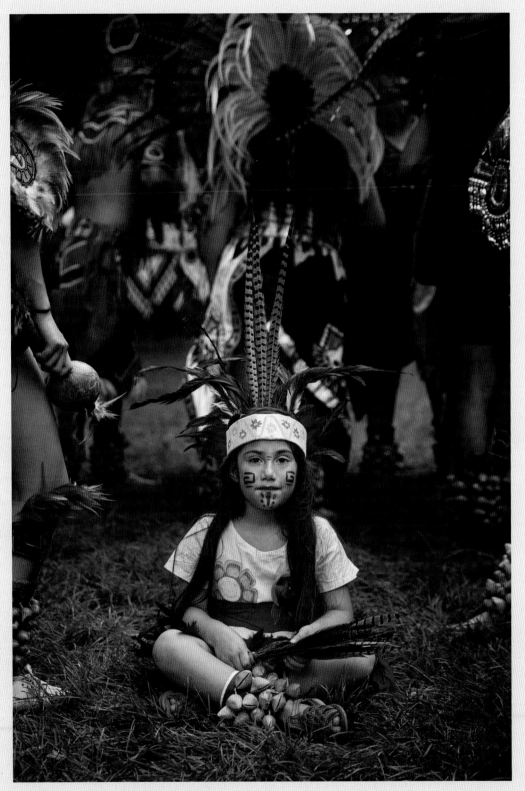

CHICAGO, USA

For specific festivals, Valentina sometimes dresses and dances like her ancestors, the Aztecs. Here, she rests after a performance, honored to celebrate her heritage.

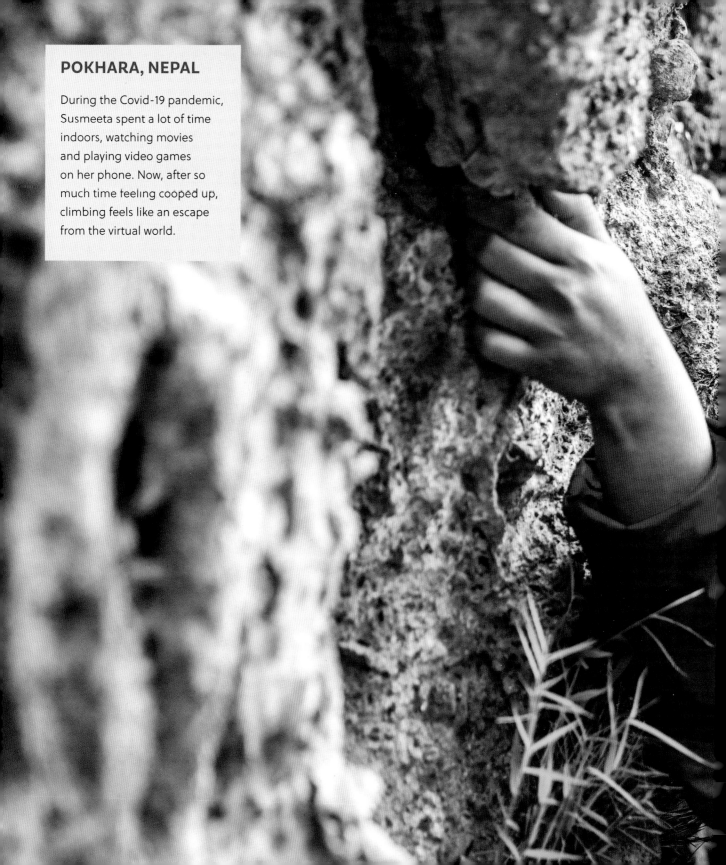

POKHARA, NEPAL

During the Covid-19 pandemic, Susmeeta spent a lot of time indoors, watching movies and playing video games on her phone. Now, after so much time feeling cooped up, climbing feels like an escape from the virtual world.

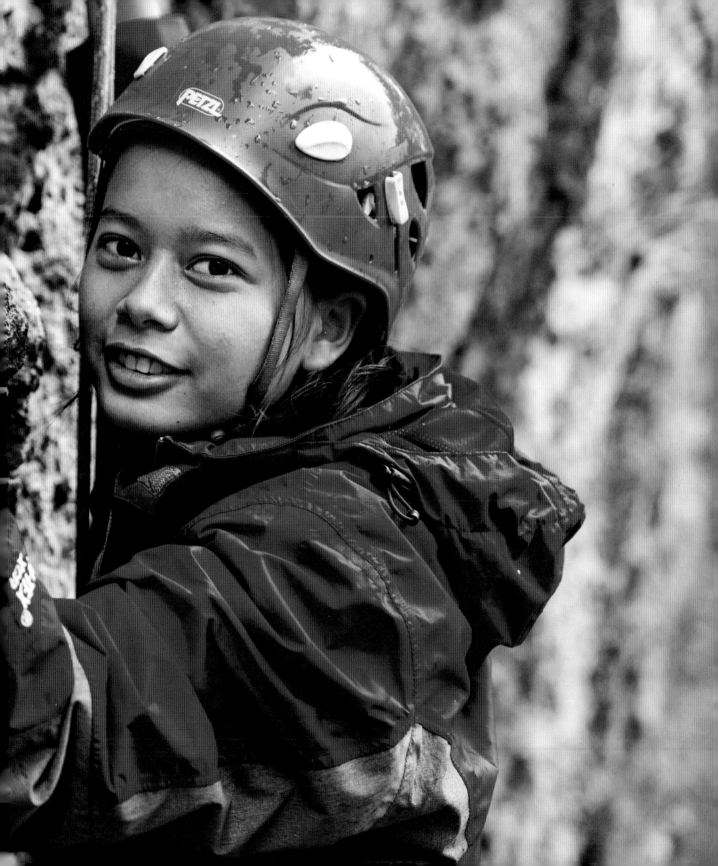

DUSHANBE, TAJIKISTAN

This is Anora, a fourteen-year-old living in Tajikistan. Her name means "pomegranate" in her language. Anora's parents decided to give her this beautiful name after seeing her birthmark. Anora never tries to hide her mark. On the contrary, she often wears scarves in the same color.

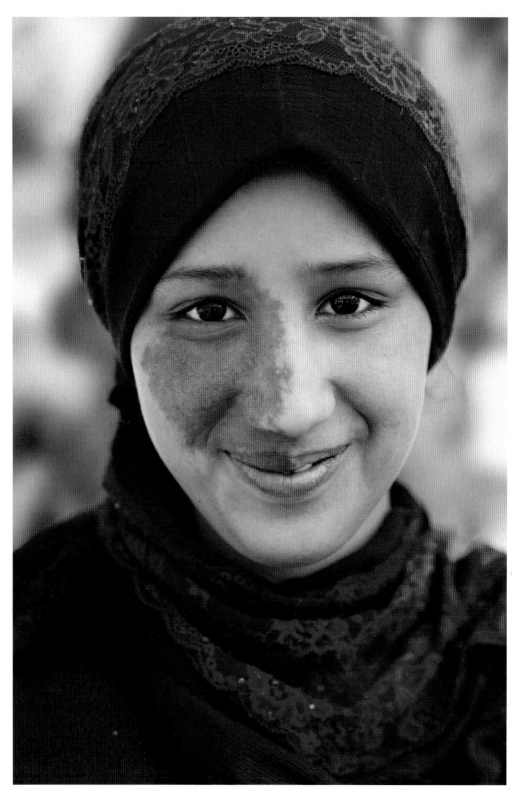

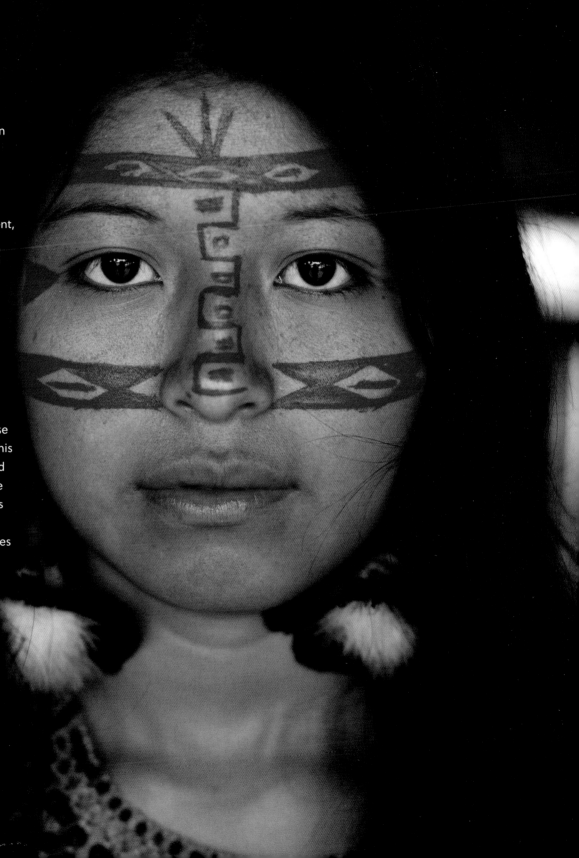

AMAZON RAINFOREST, ECUADOR

Sua is part of an ethnic group called Amazonian Kichwas. She lives in a hut with her family. No other families live for many miles around. In this isolated environment, Sua learned to be at one with nature. Her people have lived here for thousands of years, working with only what nature provides them. Sua's makeup, for example, is made from the pollen of a flower.

Amazonia is the most biologically diverse region on the planet. This huge rainforest situated in South America is one of the biggest treasures of our world, with over sixteen thousand species of trees counted so far. This remote place is also the home of many Indigenous groups of people.

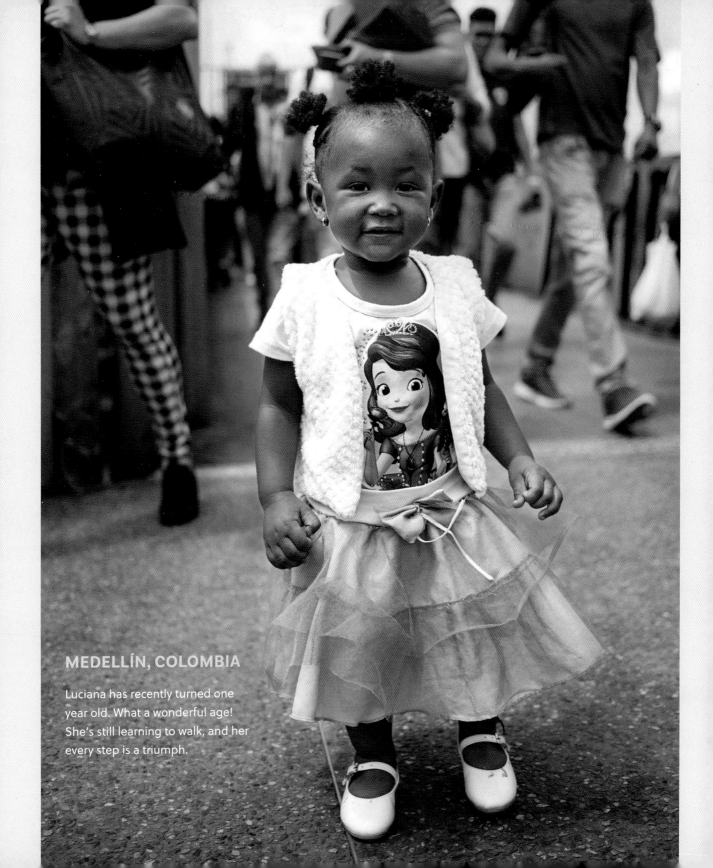

MEDELLÍN, COLOMBIA

Luciana has recently turned one
year old. What a wonderful age!
She's still learning to walk, and her
every step is a triumph.

TOKYO, JAPAN

On the other side of the world, Jeanne is the same age and celebrating the same triumphs, though she has earned herself some balloons for her efforts.

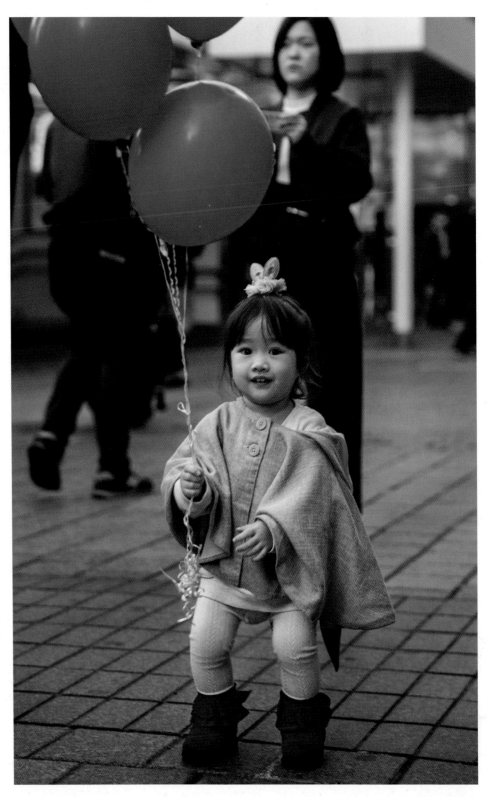

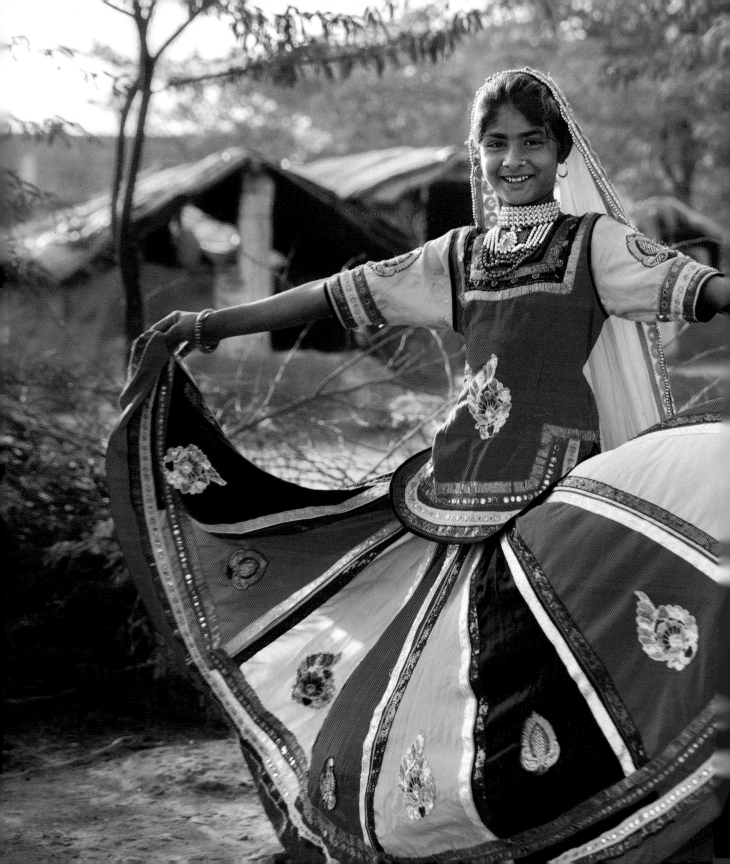

RAJASTHAN, INDIA

Indera is part of an ethnic group called the Kalbelia people. She's performing a dance that replicates the movements of a snake.

The lives of Indera's ancestors revolved around snakes, and the tribe was known for snake charming. They used to catch and raise snakes in the Thar Desert and trade their venom.

To this day, Kalbelias still have a deep connection with serpents, expressed through their traditional dances and costumes, which are designed to look like cobras. They are often brought to celebrations to perform their snake-inspired dances.

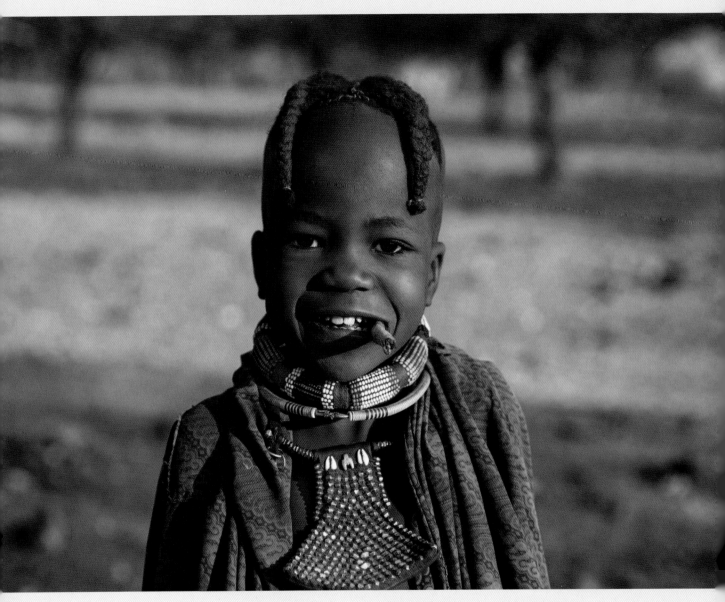

NORTHERN NAMIBIA

Kaverjata, a Himba girl, is cleaning her teeth with a twig. In many rural areas of the world, where people don't have access to manufactured toothbrushes, they use twigs or other natural alternatives. The twig's sap also works as a natural toothpaste.

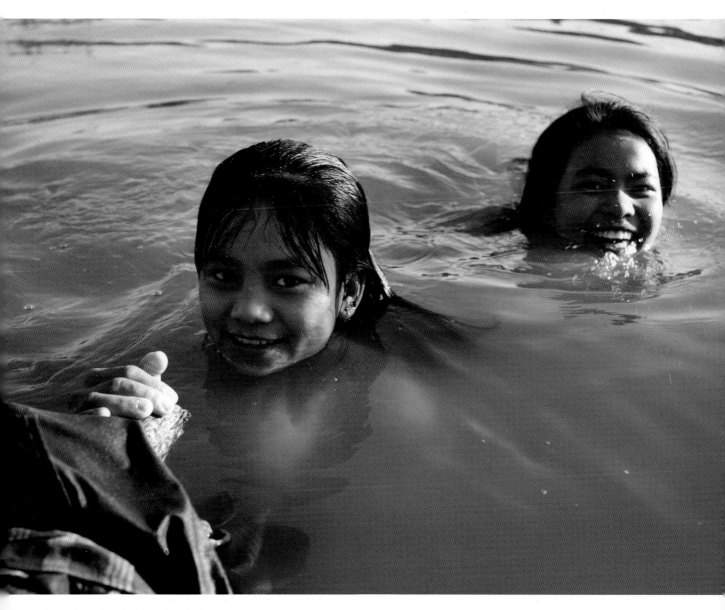

CENTRAL MYANMAR

People in this area don't have access to running water in their homes, so Soe and Thida come often to this lake to wash themselves, having fun in the process.

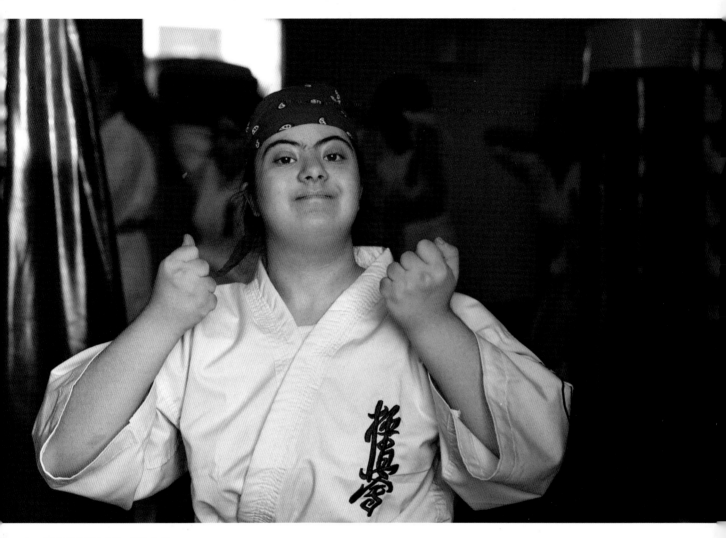

BAGHDAD, IRAQ

Manar was born with Down syndrome, which doesn't stop her from fulfilling her dreams.

Since she was little, she's loved Asian martial arts movies and wanted to practice karate. Unfortunately, there were no such classes for girls in Iraq. Now, there's a class available, and Manar can finally follow her passion with excitement, strength, and determination.

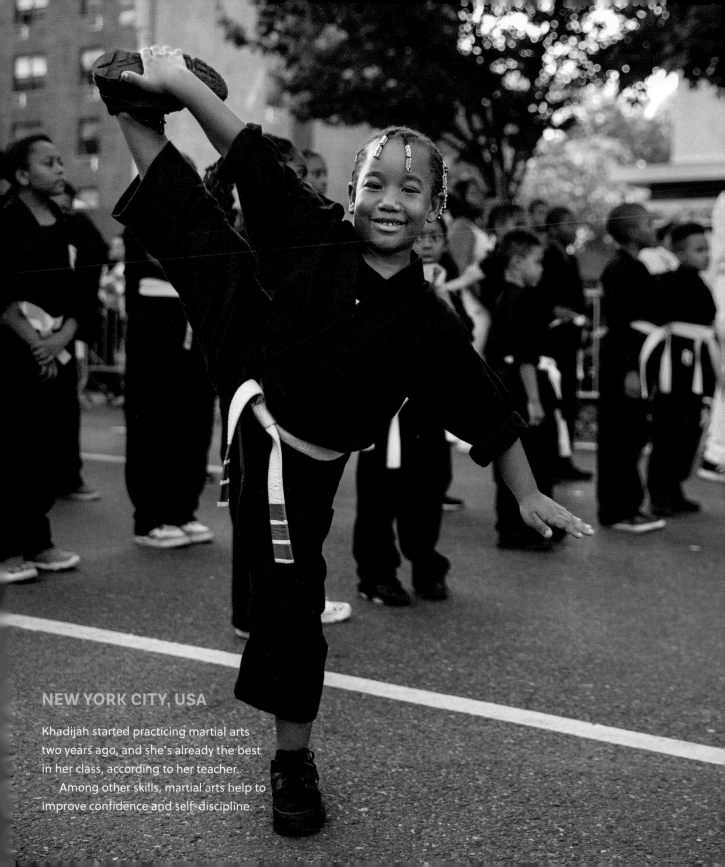

NEW YORK CITY, USA

Khadijah started practicing martial arts
two years ago, and she's already the best
in her class, according to her teacher.

Among other skills, martial arts help to
improve confidence and self-discipline.

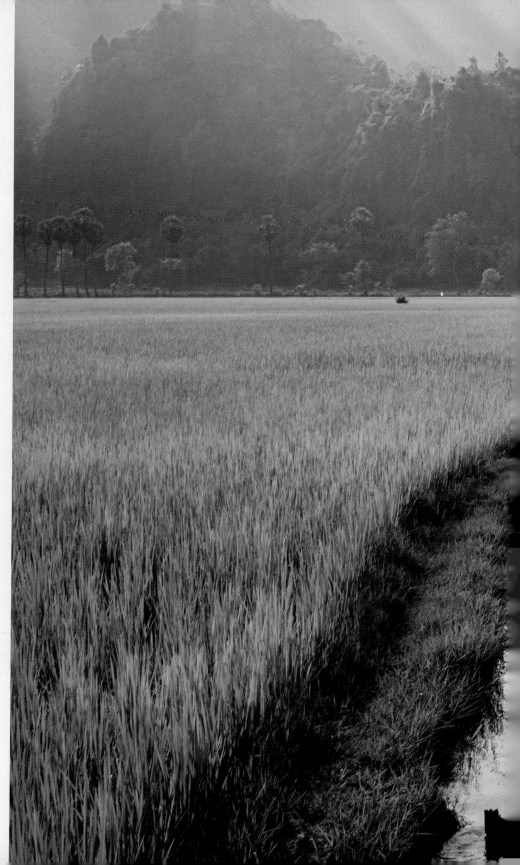

SUMATRA, INDONESIA

Indonesia is a country in Southeast Asia surrounded by seas and oceans. It consists of about 17,500 islands situated on both sides of the equator.

Setia, who lives on the country's biggest island, navigates through rice fields every day, helping her parents. Her family members, like most locals, cultivate rice, the most commonly eaten food staple in the world.

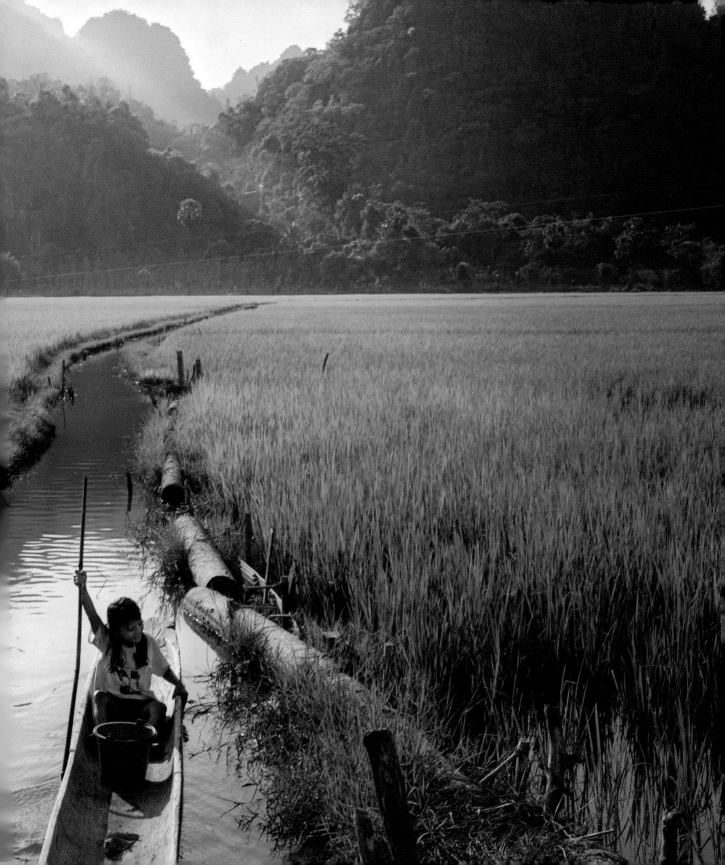

PYONGYANG, NORTH KOREA

During special events and celebrations, Korean girls and women often wear a spectacular traditional outfit, like this beautiful hanbok here. Liu Y is from North Korea, but you'll find hanboks in South Korea, too.

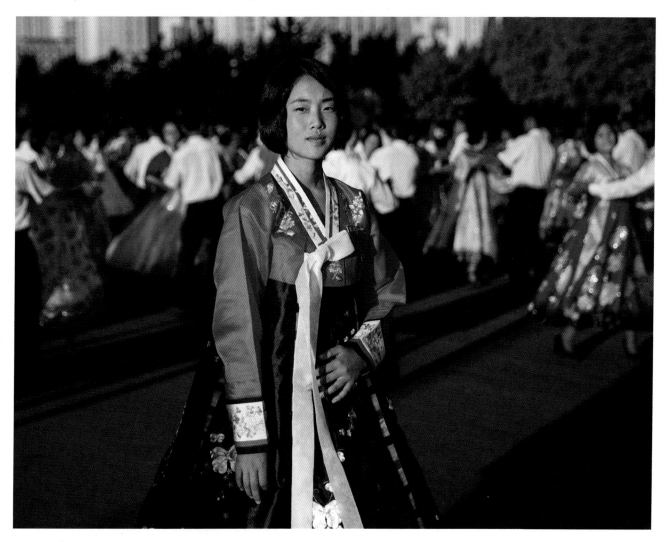

COLCA VALLEY, PERU

Up here, at almost 4,000 meters (about 13,000 feet) above sea level, the climate is harsh. The everyday clothing that the locals wear is not only warm and protective but also incredibly sophisticated and colorful. It takes a tremendous amount of work to produce, though; Carla's outfit took months to make, but she will wear it throughout her whole life. People here don't have many clothes, because they cherish quality over quantity.

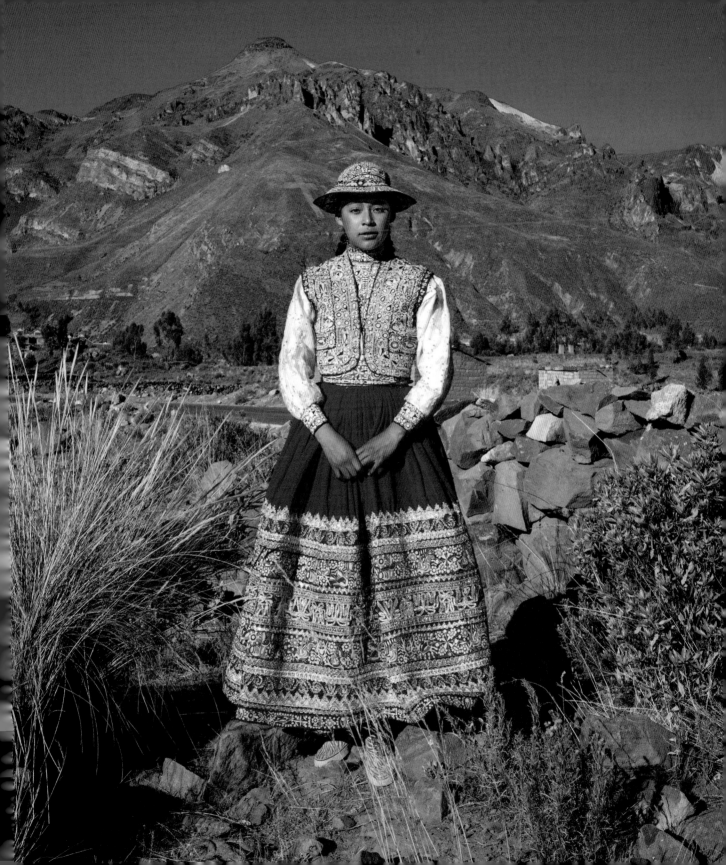

MILAN, ITALY

Like a modern knight, Rüya loves fencing. She started a few years ago;
since then, this sport has taught her patience, strategy, and confidence.

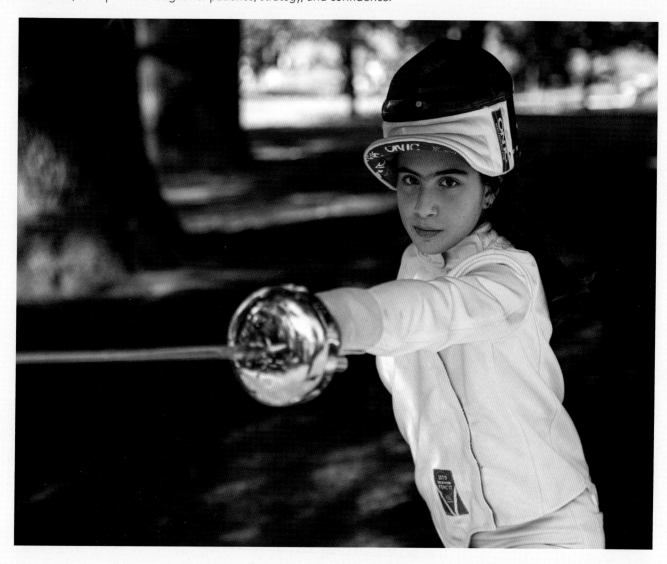

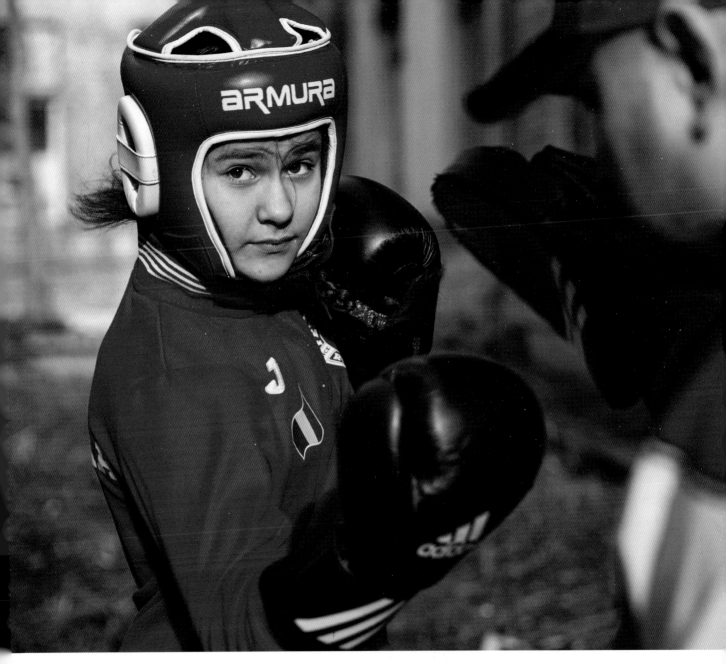

IAȘI, ROMANIA

Ana Maria's father is a boxing instructor, and, until recently, all his pupils were boys. When I asked why this was, I was told that, historically, this used to be a male sport, and to this day there are still many misconceptions regarding girls practicing boxing. But, despite all of this, one day, Ana Maria came to her father and said she wanted to try it out, too.

She immediately loved boxing so much that she started to train very seriously and soon began to win major competitions. Outside the ring, Ana Maria is rather shy, and many opponents underestimate her. That only gives her the power to prove them wrong.

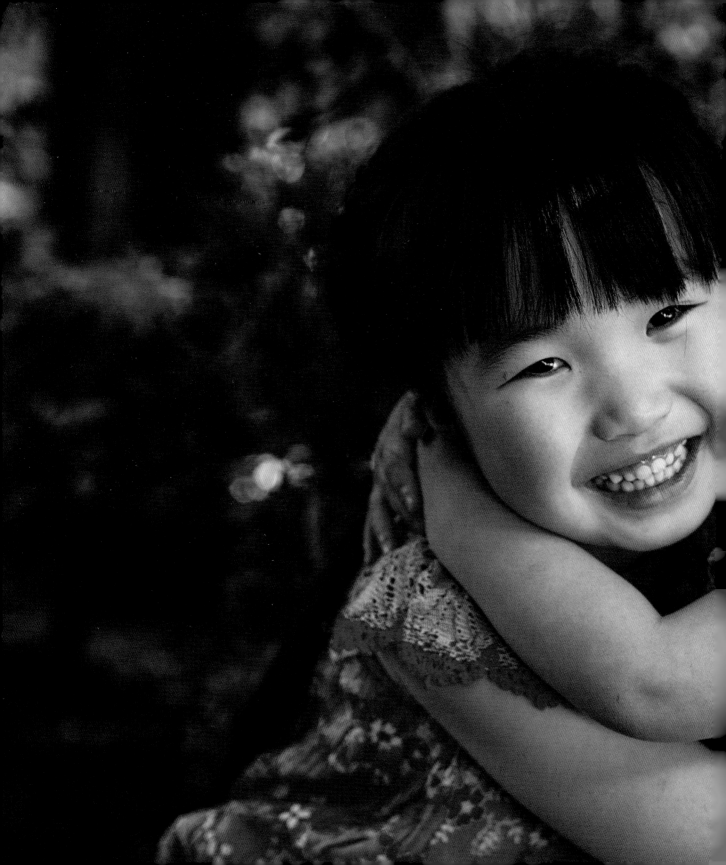

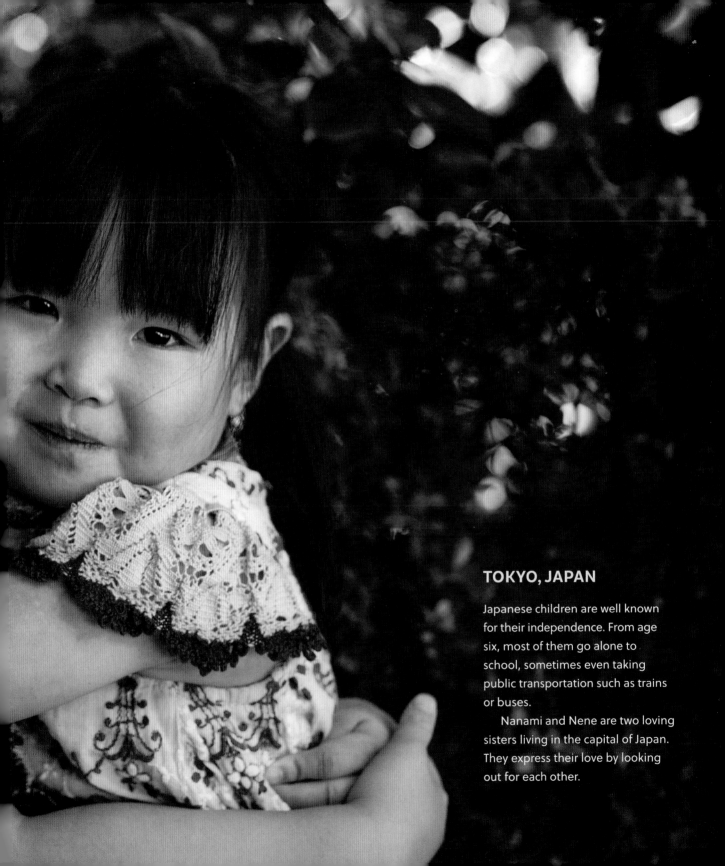

TOKYO, JAPAN

Japanese children are well known for their independence. From age six, most of them go alone to school, sometimes even taking public transportation such as trains or buses.

Nanami and Nene are two loving sisters living in the capital of Japan. They express their love by looking out for each other.

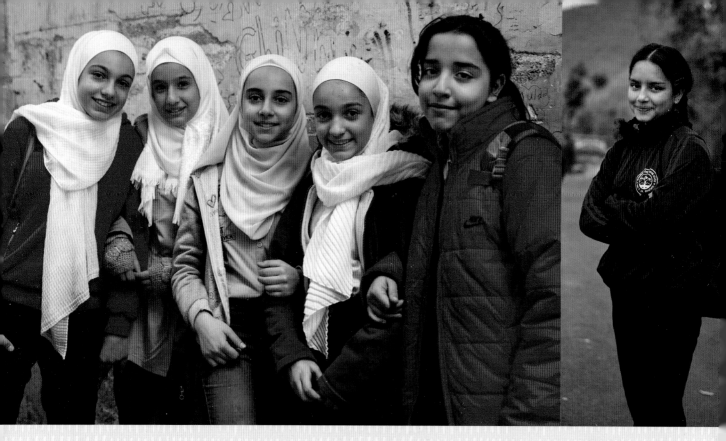

BE KNOWLEDGEABLE

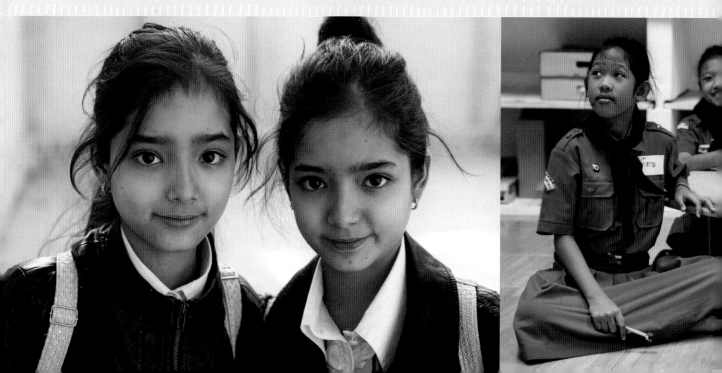

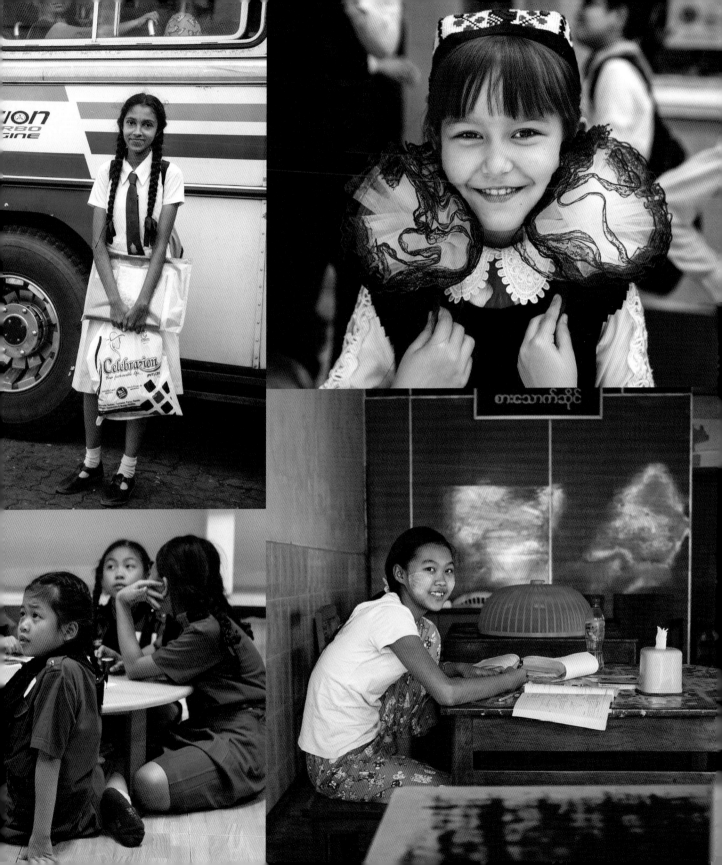

BE KNOWLEDGEABLE

I realized when I was traveling around the world that knowledge is one of the most precious gifts any of us can possess. It can be easy to take knowledge for granted, too. But the more girls and women I meet, the more I see how it's knowledge that gives them power and freedom.

For most of recorded history, across the world's cultures, girls and women have been left out of organized education. But, these days, more girls and women than ever have access to education. We all owe a debt of gratitude to the people who fought for these rights that we now enjoy and should recognize those who are still fighting.

I am also struck by the fact that we live in an age in which we are exposed daily to thousands and thousands of pieces of content. We read fewer books but more information than ever. It sometimes feels overwhelming when you're trying to cope.

It got me thinking: Does our consumption of all this mass media content give us more knowledge? I believe that real knowledge mostly comes from books, education, experts, and thoughtful discussions. It requires interaction with people, whether they are educating us, studying with us, or simply a conversation partner. The internet is also a precious tool for education, as long as we find valuable sources.

So, perhaps we need to think about quality rather than quantity.

You can be more into sports or arts, science, crafts, or languages. Maybe you're an ideas person, or a project manager, or a perfectionist, or none of those things. Knowledge will help you, no matter your path. Education teaches you to distinguish between good and bad, between truth and lies.

From what I've seen, I can honestly say: education is the biggest force to change all of our lives, and to change the world, for the better.

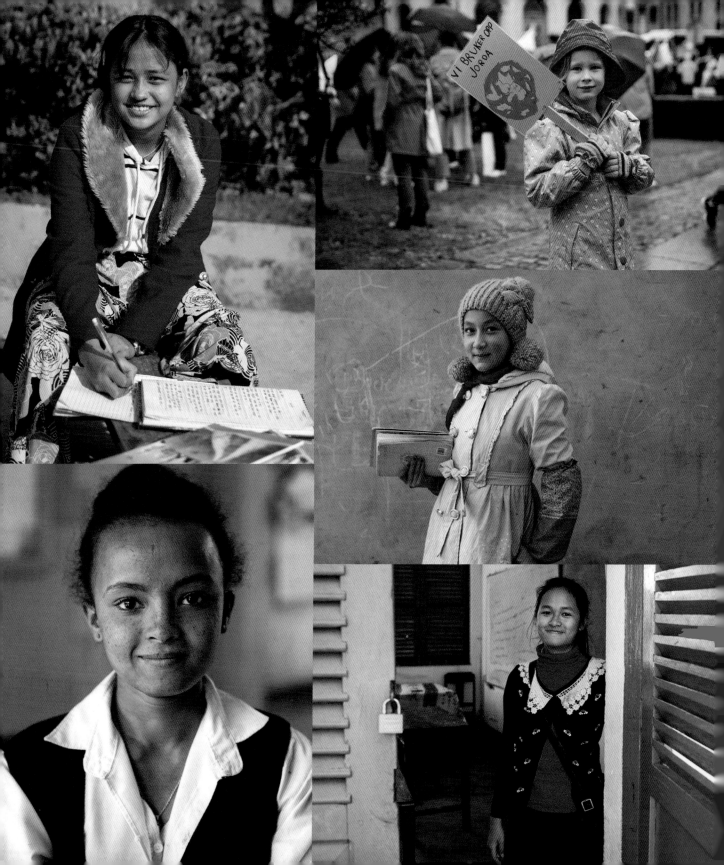

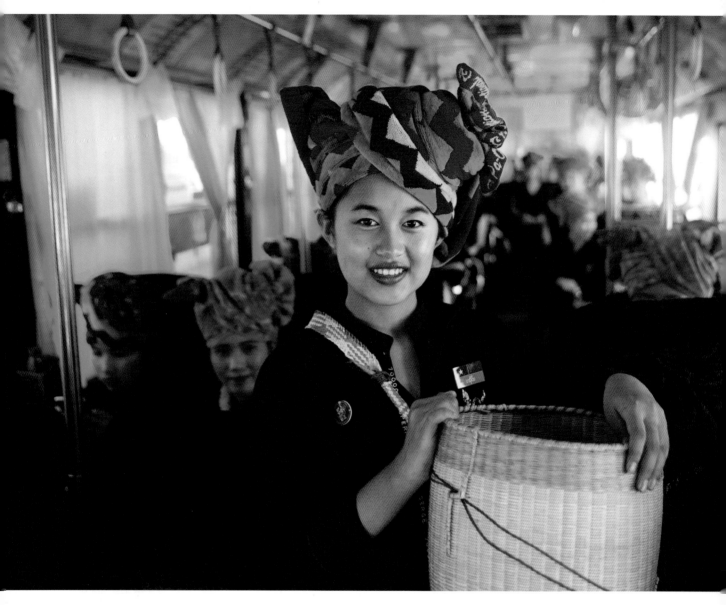

YANGON, MYANMAR

Upen is a member of a traditional performance ensemble. She was in a bus
with her colleagues, preparing to leave after a show, when I photographed
her. Although she loves to be onstage celebrating her community's
traditions, her biggest dream is to become a doctor. She told me that her
remote village doesn't have a doctor yet, but she would love to change this.

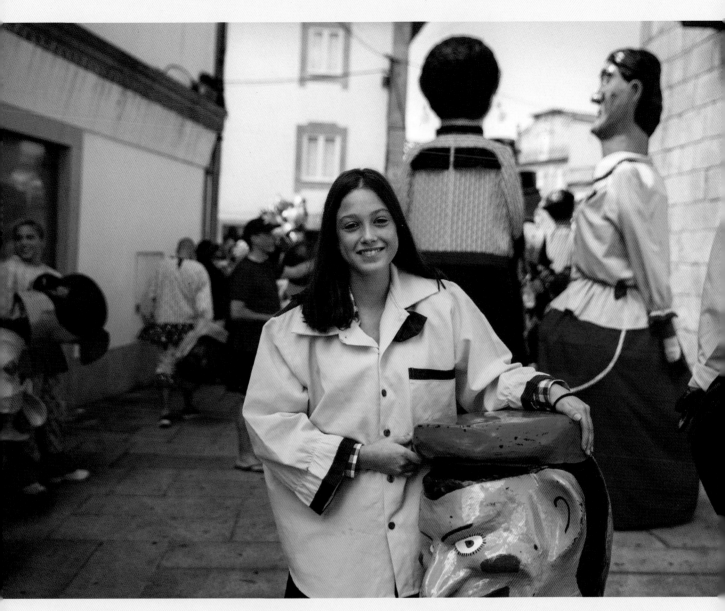

VIANA DO CASTELO, PORTUGAL

Every year, Ines dresses up as a processional giant, called *gigantone*,
for a festival. She and the other giants parade around their city.
It takes a lot of skills, and she's doing an awesome job. This vibrant
parade goes back nearly one thousand years in local history.

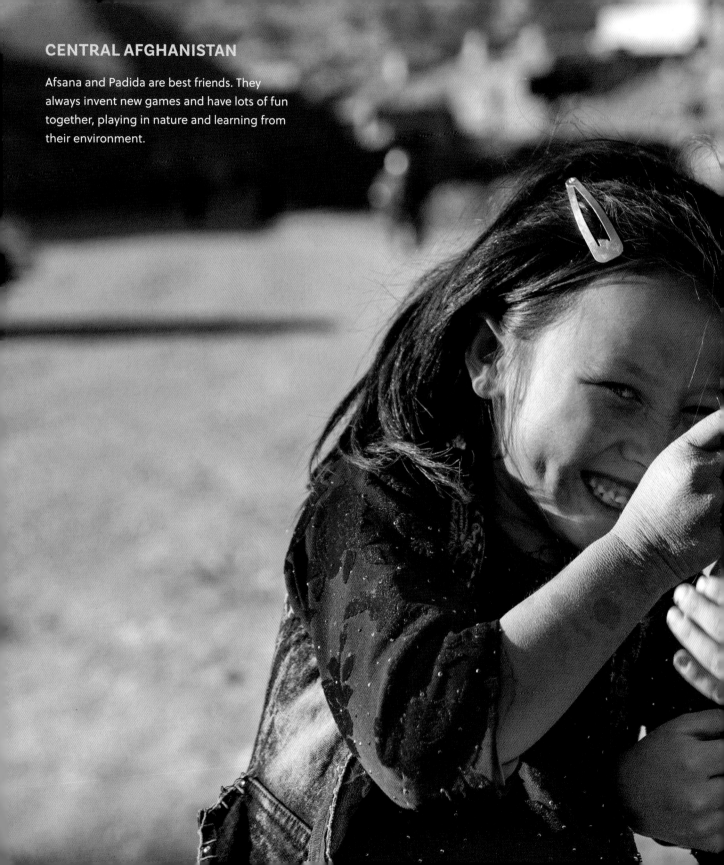

CENTRAL AFGHANISTAN

Afsana and Padida are best friends. They always invent new games and have lots of fun together, playing in nature and learning from their environment.

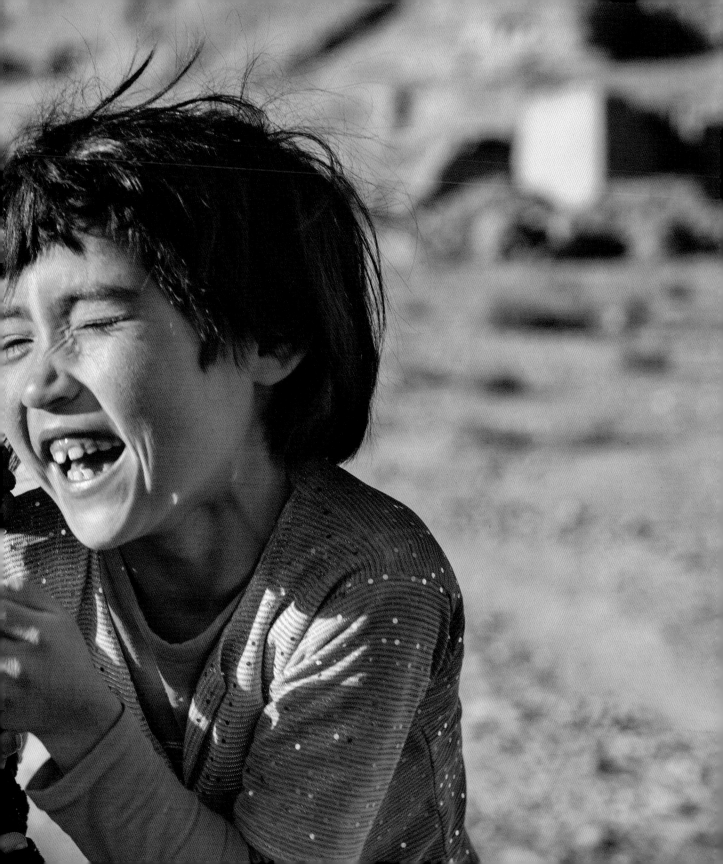

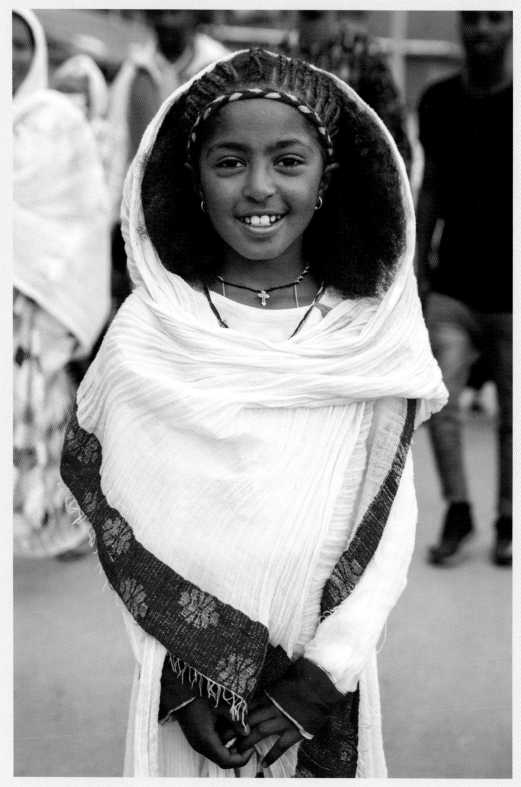

ADDIS ABABA, ETHIOPIA

I noticed Eldana when she was coming out of church during the Assumption of Mary, a major Christian celebration. All the women and girls in church were covering their heads and wearing habesha kemis, traditional Ethiopian attire. These long dresses are made from a thin, white fabric called shema, which is handwoven from cotton and keeps the body cool in this hot climate.

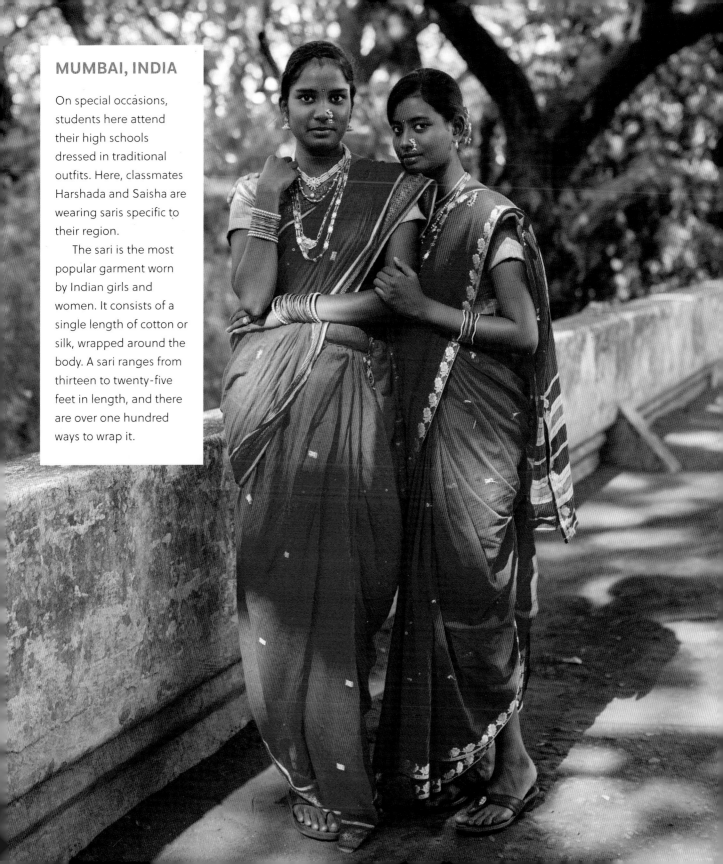

MUMBAI, INDIA

On special occasions, students here attend their high schools dressed in traditional outfits. Here, classmates Harshada and Saisha are wearing saris specific to their region.

The sari is the most popular garment worn by Indian girls and women. It consists of a single length of cotton or silk, wrapped around the body. A sari ranges from thirteen to twenty-five feet in length, and there are over one hundred ways to wrap it.

DUSHANBE, TAJIKISTAN

Maftuna, Munisa, and Mariam play elastics during a break at school.
Elastics, also known as Chinese jump rope, is a game in which two players
hold an elastic rope taut while a third player moves to make figures in the
middle. It's both fun and challenging, only getting harder as it goes.

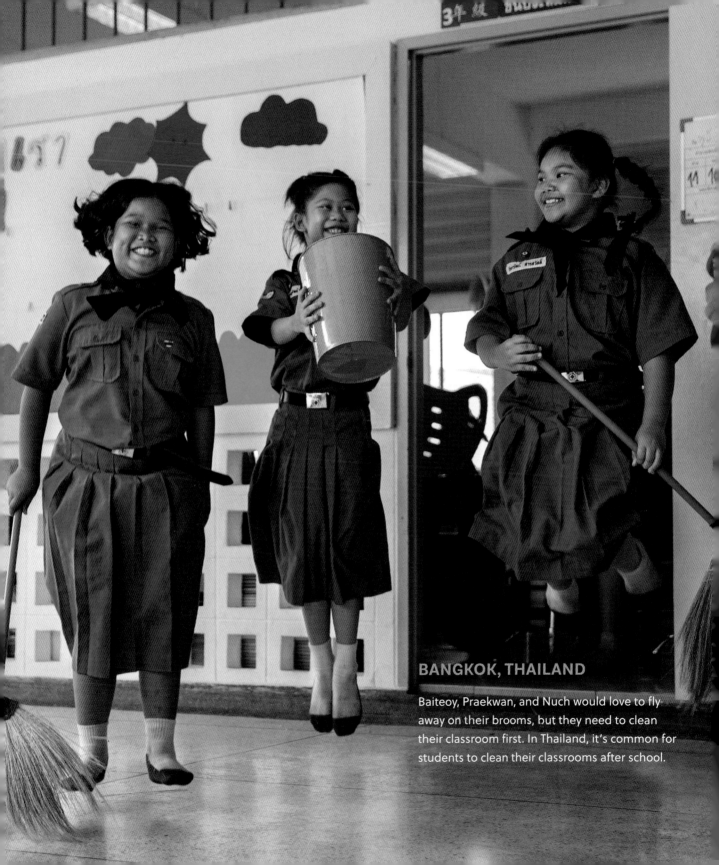

BANGKOK, THAILAND

Baiteoy, Praekwan, and Nuch would love to fly away on their brooms, but they need to clean their classroom first. In Thailand, it's common for students to clean their classrooms after school.

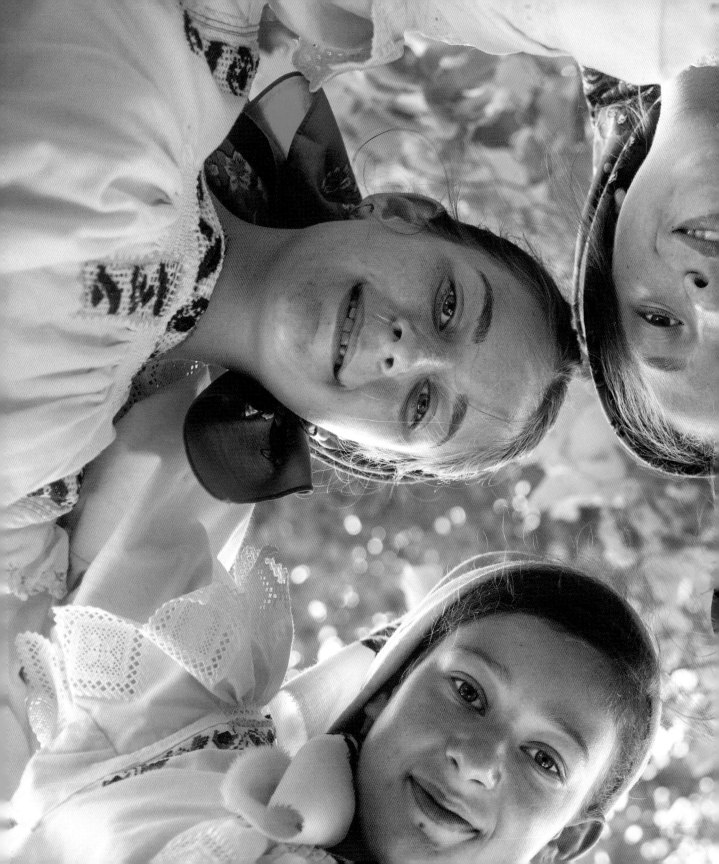

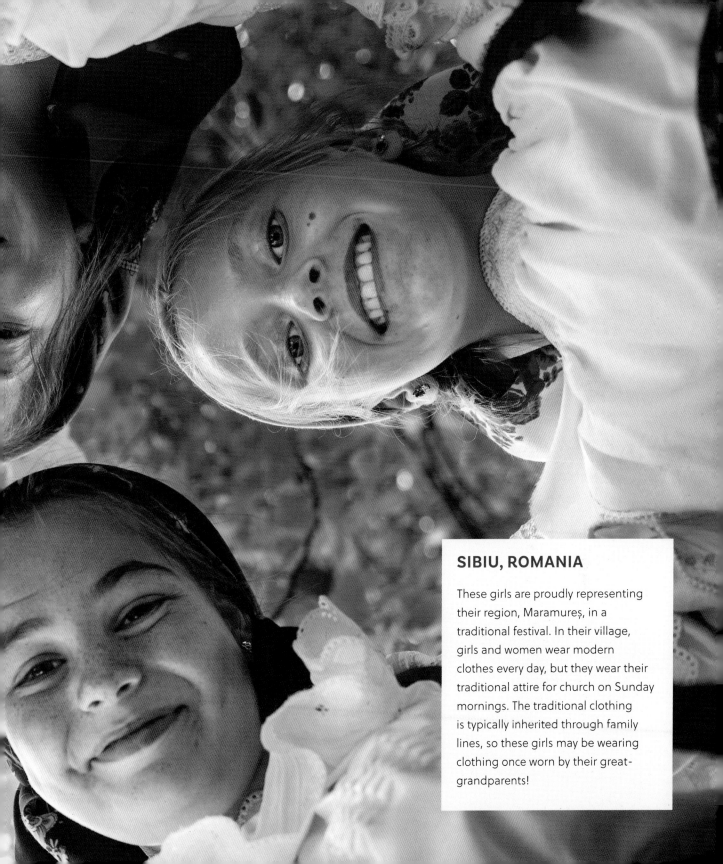

SIBIU, ROMANIA

These girls are proudly representing their region, Maramureș, in a traditional festival. In their village, girls and women wear modern clothes every day, but they wear their traditional attire for church on Sunday mornings. The traditional clothing is typically inherited through family lines, so these girls may be wearing clothing once worn by their great-grandparents!

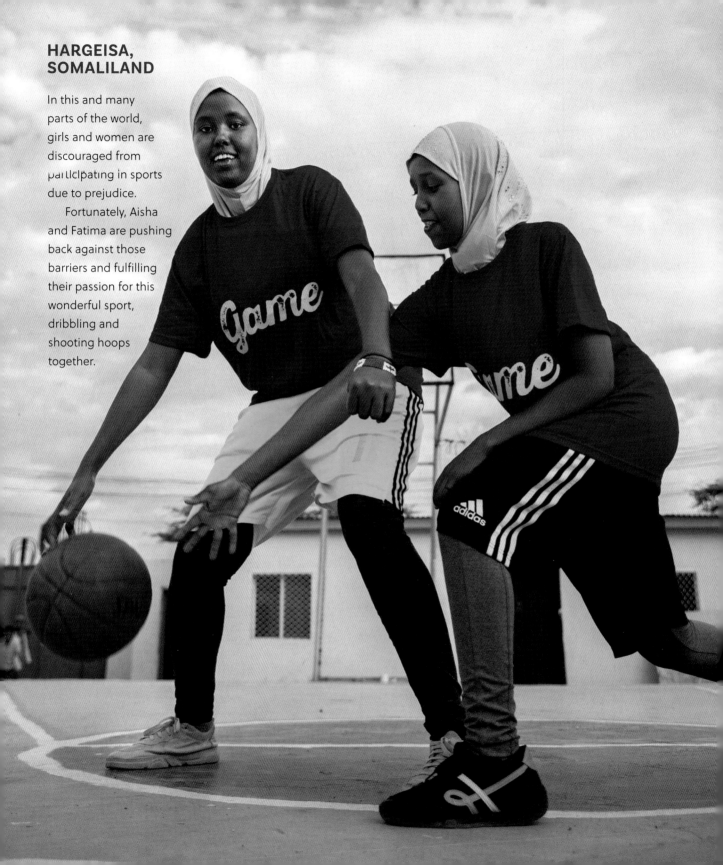

HARGEISA, SOMALILAND

In this and many parts of the world, girls and women are discouraged from participating in sports due to prejudice.

Fortunately, Aisha and Fatima are pushing back against those barriers and fulfilling their passion for this wonderful sport, dribbling and shooting hoops together.

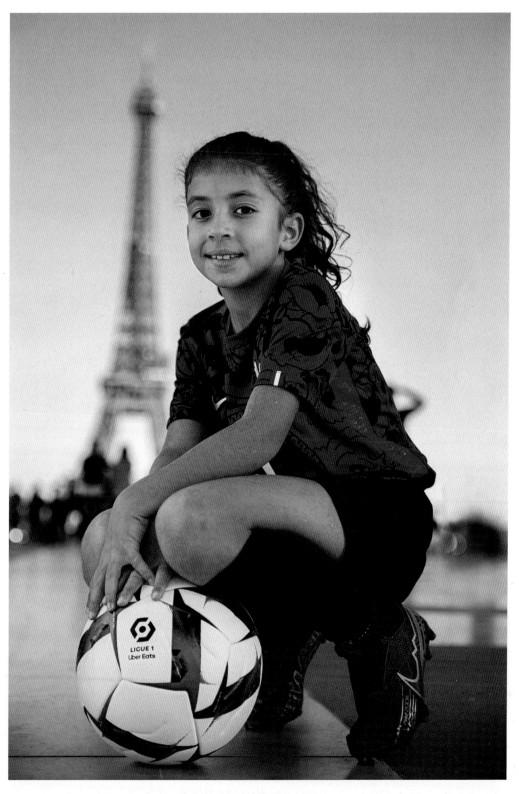

PARIS, FRANCE

These prejudices have a similar impact on women's soccer, which is often valued less than men's. But Tess, too, is doing away with those misconceptions. She started soccer three years ago, and she's incredibly passionate. One of the best soccer teams in the world, Paris Saint-Germain (PSG), plays in her city, and she watches them every time they play at home. Someday, she will play on that same field as a champion!

CHICAGO, USA

Amy is celebrating her
Aztec heritage during
a festival dedicated to
Native Americans. The
Aztec Empire reigned
for hundreds of years in
what is now modern-day
Mexico before Spanish
rule. The Aztec civilization
was celebrated for its
architectural and artistic
accomplishments.

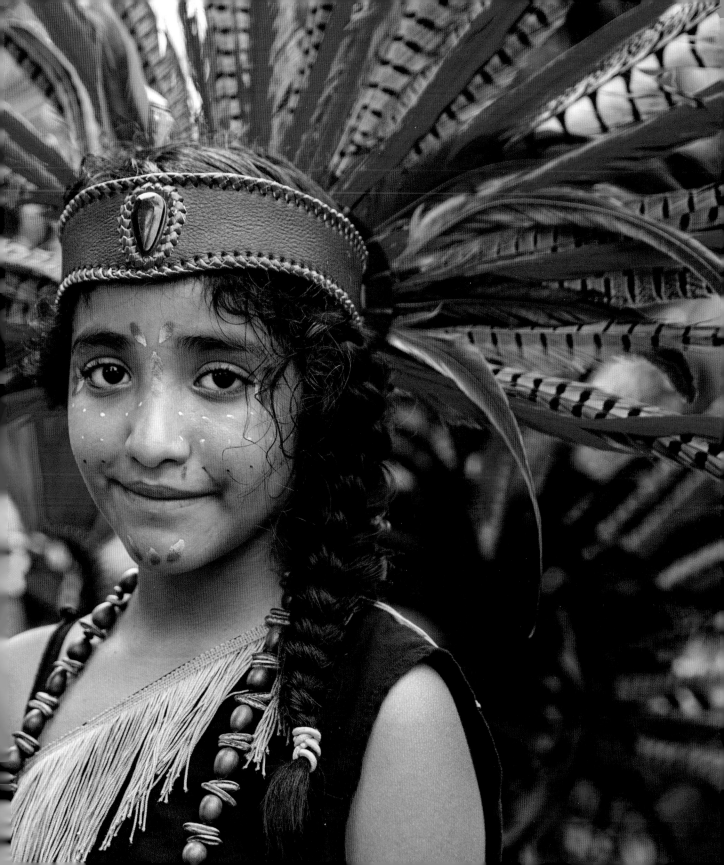

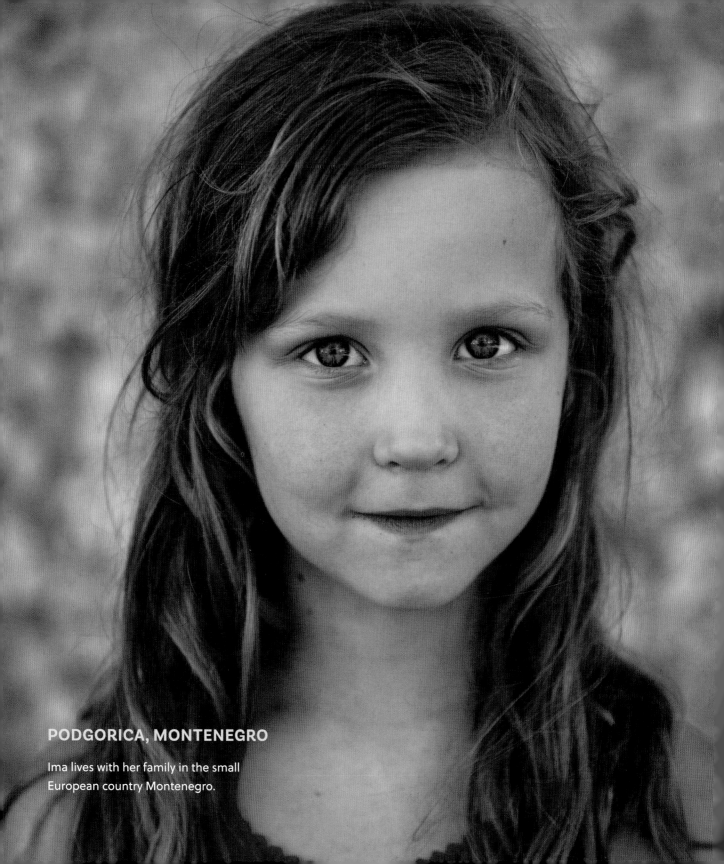

PODGORICA, MONTENEGRO

Ima lives with her family in the small
European country Montenegro.

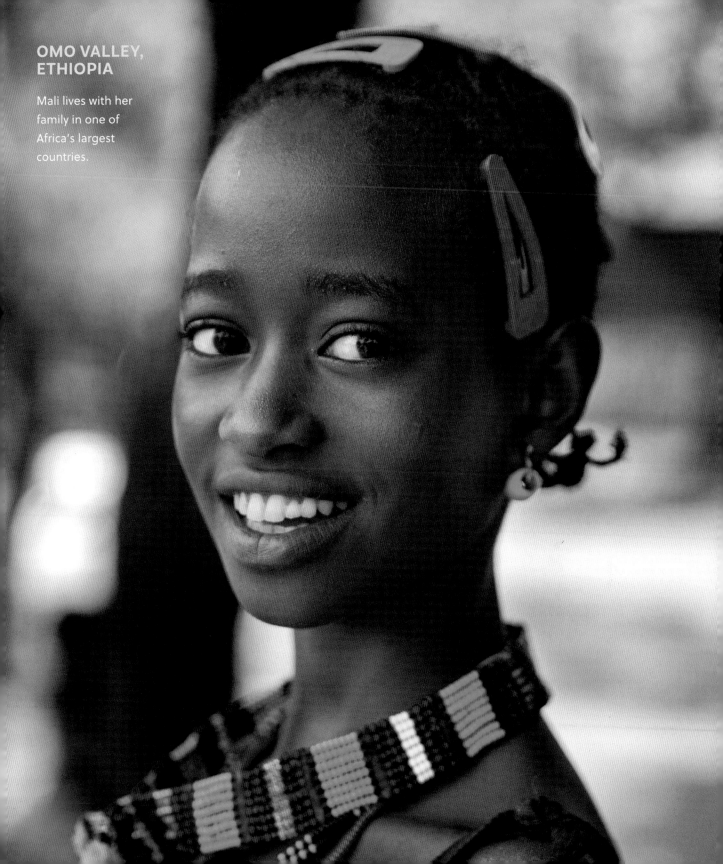

OMO VALLEY, ETHIOPIA

Mali lives with her family in one of Africa's largest countries.

RIO DE JANEIRO, BRAZIL

Maria is studying to become a graphic designer. She loves rock music and often goes to concerts. Although she was born without a forearm, she has never felt limited.

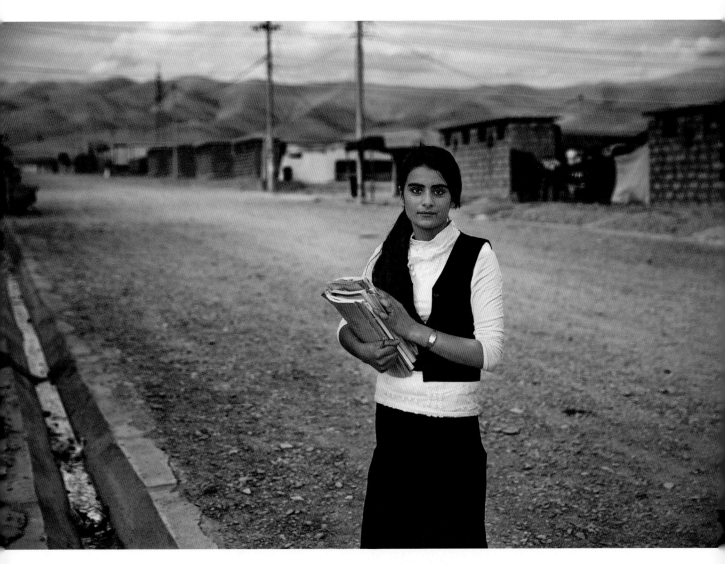

KURDISTAN REGION, IRAQ

Fatima has been displaced to a refugee camp because of war in her country. She and her family have lost all their treasured belongings. She shared with me that she has found relief in books and learning, both of which she has access to. For Fatima, knowledge is the greatest wealth one can have, and nobody can take this treasure away.

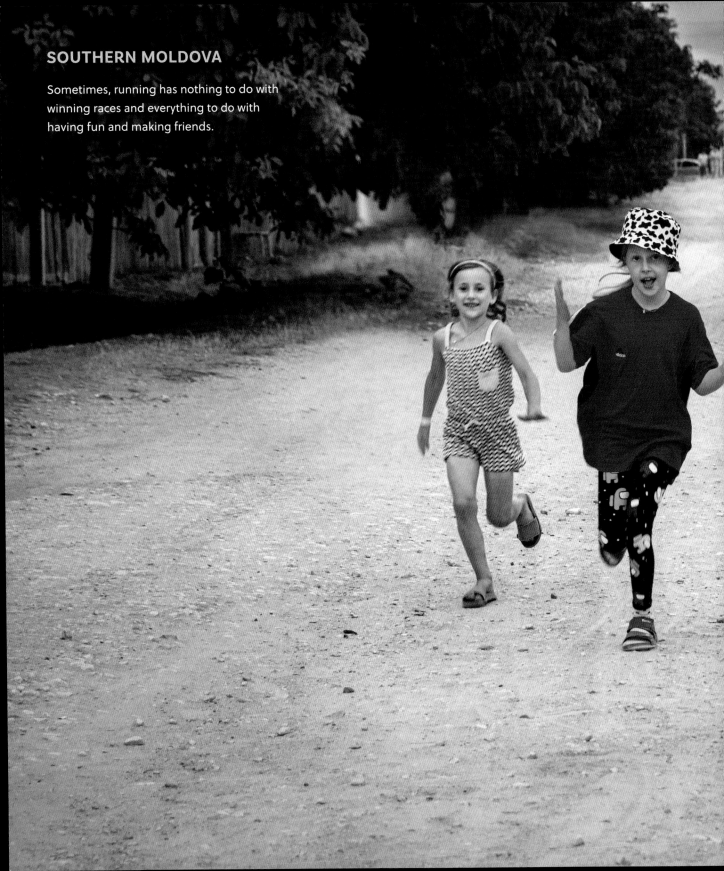

SOUTHERN MOLDOVA

Sometimes, running has nothing to do with
winning races and everything to do with
having fun and making friends.

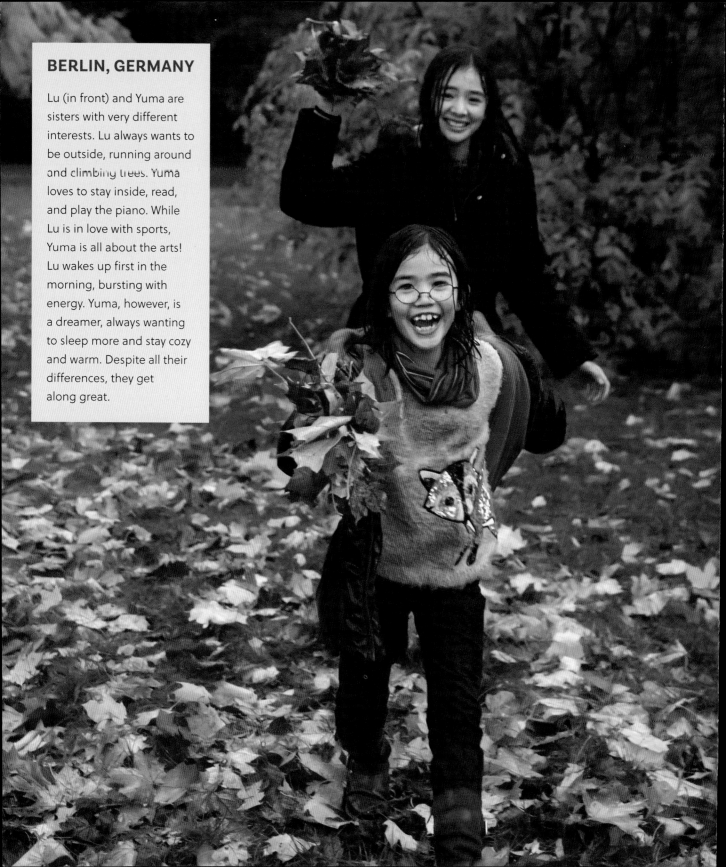

BERLIN, GERMANY

Lu (in front) and Yuma are sisters with very different interests. Lu always wants to be outside, running around and climbing trees. Yuma loves to stay inside, read, and play the piano. While Lu is in love with sports, Yuma is all about the arts! Lu wakes up first in the morning, bursting with energy. Yuma, however, is a dreamer, always wanting to sleep more and stay cozy and warm. Despite all their differences, they get along great.

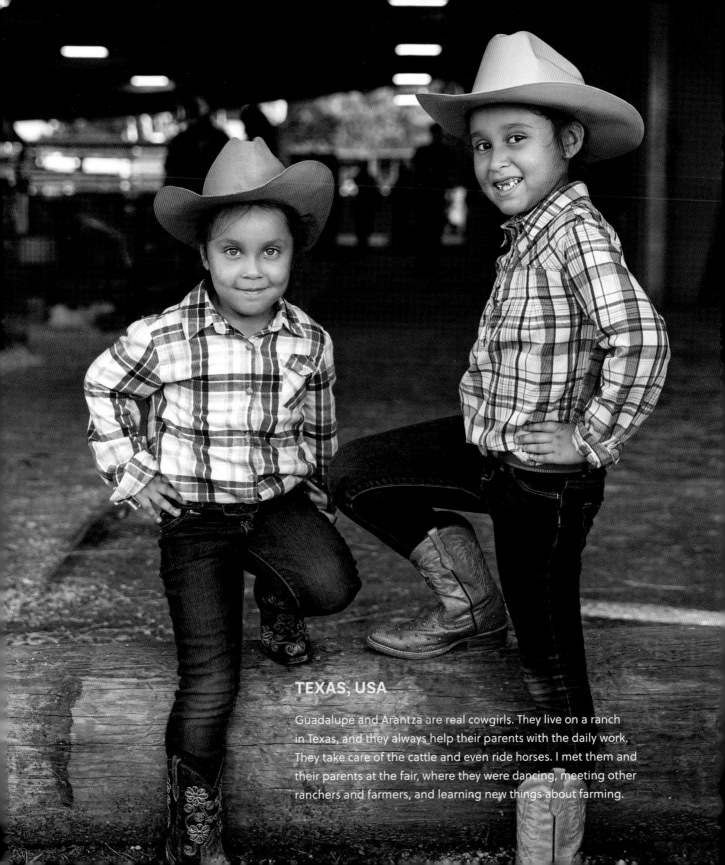

TEXAS, USA

Guadalupe and Arantza are real cowgirls. They live on a ranch in Texas, and they always help their parents with the daily work. They take care of the cattle and even ride horses. I met them and their parents at the fair, where they were dancing, meeting other ranchers and farmers, and learning new things about farming.

WAKHAN, AFGHANISTAN

Ladan lives in one of the most remote areas of the world. In this part of Afghanistan, people have not experienced many lifestyle changes over the last hundred years or so. Because of the steep mountains, this region has remained extremely isolated. Shopping is not common here, so most people make their own clothes and eat what they grow.

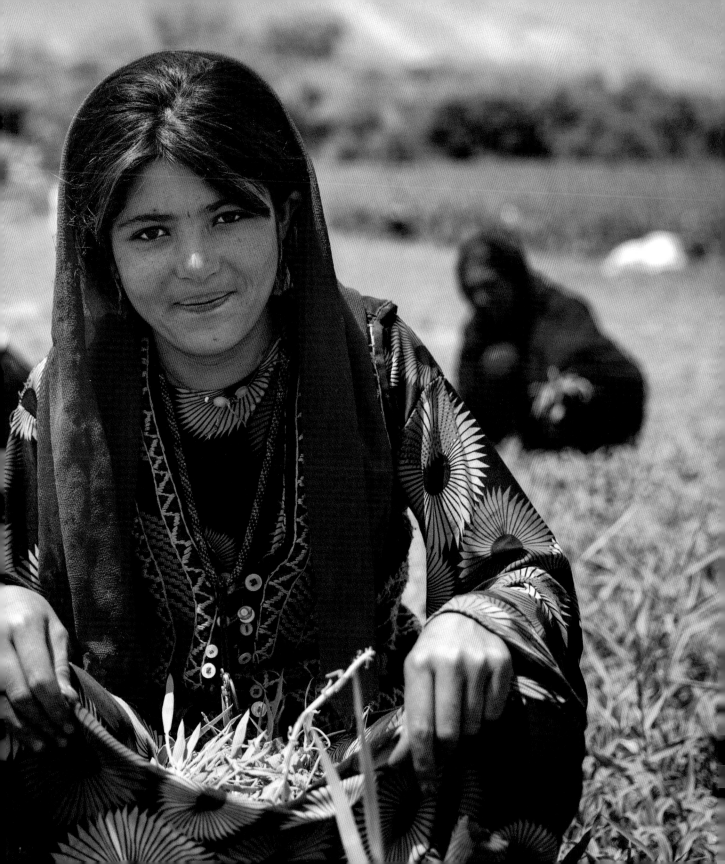

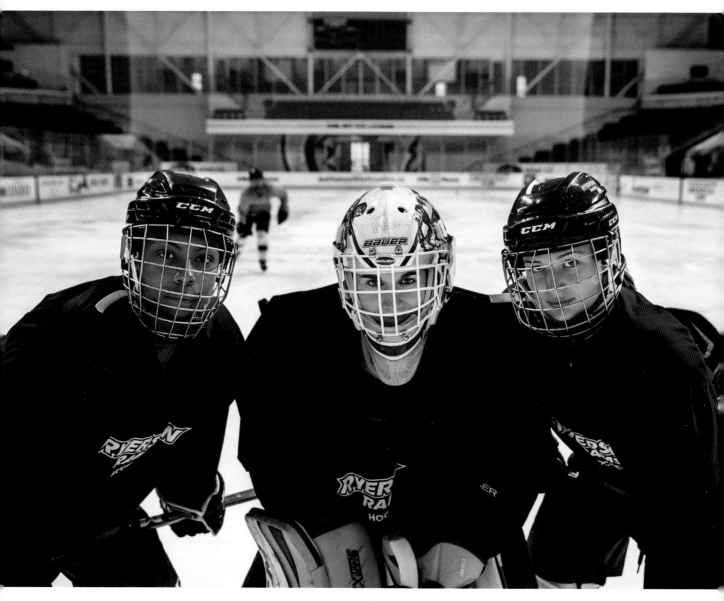

TORONTO, CANADA

Ice hockey is a one-of-a-kind sport and, arguably, no nation loves it more than Canada. It requires speed, balance, power, and strength—all at the same time! These girls have trained for years, and their team spirit is exceptional, which makes all the difference in the end.

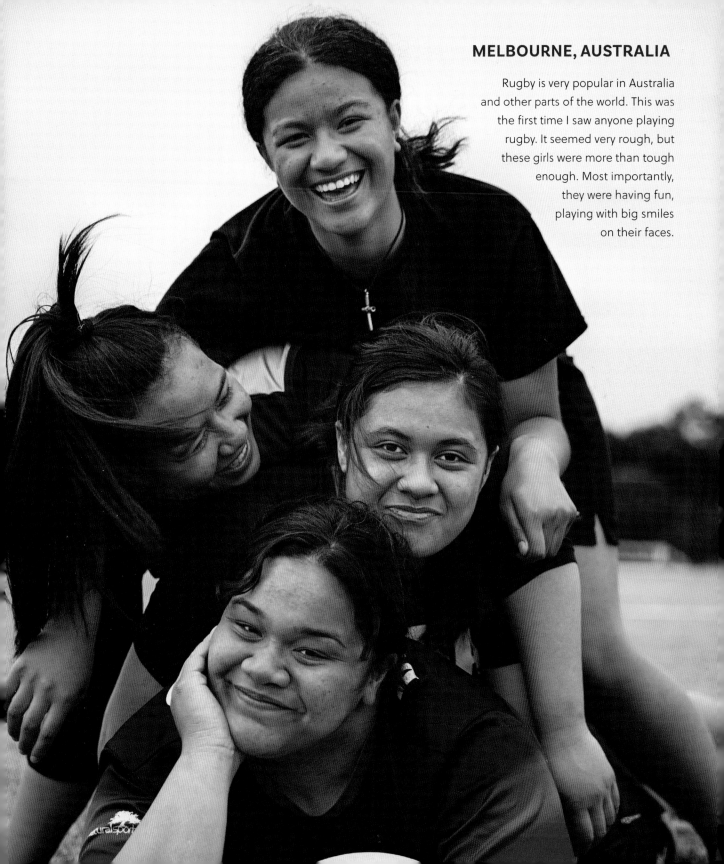

MELBOURNE, AUSTRALIA

Rugby is very popular in Australia and other parts of the world. This was the first time I saw anyone playing rugby. It seemed very rough, but these girls were more than tough enough. Most importantly, they were having fun, playing with big smiles on their faces.

ACKNOWLEDGMENTS

Thank you to all the awesome girls whom I photographed around the world and to their amazing parents. This book wouldn't have been possible without you. I hope you'll love it as much as I do. Thank you to my dear dad. Thank you for teaching me the secrets of colors in your painting studio. And thank you for giving me my first camera. You passed away too early, but I will always celebrate your bright spirit and optimism through my work. Thank you to my dear husband for your huge contribution to who I am today. Thank you to my mom, and thank you to my in-laws. Thank you to my agent, Brian DeFiore. This book exists because of your permanent trust, support, and enthusiasm. Thank you to Patty Rice, Danys Mares, Julie Barnes, and Elizabeth Garcia, and thank you to all the wonderful team at Andrews McMeel for your support and trust. Although we never met in person, it was amazing working with you. Thank you to Lucy Talbot and Melanie McFadyen for helping me with the texts. Last, but not least, thank you to all the people who donated to my project *The Atlas of Beauty*. Your support was essential and gave me the possibility to work on this book, too, while working on *The Atlas of Beauty*.

Title page photo: Naomi from Salt Lake City, USA

COLLAGE IMAGE LOCATIONS (from left to right, top to bottom):
BE FREE, PAGES 48 TO 49: Canada, Moldova, USA, Romania, Portugal, Romania.
BE FREE, PAGE 51: Tajikistan, Bangladesh, Romania, USA, Indonesia, Mexico.
BE HAPPY, PAGES 106 TO 107: Myanmar, Mexico, Thailand, Tajikistan, Namibia, Colombia, Morocco. BE HAPPY, PAGE 109: Indonesia, Ethiopia, Moldova, Morocco, Cuba.
BE YOURSELF, PAGES 158 TO 159: India, Tajikistan, Cuba, Canada, Moldova, Ethiopia, Afghanistan. BE YOURSELF, PAGE 161: Afghanistan, Iraq, Kyrgyzstan, India, Nepal, Myanmar, Indonesia, Jordan. BE KNOWLEDGEABLE, PAGES 224 TO 225: Syria, Nepal, Sri Lanka, Tajikistan, Uzbekistan, Thailand, Myanmar. BE KNOWLEDGEABLE, PAGE 227: Nepal, Norway, China, Myanmar, Laos

Andrews McMeel Publishing
a division of Andrews McMeel Universal
1130 Walnut Street, Kansas City, Missouri 64106

www.andrewsmcmeel.com

23 24 25 26 27 SDB 10 9 8 7 6 5 4 3 2 1

ISBN: 978-1-5248-8052-1

Library of Congress Control Number: 2023936241

Editor: Patty Rice
Art Director: Julie Barnes
Production Editor: Elizabeth A. Garcia
Production Manager: Julie Skalla

ATTENTION: SCHOOLS AND BUSINESSES
Andrews McMeel books are available at quantity discounts with
bulk purchase for educational, business, or sales promotional use.
For information, please e-mail the Andrews McMeel Publishing
Special Sales Department: sales@amuniversal.com.